SENEFEL

LITHOGRAPHI

The Classic 1819 Treatise

ALOIS SENEFELDER

DOVER PUBLICATIONS, INC.
Mineola, New York

Bibliographical Note

This Dover edition, first published in 2005, is an unabridged republication of the work, as originally published by R. Ackermann, London, in 1819 under the title *A Complete Course of Lithography.* The original German edition was published by K. Thienemann, Munich, in 1818 under the title *Vollständiges Lehrbuch der Steindruckerey.*

Due to an error in the original English edition, the book appears to be misnumbered between pages 85 and 92. For the sake of authenticity, the Dover edition has perpetuated this original error.

Library of Congress Cataloging-in-Publication Data

Senefelder, Alois, 1771–1834.
 [Vollständiges Lehrbuch der Steindruckerey. English]
 Senefelder on lithography : the classic 1819 treatise / Alois Senefelder.
 p. cm.
 Translation of: Vollständiges Lehrbuch der Steindruckerey.
 Unabridged republication of the work, as originally published in 1819 under title: A complete course of lithography.
 ISBN 0-486-44557-7 (pbk.)
 1. Lithography—History. 2. Lithography—Technique. I. Senefelder, Alois, 1771–1834. Complete course of lithography. II. Title.

NE2420.S513 2005
763'.22—dc22

 2005049739

Manufactured in the United States of America
Dover Publications, Inc., 31 East 2nd Street, Mineola, N.Y. 11501

A COMPLETE

COURSE OF LITHOGRAPHY:

CONTAINING

Clear and Explicit Instructions

IN ALL THE

DIFFERENT BRANCHES AND MANNERS OF THAT ART:

ACCOMPANIED BY

ILLUSTRATIVE SPECIMENS OF DRAWINGS.

TO WHICH IS PREFIXED A

HISTORY OF LITHOGRAPHY,

FROM ITS ORIGIN TO THE PRESENT TIME.

———

By ALOIS SENEFELDER,

INVENTOR OF THE ART OF LITHOGRAPHY AND CHEMICAL PRINTING.

———

WITH

A PREFACE

By FREDERIC VON SCHLICHTEGROLL,

Director of the Royal Academy of Sciences at Munich.

———

TRANSLATED FROM THE ORIGINAL GERMAN, BY A. S.

———

London:

PRINTED FOR R. ACKERMANN, 101, STRAND.

———

1819.

[Original title page]

ADVERTISEMENT

FROM

THE PUBLISHER.

———

THE Public will naturally expect some account of the motives which induced me to lay before them the Course of Lithography, by Alois Senefelder, in an English dress.

In the first place, the Art itself appeared to me of the highest utility. By means of it the Painter, the Sculptor, and the Architect, are enabled to hand down to posterity as many fac-similes of their original Sketches as they please. What a wide and beneficial field is here opened to the living artist, and to future generations! The Collector is enabled to multiply his originals, and the Amateur the fruits of his leisure hours. The Portrait Painter can gratify his Patron by supplying him with as many copies as he wishes to have of a successful likeness. Men in office can obtain copies of the most important despatches or documents, without a moment's delay, and without the necessity of confiding in the fidelity of Secretaries or Clerks: the Merchant, and the Man of Business, to whom time is often of the most vital importance, can, in an instant, preserve what copies they may want of their accounts or tables. In short, there is scarcely any department of art or business, in which Lithography will not be found of the most extensive utility.

In the next place, I have occasion to know that a correct guide to the knowledge of this useful art has been hitherto a desideratum. I speak from experience. For more than two years I have availed myself of it, in the publication of various works. During that time, however, I have

struggled with many difficulties, and been frequently embarrassed from the want of definite instructions as to many essential points. Much time and labour have thus been unnecessarily sacrificed. The art has also been practised in some of the Public Offices, and by various private individuals in this country; and I have no doubt the difficulties and embarrassments to which I allude, have been frequently experienced by others as well as myself.

Under these circumstances, a correct guide to a knowledge of the various manners of the art cannot fail to prove of the greatest benefit to all those who are desirous of thoroughly understanding it. Such a guide will be found in the following Treatise. It is the production of Alois Senefelder, the individual to whom the world is indebted for the invention of Lithography. The work is divided into two parts. In the first part, which is a history of the art, from the idea that led to its discovery, down to its last and most improved state, M. Senefelder has laid before us the various plans that he formed, and experiments that he tried, and the result with which they were attended, with the most engaging simplicity, and a truth which renders them in the highest degree instructive. In the second part, M. Senefelder has communicated in the most unreserved manner, all the knowledge which he himself at present possesses of the practice of the art. Here the reader will find the most minute and comprehensive instructions for every operation. Nothing seems to have escaped the notice of the ingenious author; his directions extend to every particular which has the least connexion with the subject, and afford the means of surmounting almost every possible difficulty.

Having now succinctly enumerated the advantages of the art, the difficulties which stood in the way of obtaining a correct knowledge of it, and the degree in which I conceive the present Treatise is calculated to supply that deficiency; I shall now briefly allude to some other circumstances which formed no slight inducement to my entering on the present publication.

In the first place, I myself entertain no ordinary degree of fondness

for the art, and feel warmly interested in the success of whatever has a tendency to promote its diffusion. I am, therefore, extremely anxious to see it naturalized in this country, and in the same flourishing state in which it is at present on the Continent. In the next place, I have the honour, for such I esteem it, of a personal acquaintance with the ingenious author and inventor; and M. Von Schlichtegroll, Director of the Royal Academy of Arts and Sciences at Munich, under whose auspices the work was ushered into the world, without whose kind and urgent persuasion the author would never have engaged in it, and who has honoured this work with an excellent Preface, is my most particular friend. M. Von Schlichtegroll has nothing more at heart than the universal diffusion of this new and useful art; and by the present publication, therefore, while I please myself with the hope that I shall be useful to the Public, I know I shall also gratify, in no ordinary degree, the philanthropic desire of my friend.

The work contains a Portrait of the author and inventor, and such Specimens of Drawing printed at my press,* as are necessary for the illustration of the different manners of the art, and the due understanding of the Instructions.

May it be the means of diffusing throughout this great and commercial country, the knowledge of a discovery, from which much benefit has already been derived abroad ; and which, from the immensity of our transactions, promises to be of more advantage to us than to any other nation !

R. ACKERMANN.

101, STRAND, 1 *March*, 1819.

* It was the wish of Mr. Senefelder to supply the English translation with impressions from the original plates, and it would have given me much pleasure to have been able to comply with his request ; but as each separate print must have paid a duty at the Custom House, the aggregate duty alone would have added above a guinea and a half to the price of each copy, without including the other expences with which such an importation would have been attended, and I was obliged therefore to give up all thoughts of this.

DEDICATED

(BY PERMISSION)

To His Majesty

MAXIMILIAN JOSEPH,

KING OF BAVARIA,

HIS MOST GRACIOUS KING AND SOVEREIGN,

THE AUGUST PROTECTOR OF THIS WORK,

AND OF

THE ART OF LITHOGRAPHY,

BY

HIS MAJESTY'S MOST HUMBLE

AND MOST FAITHFUL SUBJECT,

ALOIS SENEFELDER.

PREFACE.

———

A WORK, like the present, needs no introduction; its intrinsic value must be its best recommendation. The ingenious Author, however, being of opinion, that the appearance of this work is, in great part, owing to his acquaintance with me, and wishing that I should accompany it with an historical introduction, I willingly seize this opportunity, to testify to the Public at large the high regard and esteem which I entertain for the talents of my distinguished contemporary and countryman, who, not satisfied with what he has already accomplished, pursues his inventions with the utmost zeal and activity, with a view to further improvements.

It would be unjust to say that the contemporaries of the important discovery of Lithography, which the inventor, by incessant experiments, is endeavouring to carry to still higher perfection, have received it with indifference and neglect. With astonishing rapidity it has spread over all Europe, and other parts of the

world, and every where it has been received with due
admiration. The only obstacles which have impeded
its success, are the imperfect instruction which has, in
some places, been given respecting it by ignorant
artists and pretended adepts, and the difficulty which
the art of printing from stones (depending entirely on
chemical and not on mechanical principles,) has in the
eyes of the unexperienced. Under these circumstances,
it was natural that the inventor of the new art, who is
still living, and daily and successfully labouring towards
its improvement, should receive repeated invitations to
lay before the Public an history of his important dis-
covery, and instructions respecting the practice of
the art; in short, to write such a work as that which
we now present to the literary Public. But the inge-
nious artist, entirely devoted to his art, is much fonder
of trying experiments and attempting improvements,
than of the dry business of writing. Mr. Senefelder
often intended to commit to paper the history of his
first invention of the art, and its successive improve-
ments, down to its present state on the Continent; but
before he could carry this intention into execution, his
indefatigable mind always suggested to him some new

improvements, calculated to render it more perfect ; and this led him to fresh experiments and studies, which absorbed the whole of his time and attention. Thus it happened that the " Collection of Specimens," already begun in 1809, remained unfinished, and without any text to accompany them ; and even the work, announced two years ago by Mr. André of Offenbach, in conjunction with Senefelder, has never made its appearance.

A strong external inducement or motive, therefore, was required, to prevail upon Mr. Senefelder to give to the Public what it had so long wished and called for. Such an inducement he received in the following manner :---Several assertions having appeared in the newspapers, that Lithography had been invented at Paris, or at London, and some rumours having been in circulation even at Munich, ascribing the original invention either to Alois Senefelder, or Dean Schmidt of Miesbach, formerly Professor at Munich, I conceived myself called upon to contribute, as much as was in my power, to the removal of this uncertainty, and to prepare the way for a critical history of the new art, at a time when it was still possible to ascertain the truth. The " Advertiser

for Arts and Manufactures," which, since 1815, has appeared weekly at Munich, contains chiefly Annals of the History of Industry and Art in Bavaria; in this Journal, therefore, towards the end of 1816, and the beginning of the year 1817, I caused several letters to be inserted on the subject of the invention of Lithography; in which I called upon all friends and promoters of national industry, to correct whatever they might find inaccurately stated in the notices that I had collected from the mouths of different witnesses, and thus facilitate the discovery of a truth so important to the present and following generations. But, above all, I called on Mr. Alois Senefelder, then absent from Munich, " Not to delay any longer the publication " of a minute History of his Inventions, accompanied " by a complete course of Instructions in Litho- " graphy, detailing all its branches and different " modes of application." These printed letters I sent to Mr. Senefelder, then at Vienna.

The first of these objects has not been attained; not one voice has yet been raised to solve, with historical truth and dignity, the apparent inconsistencies and contradictions of the different rumours, and to

prevent the language of our immortal Klopstock from being one day applied to Lithography, " Covered with eternal darkness are the great names of inventors."

In the attainment of my second wish, I have been more fortunate. Mr. Alois Senefelder justly appreciated my well-meant intention, and the sincere interest I took in this important discovery, which will be an everlasting honour to Bavaria. Several conversations on this subject have since passed between him and myself; and I used every means to revive the confidence of this ingenious artist, whose spirits, by many unsuccessful undertakings, had been greatly depressed.

My principal endeavours to bring the astonishing progress which Lithography, by Mr. Senefelder's exertions, was daily making, to the knowledge of our august Sovereign, to induce that venerable national establishment to which I belong, " The Royal Academy," to enter on a scientific examination of it, and to promote the appearance of the present work---These, I say, have not been unsuccessful.

His Majesty, our most gracious King, the revered father of his people, and most liberal promoter of this

new art, was pleased to notice its most recent improvement, the substitution of metal, or even artificial paper, to stone, which Mr. Senefelder contrived during the last winter ; and, in order to encourage the publication of the present work, he allowed it to be dedicated to his illustrious name. Her Majesty, our beloved Queen, highly conversant in the fine arts, honoured the exertions of the artist with her attention, and thereby animated his zeal and activity.

The Royal Academy of Sciences appointed several of its most experienced members to examine the portable presses, which Mr. Senefelder lately contrived, in order to render the use of the art of printing from stone, metal, or artificial paper, more easy and general; and their report upon the subject has proved highly satisfactory to the ingenious inventor. The Polytechnical Society of Bavaria, by their monthly exhibitions of the productions of national industry, and by their journals, have contributed in like manner, to do justice to the invention of Mr. Senefelder, to render it more public, and to direct the attention of his fellow-citizens, and of distinguished foreigners, towards it.

Mr. Senefelder now no longer delayed employ-

ing the leisure hours which his unremitted expe-
riments and studies left him, in writing, from his
best recollections, the history of his invention, and an
unreserved exposition of its different branches or
manners, and in enriching this account with accom-
panying specimens of a most instructive nature.

Thus by the unceasing exertions of this distinguished
and meritorious artist, the present work has made its
appearance, which I do not hesitate to pronounce one
of the most interesting literary productions of the
present times.

It is divided into two parts :---1. The history of
the invention, and its different processes ;---and, 2.
The description of the manner of writing, drawing,
etching, engraving, transferring, preparing and print-
ing the stone. All this is done with the greatest
possible perspicuity and clearness, which such a sub-
ject is capable of; and the annexed specimens greatly
serve to illustrate it more fully.

The historical part gives, with the greatest candour,
which is a principal characteristic of the author, a
faithful account of the circumstances which led him to
the first experiments; of his successful and unsuccess-

ful attempts; of the internal and external difficulties
with which he had to contend; of the manner in which
one idea led to another; of the connexions he entered
into; of the successful or unsuccessful projects, which
he entertained; of the manner in which he was some-
times assisted, and sometimes deceived; of the faults
he committed; and of the uncertain and embarrassed
circumstances in which he passed a series of years.
The minuteness of this narrative, and the mention of
the personal affairs of the author and his friends,
may, perhaps, on a first view, astonish the reader. But
these very circumstances are, in a great measure, inti-
mately connected with the History of Lithography,
and its different vicissitudes; and, on the other hand,
the shortness of the time would not allow the author
carefully to finish and abridge what he intended only
for a sketch. In the history of an important invention
however, minuteness cannot be called a defect. How in-
teresting would it be to read all the private circum-
stances of the lives of John Guttenberg, or John Faustus,
if a narrative of the origin of Typography, similar to
this of the origin of Lithography, were in existence.

The wish that Mr. Alois Senefelder might openly

and minutely declare how he was led to the discovery
of Lithography, is now gratified. His narrative and
assertions being thus publicly exposed, they may be
compared with the other accounts that are in cir-
culation on this subject; and by a more distinct de-
finition of what is properly meant by the expression
" Lithography," the discussion may be conducted on
certain and fixed rules. I therefore take the liberty
to call once more on all contemporaries to notice
what they think contradictory in this account; to pre-
pare in this manner a critical history of the invention,
with a chronicle of what has been done in the first
years of this art, by whom it has been done, or
whether more than one person at the same time hit
on the same idea; and *thus to do justice to every one.*
It is greatly to be wished that a man of science, en-
dowed with sufficient acuteness and impartiality, might
render this most important service to our literature.

As to the second part, which contains a com-
pendium of instructions in the new art, it has been
more generally desired than even the history of it, and
more especially from the pen of Alois Senefelder.
Lithography, of late years, has been practised at

Munich, as well as elsewhere, with great success; and many artists have produced admirable specimens of writing and drawing. But amongst those that are fully acquainted with the subject in its whole extent, there is but one voice, that, of all the artists who have devoted themselves to Lithography, Mr. Alois Senefelder has made not only the earliest, but also the most numerous and diversified experiments in all its various branches; and, therefore, must be best able to give the desired instructions. He is a character of undisguised sincerity; and I am fully convinced that, in all his communications, his earnest endeavour is, to explain himself without the least reserve, and with the utmost clearness: he has already instructed many persons, and thereby acquired great experience as to what are the difficulties which a beginner of the art usually feels, in his first attempts. According to his testimony (to which Professor Mitterer, whom, after Mr. Senefelder, I believe to be the best and most experienced judge of Lithography, entirely assents,) cases happened, not long ago, which surprised the practical artist in the most unpleasant manner, and puzzled him like enchantment; cases

respecting which this book lays down instructions and precautions, that could only have been known to a man of Mr. Senefelder's extensive experience. If, therefore, an artist or amateur, who strictly observes the rules here given, should still meet with difficulties, he must look for the cause in the nature of his materials; for instance, in the quality of the soap, the gum, the aqua-fortis, the lampblack, or some other seemingly trifling, but in reality important, circumstance; he must not lose courage, and by perseverance and confidence in his frank and faithful instructor, he will be sure of attaining at last the object in view.

Besides those branches and manners of Lithography which were hitherto known, and successfully practised at Carlsruhe, Stutgart, Berlin, London, and Paris, several others are taught and explained, which were never before made public by the inventor; the former are reduced, for the first time, to simple and clear principles; and all those mistakes which, in spite of the strict observance of the prescribed rules, may occur in practice, are mentioned, explained, and cautioned against. Even his latest experiments to sub-

stitute metal plates, or his new-invented stone-paper, for stones, are communicated and explained. Though the process in these two last-mentioned species of printing is nearly related to Lithography, yet they essentially differ from the art properly so called, as every one of the different metals, such as zinc, copper, brass, and iron, require a different preparation. Mr. Senefelder, therefore, intends to devote another work entirely to these subjects, which, when published, will form a Supplement to the present.

May this work go forth under favourable auspices to the world; may it add to the reputation of its author, increase the esteem which he enjoys of all lovers of the arts in and out of Germany, and encourage him to continue to devote his life, to which all friends of our country and of the arts wish a long duration, to the improvement of his great and highly promising art! Reputation and fame he has amply acquired by his invention; a man, more conversant with the world, would have grown rich too; though this is not his case. But our generous King has secured him from want, in his old days: and I am convinced that, whatever advantage he may at any time derive from his art, he

will employ it in rendering that art more perfect; and in instructing his only son, now five years of age, so that he may be one day a worthy inheritor of his father's name.

Munich.

FREDERIC VON SCHLICHTEGROLL,

Director of the Royal Academy.

———

TABLES OF CONTENTS

OF THE FIRST PART.

SECTION THE FIRST,
From 1796 to 1800.

SECTION SECOND,
From 1800 to 1806.

SECTION THIRD.

From 1806 *to* 1817.

TABLES OF CONTENTS

OF THE SECOND PART.

CHAPTER THIRD.

On ACIDS, and other COMPOSITIONS, to PREPARE the STONE.

CHAPTER FOURTH.

On the NECESSARY INSTRUMENTS and UTENSILS.

CHAPTER FIFTH.

On DIFFERENT SORTS *of* PAPER, *&c.*

CHAPTER SIXTH.

On PRESSES.

SECOND SECTION.

On the DIFFERENT MANNERS *of* LITHOGRAPHY.

CHAPTER I.

CHAPTER II.

The ENGRAVED MANNER *of* LITHOGRAPHY.

CHAPTER III.

The MIXED MANNER.

PART FIRST.

HISTORY

OF THE

ART OF LITHOGRAPHY.

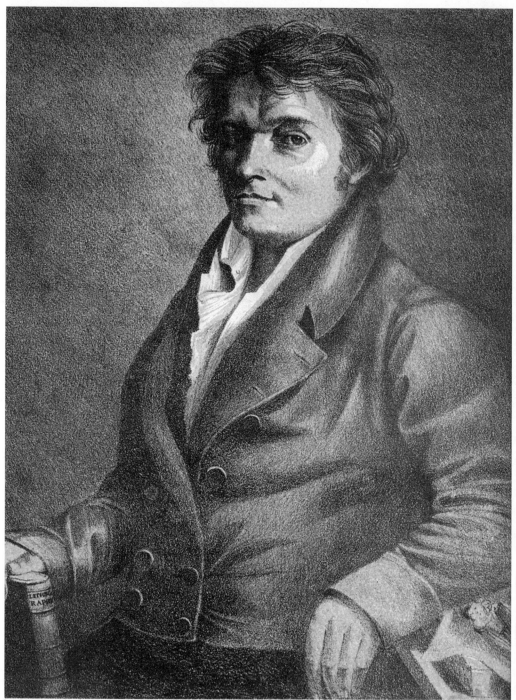

R. Ackermann's Lithography

Aloys Senefelder

Inventor of Lithography

A COMPLETE

COURSE OF LITHOGRAPHY,

&c. &c.

PART I.

History of the Art of Lithography.

HAD I been allowed to follow my own inclinations, I should certainly have embraced the profession of my father, Peter Sennefelder, who was one of the performers of the Theatre Royal at Munich. This, however, being contrary to my father's wishes, I devoted myself to the study of jurisprudence at the University of Ingolstadt; and had no other opportunity of indulging my predilections for the stage, than by occasionally performing at small private theatres, and by employing my leisure in some trifling dramatical productions.

It was in this way that I wrote the little comedy, *Die Mæd-chenkenner*, in the year 1789, which was received by my numerous friends with such applause, that I was induced to send it to the press; and I had the good fortune to clear fifty florins, after defraying the expenses of the printing.

Soon after this I had the misfortune to lose my father, and, as my reduced circumstances did not allow me to continue my academical studies, I could no longer withstand the desire to devote myself entirely to the dramatic art, as performer and author; for the success of my first essay had inspired me with the most sanguine hopes. Having, however, for the space of two years, suffered a great deal of misery and disappointment at several theatres, at Ratisbon, Erlangen, and other places, my enthusiasm cooled to such a degree, that I resolved to forsake this unpromising profession, and to try my fortune as an author.

But even in this plan I was not very successful, and the very first attempt I made to publish another of my dramatic productions entirely failed, as the piece could not be got ready for the Easter Book-fair at Leipzig : it therefore produced scarcely enough to pay the expenses I had incurred. In order to accelerate the publication of this work, I had passed more than one whole day in the printing-office, and had made myself acquainted with all the particulars of the process of printing. I thought it so easy, that I wished for nothing more than to possess a small printing press, and thus to be the composer, printer, and publisher of my own productions. Had I then possessed sufficient means to gratify this wish, I should never, perhaps, have been the inventor of the Lithographic art ; but as this was not the case, I was obliged to have recourse to other projects.

My first idea was to engrave letters in steel, stamp these

matrices in forms of hard wood, and thus form a sort of stereo-type composition, from which impressions could have been taken in the same manner as from a wooden block. But I was compelled to relinquish this plan, for want of proper tools, and sufficient skill in engraving in steel ; but it is my intention to submit this idea, with the subsequent improvements, to the public, on another occasion.

The next plan that occurred to me was, to compose one page of letter-press, in common printing characters, to make a cast of this composition in a soft matter, and, by taking another cast from this cast, to obtain a sort of stereotype frame. This experiment did not wholly disappoint my expectations. I composed a sort of paste, of clay, fine sand, flour, and pulverized charcoal, which, mixed with a little water, and kneaded as stiff as possible, gave a very good impression of the types ; and, in a quarter of an hour, became so hard, that I could take a perfect cast from it in melted sealing-wax, by means of a hand-press. I afterwards applied the printer's ink to this stereotyped block, in the usual manner, and thus obtained a perfectly clear impression from it. By mixing a small quantity of pulverized plaster of Paris with the sealing wax, the composition became much harder than the common type-metal of lead and antimony ; and, to my invention of thus forming a sort of stereotype tables, nothing was wanting but a few preparatory improvements, and a small stock of types ; but even this was too much for my limited finances, and I was therefore obliged

to abandon this plan, which I did the more readily, as I just then chanced to hit upon another, still more easy in its execution.

This was no other than to learn to imitate the printed characters, very closely, in an inverted sense ; to write these with an elastic steel pen on a copper-plate, covered with etching ground, to bite them in, and thus to take impressions from them. By practice I soon acquired some skill in this mode of writing, and began to make a trial of it. The greatest difficulty that I met with here, was how to correct the mistakes I occasionally made in writing ; for I was then utterly unacquainted with the common *covering varnish* of the engravers. I, therefore, tried to cover the faulty places with melted wax ; but the cover I thus obtained was generally so thick, that I could not well work through it. I now called to my assistance the little knowledge of chemistry I had obtained at school ; I well remembered that most of the resins, that withstand aqua-fortis, are dissoluble in æther, spirit of wine, or alcali. I tried many experiments with these, but all in vain ; I then contrived a mixture of turpentine and wax, but this likewise did not answer any purpose, as I probably made it too thin. Fortunately I did not try more experiments with these substances, for, if I had pursued them, I might never have hit on the invention of the lithographic art. At present I know very well how to prepare a covering varnish, perfectly *fit* for this purpose, with turpentine, wax and mastic. Another experiment with wax and soap, was at last perfectly successful. A com-

position of three parts of wax, with one part of common soap, melted together over the fire, mixed with a small quantity of lampblack, and dissolved in rain-water, produced a black ink, with which I could with great ease correct the faults I accidentally made.

Though I had thus overcome my greatest obstacle, yet the want of a sufficient number of copper-plates, the tediousness of grinding and polishing those I had used, and the insufficiency of tin plates, which I tried as a substitute, soon put an end to my experiments in this way.

It was at this period that my attention was accidentally directed to a fine piece of Kellheim stone, which I had purchased for the purpose of grinding my colours. It occurred to me that by covering this plate with my composition ink, I could use it as well as the copper or tin plates, for my exercises in writing *backwards*. The little trouble that the grinding and polishing of these plates would cost, were my chief inducement to try this experiment. I had, till then, seen only very thin plates of this stone, and therefore I had no conception that I should be able to use them for taking impressions from them, as they would not resist the pressure necessary for this purpose, without breaking ; but in regard to writing, I soon discovered that I could do it better and more distinctly on the stone, than on the copper-plates. Being, soon after this, informed by a stone-mason that he could procure these plates from one to eight

inches thick, I began to conceive the possibility of using them likewise for the impressions ; but before this could be done, it was absolutely necessary first to discover a method to give a higher polish to the stone, or to prepare a colour that could be better wiped off the stone, than the common printer's ink. For the stone never admits that sort of polish which is requisite for the application of the common ink ; and this, I suppose, is the very reason why the stone having, not long before, been used by engravers for etching, as a substitute for copper, (for I am well aware that many similar experiments had already been tried,) the attempt did not succeed, and was soon relinquished.

I tried all possible methods of polishing and grinding the stone, but my success was not such as I could have wished. As to the polishing of the stone, I found it the best way to apply to the smoothly-ground surface of it a composition of four or five parts of water, and one part of rectified oil of vitriol. This liquid produces a sudden effervescence on calcareous stone, which, however, almost instantly ceases, so that we might be tempted to believe the vitriol saturated ; but this is not the case, for on the same liquid being applied to another part of the stone yet untouched, it produces a similar effervescence ; the reason of this is, that the surface of the stone is almost instantly covered with a coat of gypsum, which is impenetrable to the vitriol. When this liquid is wiped off, and the stone dried, it acquires, by a slight rubbing of a rag, a most brilliant polish ; this, however, is so thin, that it scarcely allows fifty impressions to be taken from

it, without a repetition of the above process, which, however, is attended with some injury to the drawing. But if impressions are taken according to the present chemical method, and the stone has been polished before the drawing is made, several thousands of impressions may be obtained, as will be more fully described in another place.

As to the second difficulty, of discovering a colour that could be easily wiped off the stone, I found, after many experiments, that none was better than a light varnish of oil, mixed with purified lampblack, which could be wiped from the stone by means of a weak solution of potash, and common salt, in water ; but if this was not done with sufficient care, it sometimes happened that the drawing or writing on the stone was at the same time effaced, and could not be restored without great trouble. The recollection of this fact, which at that time I was unable to explain, led me, some years afterwards, to the invention of the present chemical lithography.

I have been very minute in describing the process of inventing this ink of wax, soap, and lampblack, as it was principally this invention which opened to me the way to the chemical lithography. It so happened, therefore, that I knew the ink, before I even thought of applying it to the stone ; in the first instance, I only used the stone for my exercises in writing ; the ease with which this was done, (and which, indeed, is far greater than on metal covered with etching ground,) in-

duced me to use the stone for the printing ; but, in order to do this, it was requisite to clear the stone as perfectly as the copper-plate printer does his copper-plate, though the stone will not take so high a polish as the latter.

I was trying some farther experiments for this purpose, when a new and accidental discovery prevented me from pursuing this plan.

In all the experiments I have hitherto described, I could not boast of having invented any thing new, as I had been only applying the theory of printing from copper-plates to stone plates, or rather used the latter as a substitute for the former. Had I not gone farther in my discoveries, it is more than probable that, if my circumstances had improved, I should have returned to copper-plates, as the thickness and size of the stones rendered their use by no means more convenient, and as the novelty of the invention would not have encouraged me to follow this new path.

I was firmly convinced that I was not the inventor of the art of etching or engraving on stone, or of taking impressions from stone ; I even knew that etching on stone had been practised several centuries before me. But from the moment that I abandoned the *principle of engraving*, and directly applied my new invented ink to the stone, of which I am about to treat more amply, I could consider myself as the inventor of a new art,

and from that moment I relinquished all other methods, and devoted myself exclusively to this.

As I come now in my narrative to that period, from which the Art of Lithography may be said to have drawn its direct origin, I hope I may crave the indulgence of the reader, if I mention even the most trifling circumstances, to which the new art was indebted for its existence.

I had just succeeded in my little laboratory in polishing a stone plate, which I intended to cover with etching ground, in order to continue my exercises in writing backwards, when my mother entered the room, and desired me to write her a bill for the washer-woman, who was waiting for the linen ; I happened not to have even the smallest slip of paper at hand, as my little stock of paper had been entirely exhausted by taking proof impressions from the stones ; nor was there even a drop of ink in the inkstand. As the matter would not admit of delay, and we had nobody in the house to send for a supply of the deficient materials, I resolved to write the list with my ink prepared with wax, soap, and lampblack, on the stone which I had just polished, and from which I could copy it at leisure.

Some time after this I was just going to wipe this writing from the stone, when the idea all at once struck me, to try what would be the effect of such a writing with my prepared ink,

if I were to bite in the stone with aqua-fortis; and whether, perhaps, it might not be possible to apply printing ink to it, in the same way as to wood engravings, and so take impressions from it. I immediately hastened to put this idea in execution, surrounded the stone with a border of wax, and covered the surface of the stone, to the height of two inches, with a mixture of one part of aqua-fortis, and ten parts of water, which I left standing five minutes on it; and on examining the effect of this experiment, I found the writing, elevated about a 10th part of a line, (or 1-120th part of an inch.) Some of the finer, and not sufficiently distinct, lines, had suffered in some measure, but the greater part of the letters had not been damaged at all in their breadth, considering their *elevation;* so that I confidently hoped to obtain very clear impressions, chiefly from printed characters, in which there are not many fine strokes.

I now proceeded to apply the printing ink to the stone, for which purpose I first used a common printer's ball; but, after some unsuccessful trials, I found that a thin piece of board, covered with fine cloth, answered the purpose perfectly, and communicated the ink in a more equal manner, than any other material I had before used. My farther trials of this method greatly encouraged my perseverance. The application of the printing ink was easier than in the other methods, and I could take impressions with a fourth part of the power that was requisite for an engraving, so that the stones

were not at all liable to the danger of breaking ; and, what was of the greatest moment to me, this method of printing was an entirely new invention, which had occurred to nobody before me. I could, therefore, hope to obtain a patent for it, or even some assistance from the government, which, in similar instances, had shown the greatest liberality in encouraging and promoting new inventions, which I thought of less importance.

Thus the new art was invented, and I lost no time in making myself a perfect master of it ; but, in order to exercise it so as to gain a livelihood by it, a little capital was indispensable to construct a press, purchase stones, paper, and other utensils. But as I could not afford even this trifling expense, I saw myself again on the point of being obliged to relinquish all my fond hopes and prospects of success, unless I could devise an expedient to obtain the necessary money. At length I hit upon one, which was to enlist as a private in the artillery, as a substitute for a friend of mine, who promised me a premium of 200 florins. This sum I thought would be sufficient to establish my first press, to which I intended to devote all my leisure, and the produce of which, I hoped, would soon enable me to procure my discharge from the army ; besides my knowledge of mathematics, mechanics, and fortification, might possibly promote my views in this new career.

I was quickly resolved, and, on the third day after forming my

resolution, I went to Ingolstadt, with a party of recruits, to join my regiment. It was not without some feelings of mortification and humbled pride, that I entered this city, in which I had formerly led the independent life of a student; but the consciousness of my own dignity, and enthusiasm for my new invention, greatly contributed to restore my spirits. I slept in the barracks, where I was not a little disgusted by the prevailing filth, and the vulgar jests of a corporal. The next morning I was to enlist; but, to my great disappointment, the commander of the regiment discovered that I was not a native of Bavaria, and therefore, according to a recent order of the Elector, could not serve in the army, without obtaining a special license.

Thus my last hope failed me, and I left Ingolstadt in a state of mind bordering on despair. As I passed the great bridge over the Danube, and looked at the majestic river, in which I had been twice nearly drowned while bathing, I could not suppress the wish that I had not been then saved, as misfortune seemed to persecute me with the utmost rigour, and to deny me even the last prospect of gaining an honest subsistence in the military career.

But though from my earliest years I had been uniformly deluded by hope, I still continued to yield myself up to its allurements, and new projects soon consoled me for my late disappointment; I resolved to give up, for the present, all thoughts of being an author, and to become a journeyman printer.

A page of wretchedly printed music from a prayer-book, which I accidentally met with at a shop at Ingolstadt, suggested to me the idea that my new method of printing would be particularly applicable to music printing ; I, therefore, resolved, on my return to Munich, to go directly to Mr. Falter, a publisher of music, to offer him my invention, and beg his assistance. My natural shyness alone prevented me from executing this plan immediately ; I had twice passed his door, without having the courage to enter the house, when I accidentally met an acquaintance, to whom I had occasionally communicated something of my invention ; and, in conversing with him, I learned that Mr. Gleissner, a musician of the Elector's band, was just about to publish some pieces of sacred music. This was most welcome news to me, as Mr. G. was a particular friend of mine.

Without farther delay, I called on Mr. Gleissner, to whom I communicated my new invention, offering him, at the same time, my services for the publication of his music. The specimens of music, and other printing, which I showed him, obtained his and his wife's highest approbation ; he admired the neatness and beauty of the impressions, and the great expedition of the printing; and, feeling himself flattered by my confidence, and the preference I gave him, he immediately proposed to undertake the publication of his music on our joint account. I had, in the mean time, procured a common copper-plate printing press, with two cylinders ; and, though

it was very imperfect, it still enabled me to take neat impressions from the stone plates. Having, therefore, copied the twelve songs, composed by Gleissner, with all possible expedition, on stone, I succeeded in taking, with the assistance of one printer, 120 copies from it. The composing, writing on stone, and printing, had been accomplished in less than a fortnight ; and in a short time we sold of these songs to the amount of 100 florins, though the whole expense of stones, paper, and printing, did not exceed 30 florins, which left us a clear profit of 70 florins ; and, in the exultation of my hopes, I already saw myself richer than Crœsus.

Mr. Gleissner succeeded, through his patron Count Torring, in laying a copy of this our first work before the Elector Charles Theodore, from whom we received a present of 100 florins, with the promise of an exclusive privilege. The next work, Duettos for two flutes, by Gleissner, yielded us again a little profit ; and an order from the Countess of Hertling, to print 150 copies of Mr. Cannabick's Ode, on the death of Mozart, promised us a still greater profit.

It was about this time that I laid a copy of our first work before the Electoral Academy of Sciences, with a Memoir, in which, after explaining the mode of printing, and other advantages of the new art, I also mentioned the cheapness of the press, which did not cost more than six florins. How much was I, therefore, disappointed, when, instead of seeing my new

invention honourably mentioned in the transactions of the Society, I received from its Vice President Von Vachiery, a present of twelve florins, with the intimation, that my Memoir had been very favourably received ; and, as the expenses of the press, according to my own statement, did not exceed six florins, he hoped that a double compensation would satisfy my expectations. I, indeed, expected a very different treatment from the guardians of science and art, whose duty it is to investigate the value of every new invention ; and, if approved, to submit it to the notice of government.

Promising as this beginning appeared, (in the year 1796,) we soon had the mortification of seeing things assume a very different aspect. As our income increased, we resolved to construct a new and more perfect press, by which we hoped greatly to facilitate the printing of our works. How sadly, therefore, were we disappointed, when, on the first trial with it, we obtained a blotched and dirty impression, instead of the model of perfection which we anticipated ; we took off twenty more with the greatest care, but not more than two or three were even tolerable. It is, and will be as long as I live, perfectly incomprehensible to me, how I could be so perplexed as not to discover immediately the cause of this failure. I discovered it a long time afterwards, by mere chance, but it cost me two years of great trouble and anxiety. The cause why we did not succeed, was a most trifling circumstance. In my first,

and imperfect press, it happened that by the splitting of the two wooden cylinders, each of them had a fissure, two inches wide ; but as the diameter of the upper cylinder was large enough to print the whole page in one circumvolution, without the fissure touching the stone, I made shift with the cylinder as it was, placing it always so that the fissure did not touch the stone. But, in our new press, it was necessary that the upper cylinder, in order to lay hold of the stone, should draw it first between the two cylinders ; before this could be done, however, it carried with it the cloth of the printing frame, till it would stretch no longer, and forced the stone under the cylinder ; but in this act, the paper under the printing frame was carried over the charged stone and spoiled. Every expedient I tried to remedy this inconvenience proved unsuccessful ; and most likely I should have hit at last on the very simple mode of using leather, instead of the thin cloth, but I was too much perplexed and anxious about fulfilling our engagements, and therefore preferred having another press constructed, in which the pressure, as in the printing presses, was to be vertical and uniform. In less than a week this rough press was finished ; the first trials promised success ; but the greater stone plates did not give equal impressions, probably on account of the unevenness of the table, which was only of wood. I tried to increase the pressure as much as I could, and by means of a lever, and a stone of 300 pounds, which descended from a height of ten feet, I produced a pressure of more than fifty tons on the stone ; by this

means I did not fail to obtain good impressions, but after the second or third the stones always broke. To ascertain the vertical pressure requisite to take an impression from a stone plate, I tried numerous experiments, and found that the space of one square inch, required a pressure of 300 pounds to produce a good impression in the space of a few seconds ; but leaving the weight for a minute or longer on the stone, scarcely one half of that pressure was requisite. According to this statement, the weight requisite for our music stones, of about 100 square inches each, would have been fifteen tons ; but the unevenness of the table, and the general imperfection of the machine, rendered it necessary to increase this pressure threefold, and such a weight the stone was absolutely incapable of bearing. I was soon after deterred from farther improving upon this press, as, on one occasion, I had a very narrow escape from being killed by the great stone of 300 pounds, which always fell from a height of ten feet. The consideration that the same accident might occur in future to the printers, rendered the whole press odious to me ; and I was, therefore, easily induced to pursue another plan for constructing a new and perfectly simple printing press, which I had just conceived.

At the time when I had not yet the advantage of a press, I used the following method to take impressions from the stones. Having first placed the wetted paper on the charged stone, I covered it with a few sheets of waste paper; then

placing a sheet of thick paper over it, I took a piece of po-lished wood and rubbed the surface of the paper, which with the other hand I prevented from slipping, till I believed that every part of it had been sufficiently pressed. In this way I often obtained impressions as good and clear as from a press.

This method I proposed to imitate on a larger scale. A wooden frame, of two feet square, was covered with cloth on one side ; upon this cloth I pasted a sheet of thick paper, and fastened the frame by means of two hinges upon a common square table, in which the stone was fixed beneath the frame ; in the inner side of the frame the paper was fixed by means of threads : in this way I applied it to the stone, and with a piece of wood or glass, rubbed the surface of the frame, till I thought I had touched every part of it. The first specimens surpassed our most sanguine expectations, and the hope of being yet able to keep our engagements, re-animated our depressed spirits. Two other similar presses were soon finished ; I employed my-self incessantly in writing upon the stones ; the printing began with six printers : but,—Oh! the uncertainty of human expec-tations!—not one of all the six printers could make himself master of the simple process of rubbing the surface of the stone ; out of ten impressions, scarcely one was perfect ; and if they even succeeded in printing three pages of a sheet perfect, the fourth was sure to fail, and spoil the whole. Thus, out of three reams of the best paper, only thirty-three perfect sheets could be produced.

The time fixed for the delivery of the work which we had engaged to print was now elapsed, without our having been able to furnish the requisite number, and thus we were exposed to the reproaches of our employers; our new art lost almost all its credit and reputation, and even the privilege which the Elector had promised, was refused us; and, during the life of Charles Theodore, we never could obtain it. Our little gains were consumed, even debts were incurred, and the ridicule of those whom the success of our first trials had rendered jealous, was all the fruit we had earned from our laborious endeavours to promote a new art.

As the want of a good press was the only cause of our failure, I tried to induce Mr. Falter, music-seller at Munich, to furnish me with the means of constructing one; and engaged myself to superintend the printing in his own house, if he would give me leave to write the stones in my apartments. To this Mr. Falter, who, upon the whole, had a very good opinion of the art, readily agreed, and I ordered a large press, with cylinders, to be constructed; the cylinders, provided with what are termed the cross, were both to be turned by the workmen at the same moment, and this precaution produced the most perfect impressions; for the double action of the two cylinders, forced the frame with the stone between them, while in our former press the lower cylinder directly counteracted this movement. This circumstance, together with the greater thickness of the upper cylinder, which was

fifteen inches in diameter, prevented the paper from changing its position on the stone. This sort of press I still believe to be best adapted for all lithographic printing, provided the stones are of sufficient thickness, and despatch is not a consideration ; for, in that respect, this press is not to be compared with the lever-press, and several others, but the impression is softer, more equal and exact, than can be obtained from any other press.

As soon as this press was finished and put together, I began to write on stone Mozart's *Zauberflöte*, arranged in quartettos by Danzy, and to print it, with the assistance of Mrs. Gleissner, at Mr. Falter's house ; but Mrs. Gleissner being soon after prevented from assisting me, I instructed two soldiers in the process of printing, and only furnished Mr. Falter with the written stones. But these workmen, not entering into the spirit of the art, spoiled a great deal of paper, so that Mr. Falter at last preferred printing again from copper.

About the same time Mr. Schmidt, then Professor of the Royal Military College, at present Dean of Miesbach, began to etch on stone ; he was an intimate friend of Mr. Gleissner, and often used to visit him. For about a year past it has been asserted that Mr. Schmidt is the first inventor of Lithography, and several pamphlets on the subject of this claim are already before the public. Without entering more minutely into the particulars of these rumours, I leave the thing to speak for

itself. The reader will have seen, from the present simple and unvarnished account, the natural, but troublesome, way that conducted me to the new invention. If Mr. Schmidt, about the same time, made a similar discovery, without my knowing of it, it certainly must be said that he was more fortunate than myself. According to his own statement, published in a letter from him in the *"Anzeiger für Kunst, und Gewerbfleiss,"* the course of his invention was the following :—He saw in the Cathedral of Our Lady, at Munich, a grave stone, with raised letters and figures ; this he supposed to have been effected by aqua-fortis : and, therefore, concluded that it would be possible to take an impression from it. Such was the whole amount of his discovery. If the merit and credit of a new invention may thus easily be obtained, I have certainly been much less fortunate in having been obliged to make such an endless variety of experiments in search of it. But, in my opinion, there is nothing new in Mr. Schmidt's discovery ; for the idea that those letters and figures were etched, pre-supposes the existence and use of etching, and every one, who is ever so little acquainted with the process of printing, would easily conceive the possibility of blackening, and taking an impression from these large and raised characters on grave stones, in the common manner of letter-press printing. If, however, Mr. Schmidt joined to this first idea a second, *viz.*, that fine and slightly-raised characters and drawings could be blackened by means of an instrument to be devised for the purpose, and that impressions could be taken from them, then,

certainly, he is entitled to the honour of having invented, at the same time with or previous to me, the mechanical process of raised Lithography, as it was then practised. But, upon the whole, neither he nor I can boast of having been the first to conceive the idea of using stones for printing; it is only the manner of effecting this which constitutes the novelty of the invention. At that period (1796) I had discovered, first, not only the art of printing from stone plates, but an ink to write on stone, which, at the same time, was proof against aqua-fortis, of my own composition, and not from an old Nuremberg book, from which Mr. Schmidt took his receipt:—secondly, a useful instrument to blacken the imperceptibly-raised characters:—and, thirdly, the upright pole, or lever-press, of which I shall speak more minutely hereafter.

As I am perfectly ignorant of Mr. Schmidt's experiments at the above-mentioned period, and am precluded from obtaining more particular information, I am ready to believe it on his assertion, as a gentleman, that he printed from stone so early as previous to July, 1796; but I have the most incontestable proofs, that his method widely differed from mine; and, above all, that he was perfectly ignorant of the chemical printing, which I discovered in 1798. Mr. Schmidt, and his pupils, made several trials to produce drawings on stone, but, as it appears, he could not succeed in taking impressions from them. Some of his stones, which I saw a long time afterwards, were first etched; but, subsequently, the spaces between the lines cut

out to a considerable depth by steel instruments, in the same way as wood cuts : he had impressions taken from his stones at the printing-office of the Royal Establishment for School-books, and some impressions are said to have been very clear ; I myself never happened to see any of them. The experiments of Professor Schmidt, however, procured me the acquaintance of the Rev. Mr. Steiner, who, by his liberal encouragement, greatly contributed to lead me, in order to satisfy his different requests, to several improvements, to which Lithography owes much of its present perfection. The Rev. Mr. Steiner, an intimate friend of Professor Schmidt, was Director of the Royal School Establishments, and in this capacity he had several publications under his care. Professor Schmidt's idea of pub-lishing prints of all poisonous plants from stone, for the use of the schools, met with his approbation; and, as several ex-periments for this purpose did not succeed, he resolved to apply to me, in order to attain his object. Wishing, at the same time, to publish some church music, he came to me, and requested me to cut the music lines in stone that they might be inserted between the letter-press lines, and printed all together in the common printing-press. I tried to ac-complish this, but the cutting out of the intermediate spaces, was found to be so troublesome, that it would have been much easier to cut the notes in wood at once. We, therefore, adopted the expedient of first printing the letter-press in the common way, and afterwards added the notes from the stone in our press. I, nevertheless, tried several other experiments to attain

our purpose, and, among these, I thought the following the best : I covered a well polished plate of stone with a composition of burned pulverised gypsum, butter, and alumina, mixed with a sufficient quantity of water, to the thickness of two or three cards. When this mass was dry, I drew in it the lines and points, or, in short, the whole of the music, with a steel needle down to the surface of the stone ; and, that I might see it more distinctly, I chose a dark-coloured, almost brown, stone. Having completed the drawing, I took melted sealing-wax, spread on a thin board of wood, and pressed it, while still warm, on the stone, by means of a hand-press. When it became cold, the white ground which was loosened from the stone, and adhered to the sealing-wax, was cleaned with a brush and water, and the drawing, or writing, appeared clear and raised on the sealing-wax, like a wood cut, and admitted of being printed in the usual way. I afterwards tried to substitute the composition of lead, tin, and bismuth, for the sealing-wax, which, likewise, with proper management, perfectly succeeds. When the stone is covered with the same composition, but to a greater thickness, the finest cotton patterns may be drawn on it, with greater facility, and in less time, than they can be cut in wood. All my experiments perfectly succeeded, and I greatly regret, that in the sequel, I have never had occasion to improve upon this invention, which I had almost forgotten, and which only came into my mind again when I was writing this history, which recalls many things to my memory. In the second section of this work, or

in the description of the process of stone printing, I shall take an opportunity of speaking on the subject more at large, and of relating some experiments in preparing blocks for cotton printing, which I afterwards tried at Vienna.

A musical composition on the Conflagration of New Oetting, in Bavaria, which I printed for Mr. Lentner, with a vignette representing a house in flames, induced Mr. Steiner to have some small drawings for a Catechism, printed on stone. As drawings, they were but indifferent; but he, nevertheless, encouraged me to try whether the new invention might not be applicable to the higher departments of the art. This gentleman, with the exception of Mr. André, of Offenbach, was the only person who thus reasoned : Lines and points of any degree of fineness and strength, can, according to this new manner, be produced on stone; consequently, drawings, resembling copper-plate engravings, are to be produced in a similar way; and if we cannot yet succeed in producing them, the reason of it is not to be looked for in the insufficiency of the art, but in the want of practice and experience of the artists. He, even at this early period, wisely refrained from hastily judging, as some self-sufficient and conceited connoisseurs continue to do at the present day, that the art was still in its infancy; but he was convinced, when I shewed him my first specimens of the improved chemical method of printing from stone, that the invention had already attained its highest pitch of perfection; that artists might acquire greater skill; that the operations

might be simplified, and facilitated ; the manners be diver-sified and multiplied ; but that the art itself was not suscep-tible of being further perfected. And, indeed, though I my-self, when, after the lapse of twenty years, I consider in a su-perficial manner, all the different improvements which I have made in the art during this space, the gratifying results of which are recorded in the contents of this Treatise, and seen in the specimens annexed, and which greatly surpass the expectations which I then ventured to entertain, am tempted, for a moment, to believe that the present and past state of the art, admit of no comparison whatever ; yet, upon closer ex-amination, I am convinced that I had even then invented the whole of the art ; and that all that others and myself have since done, consists only in the improvement of the appli-cation of it.—The whole still rests upon the same principles : ink, composed of wax, soap, *&c.*, gum, aqua-fortis, or any other acid, of which no one has a decided advantage over another, oil, varnish, and lampblack, are still, and in the same manner, the chief ingredients of Lithography, as they were then. In the fundamental principle, nothing has been improved, altered, or newly discovered ; no drawing, even of any lithographer, has since appeared, which has to boast of lines and points more clear, powerful, or black, than my first specimens at that period contained in some of their parts.

Those, therefore, who endeavour to excuse the want of patronage, which the art of Lithography, in its beginning,

experienced, by the argument that it was impossible to guess, at that time, to what perfection it was capable of attaining, and who pronounce recent drawings, which, in respect of the mechanical part of points and lines, are inferior even to those that were then made, to be better lithographic productions, merely because the drawing is executed by an abler artist, and the subject is nobler;—those, I say, plainly discover that they want that liberal and impartial spirit, which the Rev. Mr. Steiner so honourably displayed in the reasoning above alluded to. It has happened several times, that the art, and its inventor, have been confounded with the artist ; and some publications have even gone so far as to assert, that though I had invented the outline of the art, I had only been able to apply it to music-printing ; but that such or such a one, had the merit of having applied it to subjects of art, and had even produced prints. If these conceited and forward judges, had taken care to obtain better information, and had learned that, besides myself, (the invention of the Rolling-Press of Professor Mitterer excepted,) no person, in all the different branches of Lithography, has effected any new improvement of consequence, which he had not received directly, or indirectly, from me ; that all those artists, and producers of prints, made their first essays under my immediate direction, or were trained and instructed by persons who derived their information from my instructions, and that none of them can boast of having penetrated into the innermost recesses of the art, like Mr. Rapp, of Tubingen, the esteemed author of a work, entitled, *" The*

Secrets of Lithography;" then certainly they would never have made use of these ridiculous arguments, or have entertained these unfounded prejudices, of which they ought to be ashamed.

Had I, at that period, possessed greater facility in writing and drawing on stone, the Rev. Mr. Steiner would have furnished me with ample occupation. The next work I executed for him, was a copy-book for young girls, which possessed little merit, as I had little practice in writing. He then desired me to draw some scenes of sacred history on stone. Schoen, at Augsburg, was just then engraving for him the seven holy Sacraments, after Poussin, but they were too expensive in this shape, and he wished to render them cheaper, so that even clergymen in the country might give them as presents to the children of their parishioners ; and, in general, he endeavoured to substitute for the sacred caricatures that filled the prayer-books of the devout, such drawings as might contribute to improve the public taste. In order to accomplish this the more expeditiously, it was deemed advisable to instruct young artists in the process of drawing on stone with my ink, and thus many drawings, more or less perfect, were produced.

I was certainly now exposed to the risk of losing the secret of my art ; and, indeed, except the exact proportion in the composition of my ink, it was already lost ; but, as I still en-

tertained the hopes of obtaining the long looked-for privilege, or patent, for Bavaria, I did not hesitate to give instruction to all those that wished it. But amongst all the young artists, there was none who did not expect the most ample success on the very first trials ; and as it was necessary that they should first learn for some time, they soon relaxed in their attendance, which greatly displeased Mr. Steiner, but was a matter of indifference to me, as I was just occupied in applying a new and important discovery, in such a way, as to give an entirely new shape to my art, and to be able to produce drawings without even the assistance of an artist.

Being employed to write a prayer-book on stone, which was to be done in the common current hand, I found great difficulty in producing the letters reversed upon the stone. My ordinary method of writing music on stone, was first to trace the whole page with black lead-pencil on paper, wet it, place it on the stone, and pass it through a strong press. In this way I got the whole page traced, reversed, on the stone. But this being extremely tender, and easily wiped off, I should have preferred an ink to the pencil. After having tried some experiments with red chalk and gum-water, and common writing-ink, which did not satisfy me, I prepared a composition of linseed-oil, soap, and lampblack, diluted with water ; with this ink I traced the music or letters on paper, and transferred it to the stone, and thus obtained a perfect reversed copy on the latter. This led me to the idea whether it would

not be possible to compose an ink, possessing the property of transferring itself to the stone, so that the drawing might be made at once complete, and to prepare the paper in such a manner, that, under certain circumstances, it might discharge the ink, with which writing or a drawing was executed on its surface, upon the stone plate, and not retain any part of it.

Having observed that the stone ink, when it came into contact with the common writing ink, coagulated, (because the acid of the vitriol attracts the solvent alcali from it,) I wrote with common ink, into which I had put vitriol in excess, on paper ; and when the writing was dry, I dipped the whole sheet, for a few seconds, in a thin solution of stone ink in water ; then taking it out, I cleaned it in rain water, or a weakly diluted ley. I found the stone ink precipitated strongly on all the places covered with writing ink. After leaving the paper to dry a little, I put it on the stone, and passing it through the press, obtained a complete copy, but the impressions I took from it were never perfectly clear and equal. I tried it, therefore, in another way ; I besmeared the paper with a solution of vitriol of iron in gum-water ; when dry, I wrote on it with my stone ink, dried it again, moistened it with common water for some time in order to loosen the ink ; then put it on the stone plate, which I had previously covered with a solution of oil varnish, in oil of turpentine. The result of this experiment was more satisfactory, though not yet perfect, and induced me to undertake an endless variety of other expe-

riments, in which I altered the proportion of the ingredients, and added others. I can safely assert that this circumstance alone cost me several thousand different experiments, but I was sufficiently rewarded by the final attainment of my object. Besides, these experiments led me to the discovery of the present chemical Lithography. The art of transferring from the paper to the stone, rested principally on the greater or less affinity of one ingredient to another ; for instance, I observed that every liquid, especially a viscous liquid, such as a solution of gum, prevented the ink from attaching itself to the stone. I drew some lines with soap on a newly-polished stone, moistened the surface with gum-water, and then touched it with oil colour, which adhered only to the places covered with soap. In trying to write music on the stone, with a view to print it in this way, I found that the ink ran on the polished surface ; this I obviated by washing the stone with soap-water, or linseed-oil, before I began to write ; but in order to remove again this cover of grease which extended over the whole surface, (so that the whole stone would have been black on the application of the colour,) after I had written or drawn on the stone, it was necessary to apply aqua-fortis, which took it entirely away, and left the characters or drawings untouched. My whole process was, therefore, as follows :—to wash the polished stone with soap-water, to dry it well, to write or draw upon it with the composition ink of soap and wax, then to etch it with aqua-fortis ; and, lastly, to prepare it for printing

with an infusion of gum-water. I had hoped to have been able to dispense with the gum-water, but was soon convinced that it really enters into chemical affinity with the stone, and stops its pores still more effectually against the fat, and opens them to the water. In less than three days after my first idea, I produced as perfect and clear impressions, as any that have since been obtained. Thus this new art had, in its very origin, arrived at the highest degree of perfection as to the principle, and good and experienced artists were only wanting to shew it in all the varieties of application. The use of dry soap very naturally led to the invention of the chalk manner, and I now saw all my former experiments in quite a different light. The transition to the engraved manner, where the stone is first prepared with aqua-fortis and gum, and the drawing engraved, without being etched, was so simple that I had not the least difficulty in discovering it; and, indeed, this was the manner in which the first work, after I had made my new and important discovery of chemical printing, was laid before the public. This was " *A Symphony for Four Voices, with the Accompaniment of different Instruments,*" by Mr. Gleissner ; it was dedicated to Count Torring, and in order to make the title-page as neat as possible, I chose the new-invented engraved manner for it. Whoever possesses a copy of it, will be convinced that the title-page is engraved ; and Mr. Rapp, of Stuttgard, is, therefore, under an error, if he thinks himself the first who used stone in this manner. So early as the year 1800, I

deposited a circumstantial description of it at the Patent Office in London; and in 1803, with the Government of Lower Austria, after having obtained a privilege for it.

These new inventions, with that of the lever-press, as above described, by means of which I could take off a great number of copies in one day, enabled me to carry on my business on a larger scale. I therefore took my two brothers, Theobald and George, into my employ, and also engaged two apprentices. The Rev. Mr. Steiner, and several other persons, supplied me with sufficient occupation; and, after so many troubles, privations, and unpleasant circumstances, which had nearly exhausted the whole of my own and Mr. Gleissner's patience, promising prospects seemed at last to open to us. We earned from ten to twelve florins a day, and at the same time, (1799,) we had the pleasure of obtaining through the favour of his present Majesty King Maximilian Joseph, who about that time began his glorious reign, an exclusive privilege for our new art, for fifteen years; by which the reprinting and selling of such works as we could produce in Bavaria, was prohibited, under a penalty of 100 ducats, and the confiscation of the stock and implements. In consequence of this privilege, which, though it was only for Bavaria, entirely satisfied all our hopes, I did not think it necessary to keep our art any longer a secret, but took a pride in explaining it to any stranger, who, attracted by the novelty of the invention, came to visit our office. In this way Mr. André

of Offenbach, amongst others, was introduced to me. He happened to see some of our printed music at Mr. Falter's, and being himself a very extensive seller of music, he admired the beauty of the print, and the firmness of the colour, which did not come off on touching it, as it does from tin plates. I took all possible pains to shew him my invention in the most advantageous light, etched and printed several stone plates in his presence, and took impressions from them, as perfect as could be wished for. The despatch of the printing, the quick drying and the comparatively small quantity of colour that was used, excited his unbounded admiration ; so that he made me, on the spot, a proposal of a suitable recompense, on condition of my communicating to him the whole of the art This I did not hesitate to accept; and in a very short time we agreed that I should go to Offenbach, establish a press there, and train proper persons in writing and printing ; for which I was to receive a remuneration of 2,000 florins. Some altercations having arisen between my own family and myself, my brothers separated from me, and began to print on their own account ; this however, being contrary to my privilege, they were soon stopped: they went to Augsburg, where they tried to establish a press for Mr. Gombart, but did not succeed.

As I had an interval of three months before the period fixed for my departure for Offenbach, I employed this time in making myself more thoroughly master of the new art ; and, among other things, tried some experiments; and I discovered that my

chemical printing process was not limited to stone only, but that other substances, as wood, metal, paper, even fat substances, as wax, shellac, and rosin, may be used instead of it in some cases, and under certain circumstances. This gave me the hope of discovering, perhaps, at some future time, an artificial, less bulky, and less expensive kind of stone plate ; and in this I succeeded in 1813, by inventing an artificial stone-paper, or stone-like composition, which, spread on paper or linen, is a substitute for stones, and resembles the common vellum.

The time of my departure for Offenbach being arrived, I went thither with Mr. Gleissner ; and, without delay, applied myself to the establishing of Mr. André's press ; from which, after a fortnight, I was able to produce the first proof. Mr. André was so perfectly satisfied, and had, upon the whole, such a high opinion of the art of Lithography, that he made me proposals to leave Munich entirely, to enter into partnership with him, and to try to make the most of our art. He had three brothers, none of whom were yet settled ; and wishing to provide for them, he projected the plan of obtaining privileges or patents in Vienna, London, Paris, and Berlin ; of establishing in each of these places a number of presses, and a house, and carrying on the business as a joint concern ; the centre of which was to be Offenbach, where Mr. André intended to remain himself, while I undertook to superintend our house in Vienna. In order to make the necessary preparations for this purpose, I returned to Munich, where I resigned my prsse and

whole establishment to my two brothers Theobald and George, reserving to myself only the fourth part of the clear profit; and made such arrangements as not to interrupt, during my absence, the engagements into which I had entered. At my return to Offenbach, I found our establishment in good order, and our artists well exercised; Mr. André, who kept ten music-presses, with tin plates, at work, stopped five of them, and substituted lithographic presses in their stead. A short time afterwards he went to England, partly on business, partly in order to make himself better acquainted with the mode of obtaining patents, &c. One of our principal speculations for England was the application of the lithographic art to cotton-printing. I had, at one period, tried many experiments with regard to the manner of printing in colours on paper, as well as on cotton; and, at last, believed I had discovered a new and very advantageous way of doing it, by means of a cylinder covered with leather, at the upper part of which was fixed a vessel that supplied the necessary colour to the cylinder; so that in one day several thousand yards of cotton could be printed.

After having discovered the chemical printing process, I proposed to use a cylinder of stone, instead of the wooden one covered with leather, which I thought could not fail of succeeding. Mr. André intended to take out a patent for this; but finding that the cylinder printing was already generally used in England, he relinquished all idea of it.

After his return from England, Mr. André proposed to me to go thither, which I at last, though reluctantly, did, in the company of one of his brothers. My stay in England, however, had not the expected success with respect to establishing a lithographical office there ; the principal cause was the unnecessary precaution and anxiety of Mr. Philip André, who kept me, during the whole time of my stay, in a perfect seclusion from society, for fear of losing the secret. And thus seven long months elapsed, before even the first step towards obtaining our object, was taken. My patience at last being exhausted, the patent obtained, and Mr. Philip André sufficiently instructed in the practice of Lithography, I had not the least inclination to prolong my stay, and returned to Offenbach. The time I passed in London, however, was not entirely lost for me and my art, for I employed my time in the study of chemistry, chiefly as far as it relates to dyeing, and tried a great number of experiments with various ingredients, to improve my ink, and other materials ; I also made some progress in the aqua-tinta manner, in which Mr. Gessner, son of the poet, an artist of talent, drew some pleasing landscapes. I am convinced that the Public would have a greater number of masterly productions of the new art before them, if it had been my fortune to have fallen in with an enterprising print-seller, who employed proper artists, and undertook interesting works ; but, as will be seen in the progress of this Narrative, I was always involved in circumstances so unfavourable and discouraging, that I had scarcely any opportunity

to make use of the experience I possessed, in any work of importance.

The first, and very unwelcome news, that I heard after my return from England to Offenbach, was, that my mother had gone to Vienna, with the intention of obtaining there an Imperial exclusive privilege for my two brothers, who, not satisfied with their present situation, and jealous lest André should have the whole advantage of the new art, while they, though nearest relations to the inventor, should derive none whatever from it, had suggested to her this course as the only means of securing independence, and a prosperous business to themselves. My mother had not been long at Vienna, before Mr. André, by an accident, was informed of her intention ; and, in order to counteract it, he sent Mrs. Gleissner to Vienna, with a commission to obtain the privilege for the Inventor, and his partners. Thus these two ladies were engaged in a lawsuit, which was not likely to terminate in a very short time. The whole of this transaction, however, Mr. André had intentionally kept a secret from me during my stay in England ; and, as I could not but be highly displeased with it, I proposed, in order to settle the business, to go myself to Vienna. But to this Mr. André positively refused his assent, without entering into any discussion, or giving me his reasons for it. This, and several other circumstances, concurred to lessen my confidence in Mr. André, for whose character I had hitherto entertained the highest regard. I, therefore, persisted

in my intention of going to Vienna ; and, as in one of the dis-
putes arising out of this subject, Mr. André went so far as to
remind me how much I ought to be obliged to him for all he
had done for me, and how essentially I had bettered my
situation in entering into partnership with him, conscious
of the purity of my intentions, and of my sincere endeavours
to promote his interest, as much as if it had been my own, and
that I had done even more for him than what our contract
bound me to do, I grew extremely nettled, and the passion of
the moment so completely got the better of me, that I tore in
pieces the contract, which had only been signed the day
before, and by which the fifth part of all our profit was secured
to me, and threw it down before Mr. André, saying, that I did
not wish to make my fortune by his means.

This was one of the most eventful moments of my life, as it
was in the history of my new art, the prospects of which were
entirely altered by it, and received a new direction and ten-
dency. It was also the cause of Mr. André's not succeeding
in his speculations, and of suffering severe losses, instead of
deriving any advantage from them, both in England and
France. Had our partnership lasted longer, there is no doubt
that the lithographic art would, in both these countries, have
attained a higher degree of perfection, and have yielded great
profit to its possessors.

Having about this time become reconciled to my two

brothers, whose want of confidence and very improper conduct towards me, my fraternal love at length forgave, I resolved to take them with me to Vienna ; and thus, by uniting their interest to my own, at once to put an end to that disgraceful lawsuit, which was still going on there.

END OF THE FIRST SECTION.

SECOND SECTION.

IT was in the month of August, 1800, that I left Offenbach for Vienna, accompanied by my brothers Theobald and George. At Ratisbon I met my mother on her return from Vienna, who rejoiced me with the news that she had petitioned for a patent for my invention, for me as well as for my brothers. Thus unanimity and friendship being restored among us, we pursued our journey, full of hope, that our united and indefatigable exertions in this new undertaking, would not prove fruitless. But, alas! all our promising prospects soon proved to be merely imaginary.

In order to be clear, it is necessary to go back a little in our history. Mrs. Gleissner, whom Mr. André had sent to Vienna, as before mentioned, to secure the privilege for me and himself, or rather for our joint company, had been allowed a fair sum to defray the expenses of this expedition; and, not being disposed to live in a very retired manner, or rather believing that, to give consequence to our establishment, it was necessary to make some external show, she had drawn for considerable sums upon Mr. André's correspondent at Vienna; so that this banker, at last, began to suspect that she was exceeding the prescribed limits. About the same time he received letters

from Mr. André, in which he instructed him, in order to promote and facilitate the success of our petition, (well knowing that my name was entirely unknown, while his, being at the head of an extensive and highly respectable firm, was well known at Vienna,) to sue for our common privilege in his own name.

This determination, by which Mr. André solely endeavoured to promote our common interest, the banker communicated to Mrs. Gleissner, charging her to act accordingly, and to represent Mr. André as the principal petitioner. But Mrs. Gleissner, suspecting it to be merely a stratagem, refused to comply ; and the banker, therefore, added that, in this case, he was no longer authorized to supply her with money. This threat, for in reality it was nothing more, exasperated her so much, that she communicated the whole transaction to her landlord, Mr. Von Bogner, a highly respectable merchant ; acquainting him, at the same time, with all our plans, and the great prospects which the new art promised to open. This gentleman was easily convinced of the justice of our expectations ; and, seeing that we had taken Mr. André as a partner, merely because his capital was requisite to our first establishment, he advised her to try whether we could not obtain the privilege without this assistance, for ourselves alone, which would give us the option of either taking him as a partner, or not, as we might think fit ; and for this purpose he offered to introduce her to Mr. Von Hartl, Imperial Court Agent, who, he said, was the

best judge of the probable success of such an undertaking, and in whose power it was to promote and accomplish the business.

This offer was thankfully accepted, and Mrs. Gleissner explained to Mr. Von Hartl, the nature and tendency of our invention; shewing him, at the same time, a piece of calico, which had been printed at Offenbach, and was so perfect as not to be surpassed by the best English prints. This specimen particularly attracted the attention of Mr. Von Hartl, who was then greatly interested in a society recently established at Vienna, for the purpose of introducing English Spinning Machines into Austria, the funds of which amounted to about one million and a half of florins. A good English mechanician, of the name of Thornton, had been procured for the constructing of these machines; and the only objection that public opinion could make to the probable success of this establishment, was, that the extensive trade of the English would injure the sale of its productions. It was, however, suggested, that this objection might be obviated by uniting the spinning establishment with manufactories for weaving, dyeing, and printing calico. As soon, therefore, as Mr. Von Hartl saw that my invention would also be applicable to the printing of cottons, he promised his full and unlimited patronage and assistance in procuring the privilege; and even offered to furnish the necessary capital of 6,000 florins, on condition that I should convince him of the utility of my invention. Mrs. Gleissner, without delay, communicated to me this

offer by letter, without, however, mentioning the condition attached to it.

Such was the state of our affairs when I arrived at Vienna, with my two brothers. The expenses of the journey had nearly consumed all my money, and I found Mrs. Gleissner nearly as destitute as myself; our privilege was still far from being obtained, and the only hope of obtaining it at all, rested in Mr. Von Hartl's protection and promises. The sole resource, therefore, that I had for the moment, was Mr. Von Bogner, who liberally admitted me into his house, and to his table, and promised me his assistance, as far as his means would permit. My next care was to wait upon Mr. Von Hartl, which I did, in company with my two brothers. He received us with great politeness, but assured us that the privilege could not be obtained for any but the real inventor; and, as soon as he should be convinced of the merit of the invention, he would promote it with all his influence. This declaration offended my brothers to such a degree, that they declared, rather than be dependent on me, they would try their fortune elsewhere; and, as they had not the necessary means to return, they threatened to sell the secret to some printseller or artist, at Vienna. To prevent this, I prevailed upon Mr. Von Hartl to advance them the necessary sum, with which they immediately returned to Munich, for the purpose of exercising my privilege there, during my absence, which I allowed them to do, upon condition of remitting to me one third of the clear profit.

Having, in the mean time, constructed a small press, I laid before Mr. Von Hartl such proofs, as perfectly convinced him of the great utility and importance of my invention. He, therefore, proposed to me a contract of partnership, by which he engaged to furnish the necessary capital, and I to devote my time and practical knowledge, to our establishment. His principal object still was the application of the lithographic art to cotton-printing ; but as this could not be begun immediately, he proposed, in the mean time, to establish a press for music and works of art ; and, as soon as the other and much more extensive concern could be commenced, we intended to relinquish the printing of music to Mr. Gleissner, exclusively.

It is necessary to state here, in my own justification, that I would not have entered into partnership with any other person, so long as my connection with Mr. André was still in existence. As soon as I was perfectly acquainted with the state of our affairs at Vienna, I wrote to Mr. André, representing to him that they were not so bad as he was induced to believe ; and that if he thought proper to go to the necessary expense, success might still crown our plans, and the privilege be obtained. But this proposal Mr. André, or rather his brother, positively refused to accept, and thus I considered myself at liberty to act thenceforward as I pleased.

As soon, therefore, as I had set up a great press, Mr. Von Hartl and myself requested that a committee might be appointed by

the government of Lower Austria, to investigate our new art. This committee, besides the local magistrates, consisted of Mr. Von Jacquin, Professor of Chemistry, and Mr. Schmutzer, Director of the Academy of Engraving. I went, in their presence, through all the processes and different applications of my new art, on paper, as well as on calico, with such success, as to obtain their unqualified approbation, which they very strongly expressed in their report on the subject. In the same manner I satisfied a committee of the Imperial Aulic Council; and some time afterwards I had even the honour to exhibit my process before his Majesty the Emperor himself, in whose presence I made several trials with a little hand-press, that obtained his entire approbation. We were now pretty sure of obtaining our long looked-for privilege, without any farther difficulty; and the most promising prospects seemed to open upon us. As I well knew that Mr. Von Hartl's great and favourite project was to apply the lithographic process to calico printing, I devoted all my time to improve this branch of the art, and to make myself master of the art of dyeing and colouring.

Meanwhile the print and music-sellers, at Vienna, left no stone unturned to counteract our application for the privilege, because they were apprehensive of being totally ruined by the introduction of this new art; particularly, when they knew that I had secured a powerful protector in my new partner Mr. Von Hartl. In order to avoid this, they proposed to me

to relinquish my intention of setting up an establishment of my own ; upon condition, that the joint company of print and music-sellers should supply me, throughout the year, with a certain quantity of printing work. I now calculated that with three presses for printing music, I should be able to print every day 6,000 pages of music ; which, estimating the hundred at the low price of twenty-five creutzers, would make a sum of twenty-five florins ; and taking the year at 300 work-days, would yield an annual profit of 7,500 florins, which could be obtained without any risk, as the company of print-sellers engaged to indemnify me, in case they could not procure the necessary employment in printing.

This plan, however, though it seemed to me most advantageous and promising, did not receive the approbation of Mr. Von Hartl, who was wholly averse to my submitting to any restriction as to an establishment of our own ; and I was, therefore, under the necessity of relinquishing it, much against my own inclination. Another, and likewise highly-advantageous, offer, that was made to us about the same time, to sell to us the long-established and very respectable business of the print-seller Mr. Eder, was likewise roundly rejected, by the advice of Mr. Von Hartl ; though I am convinced that it would, in time, have proved a most lucrative concern, and would have yielded as much profit to Mr. Von Hartl, as he afterwards sustained loss.

As I had been associated with Mr. Gleissner from the very beginning of my lithographic career, and owed him obligations, I thought it unjust to forsake him at a moment when he stood most in need of me ; I had, therefore, induced Mr. Von Hartl to let him come to Vienna, and to furnish him with the requisite money for the purpose ; and, as the sum allowed by him was not sufficient to pay his debts and travelling expenses, I borrowed 400 florins on my own credit, for this purpose. He now arrived at Vienna, with his family, and one of my first apprentices, Mathias Grunewald. As Mr. Gleissner's Symphonies had obtained universal approbation, we began to print several of them as the first works of our newly established press ; though it would have been more advantageous to have begun with the compositions of some more eminent composer, such as Haydn, whose name alone would have been a sufficient recommendation at Vienna.

In order to establish any branch of lithographic printing, it was indispensably requisite to have a considerable stock of stone plates, of all dimensions ; and as we foresaw, that in our establishment this point would be a very essential one, Mr. Von Hartl, who was in the habit, every year, of making a tour for the benefit of his health, resolved this year to visit Munich, Augsburg, and Solnhofen ; and to take me with him, in order to make, at the quarry itself, the best and most advantageous arrangements for the supply of stone plates, at any future period. Another reason that contributed to this reso-

lution was, his wish to inspect the estate of Riedau, which had been represented to him as peculiarly well situated for the establishment of a cotton manufactory, and which had just been offered for sale.

This journey, on which we set out shortly afterwards, proved one of the greatest enjoyments of my life. At Augsburg we made a contract with a paper-maker, for the supply of music-paper. At Munich we inspected the establishment of my brothers, which, however, did not yield great profit to them and at Solnhofen we purchased several hundred stone plates, and made the necessary arrangements for our future supply. On our return to Vienna, the first thing I did was to engage some music-writers; and I succeeded in finding two young men, who, in a very short time, attained great perfection. Mr. Gleissner's compositions were soon finished, and it became necessary to look out for more work, in order to occupy the writers and printers we had engaged. I therefore advised Mr. Von Hartl to purchase some new music, of the best composers, such as Krommer, Beethoven, Haydn, &c., to which he agreed; but said, he waited only for a proper opportunity for seeing these gentlemen, as he expected them at his own house As this, however, was delayed from one week to another, we were obliged, in order to employ our men, to print a great quantity of pieces, composed in the mean time by Mr. Gleissner. Thus, (a collection of overtures excepted,) we printed, for nearly a year, nothing but Mr. Gleissner's works, which consumed

our whole stock of paper, and remained useless upon our hands. About this time I was myself very little occupied with Lithography, but devoted my time to the study of dyeing and colouring, and to experiments connected with these arts, which cost me a great deal of money ; and, after all, I found, that, in order to superintend a calico-printing establishment, where my invention should be adopted, it would not be necessary for me to understand the management and composition of colours myself, but that we might employ any person of experience in that branch. As soon as I felt myself master of the art of dyeing, I accompanied Mr. Von Hartl to Pottendorf, the great spinning manufactory, where I became acquainted with the ingenious Mr. Thornton. My idea of printing calico with large stone plates did not, at first, receive his approbation, as he was too much prepossessed in favour of the English cylinder-printing ; and I was, indeed, myself convinced, that the difficulty of exactly applying calico to the stone, required still further improvements and inventions. He, therefore, resolved to procure a very thick piece of stone, to turn out of it a cylinder at least eight inches in diameter, and to apply this to the printing in the same way as copper cylinders. But, before these stones could arrive, I conceived the idea that it might be possible to substitute copper, or metal, for stone cylinders, and to etch them in the usual way. To this Mr. Thornton objected, that printing cylinders ought to be engraved, and not etched ; for, if the latter method was applicable, he was sure the English artists

would, long ago, have preferred it. This argument, however, did not convince me ; I tried an experiment, which still more corroborated my opinion ; but, in order to settle the question at once, Mr. Thornton, who had brought with him from England a small model of a press, with a cylinder, engraved by the best English pattern engraver, proposed, that I should etch this same engraved pattern on another cylinder, according to my method, and then we could compare the results. This proposal I eagerly accepted ; a perfectly similar cylinder of zinc was procured ; and, as the pattern was very simple, I accomplished the drawing and etching of it in half a day, instead of a week, as Mr. Thornton expected. We now proceeded to the comparative trials; first, with the copper cylinder, which, of course, gave very clear and distinct impressions. We then exchanged the copper cylinder for the zinc, and I had the triumph of seeing that the print produced by it, was as neat and clean as the former, and, at the same time, much stronger and more beautiful ; and, therefore, the impressions were unanimously declared the best. The reason of this, I believe, is, that the lines made by the graver, gradually contract in breadth, from the surface downwards, and therefore cannot take a sufficient quantity of colour ; while the etched lines, being of a uniform breadth, absorb and give back nearly double the proportion of colour. This experiment decided the practicability and advantage of my etching method ; and Mr. Von Hartl only waited for the next general meeting of the proprietors of the calico manufactory, to introduce it upon a large

scale. Nobody rejoiced more at this success, than myself ; as
I imagined the time was now come, when Mr. Von Hartl's
liberality, in the protection of the new art, would be rewarded ;
for, in truth, his expenses already amounted to a very consi-
derable sum ; in return for which, he had nothing but a large
stock of stones and music.

In the beginning of the year 1803, we had, at last, the satis-
faction of obtaining our long wished-for privilege for the
Austrian dominions ; and I thought that it would be most con-
ducive to our interest, to open an establishment for the sale of
our productions. To this proposal, however, Mr. Von Hartl
was decidedly averse, as he believed it would only add to our
certain expenses, while it afforded no certain prospect of gain.
We resolved, therefore, to contract with some bookseller for
the sale of our works, by commission ; and, after some deli-
beration, fixed upon the house of P. Rehm and Co., who
undertook the business for a commission of 25 per cent., and
promised to account every month for the receipts. At the end
of the first month, I expected to receive a good sum ; but found
myself miserably disappointed, when, on inspecting their
books, I learned that the total amount of the music sold by them
was no more than 10 flor. 48 xr. The consideration of the pro-
verbial difficulty of all new beginnings, consoled me for the
present ; but at the end of the second month, our profit was
no more than 1 flor. 36 xr. Our patience was now exhausted ;
and, as Mr. Von Hartl, about the same time, sustained con-

siderable losses from different quarters, he lost all courage and inclination to persevere longer in the protection, and to spend more money in the introduction, of so unproductive an art. From this, his first impulse, he was however dissuaded, by his confidential friend and secretary, Mr. Steiner, who represented to him, that it was not so much the fault of the new method of printing, as the injudicious choice of our works, that prevented a more extensive sale : if the lithographic printing process were applied to more popular and worthy objects, he had no doubt but it would prove a perfect gold mine to him, and every body concerned in it ; but, for this purpose, it would be necessary to commit the management of the sale to an experienced and industrious man, and he knew no one better qualified for the purpose than a Mr. Grund, a well known print-seller and auctioneer. To this plan Mr. Von Hartl, who had already despaired of success, was easily induced to consent, and he even advanced considerable sums for the first establishment of this new concern. Mr. Grund was to deliver his account of sales every quarter, and to receive 30 per cent. for his commission ; but nearly twelve months elapsed, and neither account nor money was forth-coming. It was, therefore, easy to foresee, that in this way no success could be obtained ; and, to save the whole undertaking from ruin, it was deemed necessary to have recourse to another plan. This was, to set up an establishment of our own, for the sale of our works ; Mr. Steiner promised, in this case, to become a partner, and embark some capital in our new concern, for which he asked no

more than one-third of the clear profit of the whole. I found myself, at this period, in a very embarrassed situation, as the small debt of 400 florins, before alluded to, had, by dexterous management, increased, in the short space of a few years, to the sum of 2,000 florins; the payment of which was now peremptorily demanded. I was not able to satisfy this debt, and Mr. Von Hartl made it the principal condition of his interference in my favour, in this case, that I should agree to the plan last proposed by Mr. Steiner, and take him as a partner. Under the existing circumstances I had no choice, but was obliged implicitly to submit to every condition. The principals of the new establishment were now, Steiner, myself, and a Mr. Grasnitzky, who, in some former transactions, had gained the confidence of Mr. Von Hartl, and was esteemed very intelligent as a man of business. Under his direction, Lithography seemed, indeed, to revive at Vienna; new artists and writers were employed, and music, and works of art, were printed on a large scale. Amongst the latter, one of the best productions was, an imitation of *Preissler's Drawing-Book*, which was executed by an artist of the name of Charles Müller; who, in a very short time, acquired great skill in the ink and chalk manner: the first number of it was printed under my direction, and is, as I understand, superior to the rest that were printed in a new sort of press, invented by Mr. Grasnitzky. I rejoiced, most sincerely, at the success which our establishment now promised to have, as I hoped that, at the end of the year, I should have my share of the profit; but,

even in this expectation I was deceived, for Mr. Steiner declared, that, till the capital of 20,000 florins, advanced by Mr. Von Hartl, was repaid, (which could not be expected in less than ten years,) I had no prospect of receiving any part of the profit. Unjust as this intimation was, I was but too well convinced that, without involving myself in an expensive lawsuit, I had no means of redress ; and, being thus frustrated in all my prospects, I determined to sell the whole of my share in the establishment to Mr. Steiner ; he offered me the sum of 600 florins, which I at last agreed to accept, but he paid me no more than 50 florins, having a demand on Mr. Gleissner of 550 florins, which was entirely unknown to me. The loss of my privilege, for which I had made so many sacrifices, grieved me indeed very much ; but Mr. Von Hartl, to comfort me, bade me look to the example of other inventors, who had not fared better, or derived more benefit from their inventions, than I had from mine. The only prospect that now remained to me, was the calico printing ; and as the proprietors of the spinning and weaving manufactory at Pottendorf had come to the resolution of having a printing manufactory, in addition to the two others, I set out for Pottendorf, to try my experiments on a large scale. There I constructed a large printing-press, in which two cast-iron cylinders, two yards long and eight inches thick, were employed, instead of the copper ones ; and Mr. Thornton most ingeniously contrived the motion and management of them, so that the whole process of printing seemed to be performed of itself, without the

aid or assistance of men. My next occupation was to draw and engrave the pattern in the upper cylinder. The proposed pattern was a very simple one, consisting of a small flower, which, in order to cover the surface of the cylinder, was to be repeated at least 30,000 times; reckoning, therefore, only half a minute for the engraving of one flower, the whole could not be completed in less than a month; and, in doing the first flowers, I found it so very difficult to make one exactly like the other, that I despaired of accomplishing this object. But, to avoid the shame that would have been the necessary result of my failure, I set about contriving a drawing machine; by which, without being a good draftsman, I could execute the most difficult pattern in two days, with greater correctness than can be ever obtained with the graver. In this way I drew the pattern on the cylinder, etched it afterwards, and took some proof impressions, in the presence of Prince Esterhazy and others, which met with universal approbation.

It was now the plan of Mr. Von Hartl to obtain an exclusive privilege for the cylinder calico printing, to sell this to the company, and to procure for me the appointment of director of the establishment, in the same manner as Mr. Thornton was of that of the spinning manufactory; who, besides an ample salary, had the fourth part of the clear profit of the whole. This was a most welcome prospect to me, as I might thus hope to become, in a few years, a rich and independent man; and I thanked Mr. Von Hartl, most sincerely, for his good

intentions towards me. But Fortune had resolved to destroy this fair prospect, as she had done so many others. It was just at this period, that Buonaparte succeeded in cutting off all communication between England and the Continent, so that it was impossible to obtain English spun cotton, even at the highest prices. This circumstance forced the manufacturers of Germany, as well as of the adjacent countries, to have recourse to the Pottendorf spinning manufactory for the necessary supply; and the sale, in a short time, was so great, that the whole of the overstocked magazines were soon emptied, and even the most sanguine expectations of the proprietors were surpassed. With these prospects they thought it unnecessary, and even injurious to their interest, to set up a new and different establishment, as the calico-printing would have been ; they entirely gave up their former project, and even Mr. Von Hartl relinquished his plan of suing out a privilege for the cylinder press, which, through the treachery of a foreman, had been already copied, and communicated to several other manufacturers.

Thus once more disappointed in all my promising prospects and hopes, I bitterly complained of the hardship of my fate to a friend of mine, Mr. Madlener, bleacher, at Pottendorf; and this truly excellent man immediately promised to provide for me in another way. He introduced me to a Mr. Blumauer, calico-printer, at Vienna, who purchased from me a model of my cylinder-press for 500 florins ; and, not long after, he pro-

cured me the acquaintance of Messrs. Faber, two brothers, who possessed a calico-printing establishment at St. Pölten, and engaged me, by a formal contract, to erect there a complete cylinder-press. I was already on the eve of my departure for St. Pölten, pursuant to my engagement, when, by a most providential chain of circumstances, a new prospect of making considerable progress in the improvement of my lithographic inventions, seemed, all at once, to open upon me. During my residence at Vienna, I had had several letters from my brothers, complaining of the want of work, and the consequent difficulties with which they had to struggle ; I, therefore, had no great inclination to return to Munich, though I could not boast of having been, in any way, successful at Vienna ; and should, therefore, after the fulfilment of my engagements, have, most likely, returned to Mr. André, at Offenbach, as Gleissner and his family were well provided for at the establishment of Steiner and Grasnitzky. It happened, however, that a traveller coming from Munich informed us, that my two brothers were in a very prosperous way there ; that they were employed by several public establishments ; that they had sold the privilege to the government ; and that they had entered into a very advantageous partnership with Mr. Hazzi, for setting up a lithographic repository, for the sale of works of art. This news induced Mrs. Gleissner to go herself to Munich, to inquire into the truth of this information. At Munich she found my first apprentice Grünewald, who, in 1804, had left Vienna, in hopes of bettering his fortune, in-

tending to establish a lithographic press at Leipzig, for Messrs. Breitkopf and Härtel. Having returned to Munich, he persuaded Mrs. Gleissner to set up a little press, to which she agreed, in the hope of realizing some profit to cover the expenses of her journey. In this way she became acquainted with Abbé Vogler, who gave her some of his music to print. Abbé Vogler was so much pleased with this lithographic method, that he proposed to Baron Christoph Aretin, to set up a lithographic establishment at their joint expense, and to associate with them the inventor of the new art, and Mr. Gleissner. Baron Aretin agreed to this proposal, and both entered into an agreement with Mrs. Gleissner, pursuant to which I was to come to Munich with Mr. Gleissner, to establish the presses, and superintend other arrangements, the capital for which they offered to advance.

The news of this proposal very agreeably surprised me, as Baron Aretin, who had been my school-fellow at Munich, was a man for whom I always felt the greatest esteem and respect. I, therefore, most joyfully concluded the contract; and, as Baron Aretin and Abbé Vogler seemed to wish that I should repair to Munich, without further delay, I endeavoured to leave Vienna almost immediately. The only thing that bound me to it was, my engagement with Messrs. Fabers, which I could not hope to complete in less time than several months. But, such was the liberality of these gentlemen, that they not only gave me leave, for a few months, to go to Munich, to

arrange this lithographic establishment, but they even advanced a considerable sum for copper cylinders, which they wished me to procure at Munich, for their manufactory at St. Pölten.

END OF THE SECOND SECTION.

THIRD SECTION.

IT was in October, 1806, that I left Vienna, in Mr. Gleissner's company ; we first directed our course to the Convent of Atl, near Wasserburg, which Baron Aretin had lately purchased, and where we were met by Abbé Vogler. His favourite plan was to establish a lithographic press there ; but, as this was totally inconsistent with my other views, we all proceeded to Munich. There Abbé Vogler made several propositions, of a nature highly calculated to promote his own interest, but manifestly injurious to Baron Aretin, and which we, therefore, rejected. As he refused, moreover, to pay his share of the requisite capital in cash, but offered in its stead old music, at enormous prices, our partnership was soon dissolved.

About the same time a young man of the name of Strohofer, an apprentice of one of my younger brothers, made an attempt to establish himself at Munich ; this being contrary to our patent, he was soon interdicted. Abbé Vogler, who happened to fall in with him, conceiving that he had found the very man he wanted, for the accomplishment of his projects, without our assistance, entered into an agreement with him, and appointed a place where he should meet him again. No sooner had Strohofer, who possessed a high degree of effrontery,

reached Stuttgard, on his way, than he published pompous advertisements in praise of his skill and talents ; at the same time offering his services to any one that wanted them. In this way he became acquainted with Mr. Cotta, the eminent bookseller, who soon discovered the superficial nature of his acquirements, but, at the same time, justly appreciated the great importance of this new method of printing ; and thus, through the co-operation of an amateur, Mr. Rapp, was produced the work, entitled, " *The Secret of Lithography ;*" the first publication that exhibited the new art in the right point of view.

At the very outset of our establishment at Munich, the most favourable prospects opened upon us, through the liberal patronage of Baron Aretin. Several presses for music, writing, and even works of art, were set to work, and the publication of Albrecht Dürer's **Prayer Book**, which soon followed, obtained the unqualified applause of all who saw it, and fixed the reputation of our establishment ; for, even those who hitherto had not entertained a favourable opinion of the new art, were convinced by this work, that it was not so unimportant an invention as they supposed.

Mr. Mitterer, professor at the Public School, had contributed much to prepossess the public opinion at Munich, in our favour. He had been made acquainted with the whole process of Lithography by my brothers ; and, as the chalk-manner enabled him to multiply, in an expeditious and cheap way,

his copies for his pupils in drawing, he obtained permission to establish, at the expense of the government, a lithographic press, for the national school, and my two brothers were employed to conduct it. This was, properly speaking, an infringement of my privilege ; but the fact was, that my brothers, on account of their exercising the lithographic art at Munich, by my permission, were commonly considered as the proprietors of the privilege itself.

In the course of time, when several other presses were set up in public establishments, as well as by private individuals, Baron Aretin, who expected to have enjoyed the exclusive privilege, as long as he was in partnership with me, and advanced the capital, preferred a complaint to the proper authorities, but he received for answer, " That this art was no longer a secret ;" as if the circumstance of keeping it a secret had been the condition of the privilege. If so, I must not have employed any person in assisting me in writing, drawing, or printing ; the secret, and consequently the privilege, would thereby have been lost.

My partnership with Baron Aretin lasted about four years, during which period I executed a great variety of works, such as circulars, tables, and other things, for the government; plans, maps, and works of art, in the different manners. It was then, also, that I conceived the first idea of a Treatise on Lithography, similar to the present, and even published the first number of spe-

cimens, that were to accompany it. But, upon the whole, our establishment had not the expected success, partly because it was very difficult to procure clever artists, chiefly in the writing department, and partly because we wanted a proper person to direct the mercantile part of our business, for which I felt myself wholly unequal. Besides, my time was completely occupied with the superintendence of our five presses ; and as our printers were generally of the most ignorant class of society, it often happened, that in the printing, they, by their awkwardness, spoiled the stones, which I was obliged to repair. Of some works, which we executed for the government, we had as many as 15,000 copies to take off, which gave me time to prepare, in the mean time, other stones ; but as it was necessary that all the work for the government should be done in a great hurry, and at a very short notice, we were always obliged to keep a greater number of presses and pressmen, than our other occupations required ; and thus the profit gained in one busy week, was lost in the succeeding ones, when some of our presses had nothing to do.

About this time, Baron Aretin, who had been appointed director of the court of appeal at Neuburg, removed from Munich, and Gleissner and myself received appointments in the royal board of survey ; and we, therefore, resigned our establishment, partly to Mr. Von Manlich, director of the royal gallery of pictures, and partly to Mr. Zeller. The interest which Baron Aretin had taken in the art of Lithography,

had essentially contributed to make it more known, and to attract the public attention towards it; scholars, as well as statesmen, came to inspect our presses; even their Royal Highnesses the Crown Prince of Bavaria, and his sister, Charlotte, the present Empress of Austria, honoured our establishment with their presence. His Royal Highness the Crown Prince, wrote, with chemical ink, the following words on a piece of paper, " Lithography is one of the most important discoveries of the eighteenth century ;" and his Royal Sister wrote the expressive words, " I respect the Bavarians ;" which I transferred in their presence to the stone, and took impressions from it. I shall always consider it one of my greatest misfortunes, that my connexion with Baron Aretin was so early dissolved ; for the prospects which he opened to me promised to place me in such circumstances, that I might have devoted my whole time to the improvement of the new art, and its various applications ; and I never shall cease to regret, that I was thus deprived of the best opportunity of serving my country, and, perhaps, society at large, in the way most congenial to my abilities and talents, and thus justifying the confidence and high opinion with which the Baron honoured my exertions.

Another fair prospect of being employed to establish in France, with a proportionate capital, a great imperial lithographic institution, through the recommendation of Mr. Von

Manlich, and the celebrated Denon, was frustrated by the subsequent political events.

A third prospect, of no less consequence, that of establishing a calico-printing at Munich, or Augsburg, in conjunction with Count Arco, High Chamberlain to the Dowager Electress, was defeated by the want of skill of a turner at Munich, who spoiled our copper cylinder, and thereby caused our first experiments to fail.

This last plan was, upon the whole, a most unfortunate one for me, for it cost me much time and money, and even prevented me from fulfilling the engagement with Messrs. Faber, already mentioned by me. One day, when Count Montgelas, then prime minister, visited our establishment, I happened to make, in his presence, some experiments with a small model press, in the manner of printing on calico; these experiments obtained his marked approbation, and he readily promised to patronize the establishment of such a manufactory on a large scale. In order to convince him more fully of the importance of this method, I mentioned my engagement with Faber; this, however, had a very different effect from what I intended, and his Excellency declared that, if I chose to employ my inventions to the advantage of a foreign country, I could not expect any assistance in my own; that even a royal ordinance existed, by which it was forbidden to any subject of the king-

dom to practise in a foreign country an invention, the exclusive possession of which would be of importance to Bavaria; and that this regulation being strictly applicable to my case, it would be inexcusable in me to have any farther connexion with Austria.

This prohibition made me very uneasy, as I feared that it would place my conduct in a very unfavourable light, in the eyes of Messrs. Faber, for whose liberal behaviour towards me, I entertained the highest gratitude. I made, therefore, several attempts, to fulfil my engagement, to go to St. Pölten, and establish their presses, but these also were defeated by the bad management of their agent at Munich; and thus I lost all the profit and fair prospects, which this engagement held out to me.

It may not, perhaps, be altogether uninteresting, to enumerate all the different Lithographic establishments, which, in the course of time, were established at Munich.

The first of all was that established by myself and Mr. Gleissner, which was afterwards carried on in our name by my two brothers, Theobald and George, up to the year 1805. They then sold it to the Sunday School, where, under Mr. Mitterer's able direction, it has become one of the most perfect, even for works of art.

Strohhofer, an apprentice of my brother Charles, from whom

he learned the elements of the art, entered, in 1806, into partnership with Mr. Sidler, who set up a press for the Royal Exchequer; and, after the expiration of my privilege, he established his house on a larger scale, chiefly for music and circulars, and it still flourishes at Munich.

The convenience and saving in multiplying the copies of royal ordinances or circulars, by transferring them to the stone, instead of having them transcribed by hand, induced Mr. Von. Hartmann, President of the Administration of Domains, to have a lithographic press, for that purpose, in his office. He, therefore, sent for Sennefelder, to establish one. The messenger, by mistake, went to my brother Theobald, instead of me, who accepted the offer, erected the presses, and received the advantageous appointment of Inspector of this establishment, under very favourable conditions; and being allowed to work, when not engaged at this office, on his own account, he contrived, in a short time, to realize very considerable sums of money.

This success led many others to consider the art of Lithography as the means of getting rich in a short time, and thus two of my brother's occasional assistants, Helmle and Roth, contrived to establish a press of their own.

About the same time another press was established at the

Royal Institute for poor children ; and, in another quarter, Mr. Dietrich set up a similar one.

My own prospects, about the year 1810, wore a very unpromising appearance ; and though, by indefatigable zeal and numberless experiments, I had made myself perfectly master of the new art, I should, but for a lucky accident, have been obliged to apply to some of my former pupils, for employment. I had even the mortification to see myself abused in the public papers, which asserted that, though I had discovered the principle of the art, which, from selfish motives, I had long kept a secret, yet I had never been able to apply it to any thing but music. This unfounded and humiliating assertion, wounded me deeply, as it was well known that all the Lithographers of that period, had been taught by me ; and that none of them, not excepting even Professor Mitterer, the most accomplished of them all, understood the whole of the art so perfectly as I did.

As to the charge of having kept it a secret, I do not hesitate one moment to pronounce it a falsehood ; for, as soon as I had obtained my privilege for Bavaria, in 1799, I communicated the whole of my process to every one who wished to know it, even to perfect strangers ; and this openness, and the pleasure I took in publishing every discovery that I conceived to be of any use to society, frequently drew upon me the bitter reproaches of those who lived with me, and who used to say, that I might have been a very rich man, had I been more re-

served in regard to my discoveries. This, however, could not have been the case, since from my own means alone, I could never have produced any thing perfect, as it would then have been necessary for me to write, draw, and print every thing with my own hands, which was impossible.

I rather suspect that the opinion of my art having been long kept secret, arose from the circumstance that several of my former workmen, or other persons, who had, by accident, heard something of Lithography, treated it as a great secret, in order to obtain greater consequence ; some of them even went so far as to travel about, and to sell their secrets and prescriptions, to credulous persons, in some cases for considerable sums.

After this short digression, which I thought necessary for my own satisfaction, I return to our history.

In the year 1809, as I before stated, there were established at Munich six public lithographic printing-houses, besides my own, and several other presses, that amateurs or artists had erected for their own use. Among the latter, Mr. Mettenleithner was the most distinguished. This gentleman, to whom I shewed several specimens of the new art, as early as 1796, did not conceive a very favourable opinion of it, but was entirely converted on seeing some of the highly-finished specimens from the presses of Messrs. Mitterer, Strixner, and Piloti, and induced to try some experiments himself, in conjunction with

a young man of the name of Dallarmi. Some time after this, Mr. Mettenleithner established a lithographic press at Rome, which, however, did not meet with the expected success. In the year 1807, Mr. Werz, and my former pupil Grunewald, attempted to set up a similar establishment at Milan, but were likewise disappointed in their expectations.

Mr. Mettenleithner, in conjunction with one of the best printers of Baron Aretin's press, about this time laid the foundation of the present lithographic establishment at the Royal Board for surveying the kingdom; and his son-in-law, Mr. Winter, soon after set up a similar one for the use of his Majesty's Privy Council. Mr. Mettenleithner in a short time employed between thirty and forty draftsmen, to draw the 15 or 20,000 plans, that were to be printed from stone plates. According to a royal ordinance, the whole of the kingdom was to be surveyed, and most accurately measured, for the better regulating and proportioning the land and assessed taxes; now, as it was necessary to have at least two copies of each original map, it appeared that the expense of doing this by hand, would be far greater than to have it drawn on stone, by which means a great number of copies could be taken, if required, and the greatest similarity between these copies be preserved.

They had been some time at work, when they happened one day to want a stone plate of larger dimensions than their common plates, and knowing that I possessed very large plates,

they desired me to sell one to them ; I readily acceded to this request, and so became, by mere accident, acquainted with Mr. Von Badhauser, one of the commissioners. In a conversation with him, I discovered, that it was owing to a mere intrigue, that the superintendence of this extensive establishment had been withheld from me. Another of the commissioners, the celebrated astronomer Schiegg, was also very much dissatisfied with the prices and management of the lithographic presses, and, therefore, proposed to submit the whole concern to my direction.

I was accordingly summoned to Mr. Von Utzschneider, president of the board, who, in a most flattering and liberal manner, acquainted me with the resolution of the royal commissioners to intrust me with the superintendence of the lithographic part of the establishment ; and that they should feel proud to see me, the inventor of this useful art, employed in their office ; and he left it entirely to me to suggest the plan, upon which I should think it most advantageous to arrange the establishment. I, therefore, proposed to them, what I conceived the most advantageous way for the Board to carry on the business, namely, to print their plans and maps by contract, at two kreutzers per plate ; by which they would save two-thirds of their expenses. This offer, however, to my great astonishment, did not meet their approbation ; and Mr. Von Utzschneider suggested to me, that it would be better to demand an adequate yearly salary for myself and Mr. Gleissner,

and to give up the whole of our time to the establishment. This I did accordingly, and, in a few days, I saw my most sanguine hopes realized, and an ample and comfortable provision secured to me for life ; so that I have every reason to respect this excellent man, as the creator of my fortune, who secured me from want for the rest of my days, and placed me in such circumstances, that I need not look to my art alone as a means of subsistence. All the useful improvements and additions that I have since made in it, are entirely owing to the ease and independence which his patronage procured for me. My salary as Inspector of the Royal Lithographic establishment, was fixed at 1,500 florins a year, and that of my friend Gleissner at 1,000 florins ; and I, moreover, obtained permission to continue the business which I had hitherto carried on in conjunction with Baron Aretin. This happened in October, 1809.

At first my new office absorbed the whole of my time ; but, as soon as I had succeeded in arranging the business, and in training some workmen, I had more leisure, and I devoted it most conscientiously to the improvement of the private establishment in which I was concerned with Baron Aretin ; which I had the pleasure of seeing in a flourishing state, just at the period when Baron Aretin's promotion in the public service called him away from Munich. This circumstance broke up the whole concern, at the very moment when we began to reap the fruits of our exertions ; we resigned our presses to Mr. Von Manlieh, and Mr. Zeller, as mentioned above ; and the only

consolation we had was, that in the hands of these truly patriotic and spirited gentlemen, our establishment continued to be useful to our country.

I intended to keep two presses myself for my own use, and as I married about the same time, I hoped that my wife might be able to superintend this limited concern, and render it a lucrative one for us ; but though our prospects at first seemed favourable, in the course of time things turned out otherwise, and I was, therefore, easily pursuaded to relinquish the business. Mr. Gleissner, being more sanguine in his expectations, took my workmen into his pay, and began very successfully ; but having, soon after, the misfortune to be seized with a dangerous illness, which ended in mental derangement, his family was obliged to give it up.

Being now less encumbered with business, I earnestly directed my attention to the production of a lithographic Compendium, the first number of plates for which had already been published, and honoured with the public approbation. Some artists, in the mean time, had made such progress in the art, that what I thought a perfect print this year, did not seem so in the next ; and I had taken it into my head, that all the specimens of the different manners, that were to accompany my compendium, ought to be unquestionable master-pieces of the art. In the year 1811, when my much-respected friend Mr. André paid me a visit at Munich, I communicated to him

my plan, which he so fully approved of, that he instantly offered to undertake all the expenses connected with it. We agreed that the work should be published at Offenbach, and that the necessary drawings should be executed by the best artists of Frankfort. But we soon found that it was not very easy to meet with proper artists, and the few that we thought qualified, asked treble the price of a similar engraving in copper, as they were not yet masters of the new art ; so that we were obliged to defer the publication of our compendium, till another and more favourable period.

More than two years now elapsed, in which little or nothing was done towards the completion of this my favourite design ; from time to time I finished a plate for this purpose, but hitting always in a short time upon something that I thought better, I rejected it again. But my mind was deeply impressed with the obligation I was under towards my family, as well as towards myself, to state to the Public at large all the facts and circumstances that attended the origin and progress of Lithography ; and to leave this as a bequest to my family, which, perhaps, one day, when I should be no more, would entitle them to the gratitude and respect of their contemporaries.

In 1816, when Mr. André, to whom I communicated all the improvements and new discoveries I had made since I left him, was at Munich, the period for the publication of my long-projected compendium was finally fixed, and I promised him

to lose no time in composing the description of all the different manners, and their management, while various artists were engaged in executing the requisite specimens. Some unforeseen avocations, however, prevented me from making a rapid progress; the principal of which was my journey to Vienna, to establish a lithographic office for Mr. Gerold, a respectable bookseller there. I had hoped to return in about three months, during which time I conceived the Munich artists would be able to proceed with their drawings. But I had the misfortune, soon after my arrival at Vienna, to fall seriously ill ; and, as I recovered very slowly, the period of my return was considerably retarded.

Mr. Gerold's lithographic establishment did not, at first, meet with the expected success ; chiefly owing to some impediments purposely thrown in his way by Mr. Steiner. Vienna, I am inclined to believe, is a very congenial and favourable place for Lithography, in which it might soon reach a high degree of perfection, as it contains an abundance of good artists. Those who particularly patronised Mr. Gerold's new office, were, Colonel Von Aurach, Captain Kohl, and Mr. Kunike, an eminent professor of drawing, who, by actual experiments, had convinced themselves of the high value of the new art. The last of these gentlemen contrived a very ingenious method of producing, with little trouble, a great number of original drawings, or copies of the same drawing. As our printers were far from being expert in this new process

of printing, many copies were but imperfectly printed, and would, according to our usual practice, have been destroyed ; this was more particularly the case in printing one drawing in chalk with two stone plates. Mr. Kunike, instead of destroying these imperfect copies, corrected and finished them by hand with black Paris chalk, and thereby rendered them true original drawings ; in the same space of time in which he could have executed one entire drawing by hand he was able to correct and finish twelve imperfectly printed copies, so that they could not be distinguished from the original, which they sometimes even surpassed in excellence.

A short time before my departure from Vienna, a number of the *Journal for Industry and Arts,* published by the Polytechnic Society at Munich, fell into my hands, in which I found a series of letters by Mr. Von Schlichtegroll, director of the Royal Academy of Arts, containing an enquiry into the origin and progress of the invention of Lithography. He had carefully collected all the information on this subject, which he could collect from my brothers, some inhabitants of Munich, and other authorities. On my return to Munich, I immediately waited upon him, to thank him for his patriotic exertions, and to give him some further information on this subject ; and I was so fortunate as to find in him an active promoter of the useful arts, who was kind enough to take a particular interest in my past and present undertakings, and did every thing in his power to advance them. It was he who

directed the attention of several distinguished and learned characters towards the new art, who procured me the opportunity of submitting specimens of my last improvements to the Royal Academy of Sciences, and the Polytechnic Society, of which he was then president; it was through him that I had the distinguished honour of exhibiting my newly-invented portable hand-presses to their Majesties our gracious King and Queen; and I shall never forget the moment when the sincere approbation of their Majesties amply recompensed me for all the trouble, misfortunes, and disappointments, of my past life, and encouraged me to devote the rest of my days to the service of a country, that has the happiness to be governed by so excellent a Monarch. But, alas! life is of such short duration, that at the end of it scarcely any thing is left us but the regret of disappointed hopes and baffled schemes, the execution of which our active zeal and warm imagination represented to us as easy and practicable.

It is to Mr. Von Schlichtegroll's continual encouragement, that the present *Treatise on Lithography* owes its origin and completion. When, after the discovery of the chemical process of printing from stone plates, I saw the first perfect specimens of it, and resolved to make this invention useful to me, I little suspected that the greater part of my life would be spent in this pursuit; but merely looked to it as a means of ameliorating my condition, so as to be more at liberty to choose the mode most congenial to my feelings and talents of labouring

for the public good, and enlarging the sphere of useful inventions. But still, as it is, I esteem myself happy in seeing, in my own life-time, the value of my invention so universally appreciated; and in having myself been able to attain in it a degree of perfection, which, in a thousand other inventions, has not been reached till long after the death of the first inventor.

Mr. Von Manlieh, director of the Royal Gallery of Pictures, has published for some years back, numbers of drawings from the royal collection of the original sketches of great masters, of which many are highly beautiful, and in the judgment of all connoisseurs, true *fac-similes* of the original.

Still greater praise is due to the collection of copies from the Royal Picture Gallery, published in seventy-two Numbers; it has obtained the unqualified approbation of the Public, and would have been still more admired, had the printers been as skilful as the artists. The greater part of these drawings are in the chalk manner, and produced with two or more stone plates; if the effect of the different plates is well calculated, the stone print becomes a perfect imitation of the original, and sometimes cannot be distinguished from it, even by experienced artists. The venerable Mr. Von Manlieh, and his worthy pupils, have, by this work, greatly raised the value and reputation of Lithography, for which I here publicly express to them my grateful acknowledgments; which are equally due

to Professor Mitterer, and his pupils, to whom Lithography is also very greatly indebted. Professor Mitterer has obtained a degree of perfection, particularly in the chalk manner, that may properly be termed the *ne plus ultra* of the art. He is, moreover, the inventor of a press, called, " Roller, or Star Press," which, in its present improved state, is all that can be desired in regard to power, expedition, and ease.

Since the year 1809, I have devoted all my leisure to the improvement of Lithography, and to the reducing of all operations, in its different branches, to the most simple and certain principles. Thus I have, by numberless experiments, succeeded, for instance, in simplifying the manner of transferring from paper, upon which drawing or writing is previously executed with prepared ink ; and particularly in transferring leaves of old books or old prints to stone, by which, in the most easy manner, lithographic stereotypes may be obtained. Such progress has also been made in printing in colours, that I produce not only coloured prints, but likewise copies so like oil-paintings, that it is impossible to discover any difference between these copies and the original pictures. I farther discovered a new method of printing playing cards, tapestry, and even calico, by which two persons in one day can print 2,000 pieces of the size of folio sheets, even if the pattern should consist of 100 or more different colours. Incredible as this assertion at present may seem, I hope, if I have life and health, to lay before the Public astonishing specimens of this new process.

Among the new methods of Lithography that I introduced during this period, the following are the principal ;—the engraved chalk-manner, the dotted manner, some new kinds of aquatint, the transformation of the raised or relief manner into the engraved, and *vice versâ*, and a new method of writing printed characters, by means of a machine, for splendid works.

My next aim was to apply a remedy to the uncertainty of lithographic printing, so generally complained of; or to the circumstance that the plates were so frequently spoiled in the press, from the want of skill in the printers. This I completely effected by a printing press, in which the wetting, cleaning, and charging of the stone, is not performed by hand, but by the mechanical power of the press itself; which, if requisite, may be placed beside the water, and worked nearly without any human assistance. By this invention, I venture to flatter myself, Lithography has attained its highest degree of perfection. A model of this new-invented press, was exhibited by me in 1817, to the Royal Academy of Sciences ; and the Committee, appointed to examine it, was so pleased with the ingenuity of the invention, that the gold medal was voted to me for it.

But the most important of all the improvements which I have been fortunate enough to contrive, is, the invention of a substitute for the calcareous stone plates hitherto used in Lithography ; which, from their unevenness, weight, and fragility,

often prove troublesome ; and, besides, take up a great deal of room, and thus require extensive space for even a moderate establishment. In trying to remedy this inconvenience, I ascertained that the chemical printing process is, under certain restrictions, equally applicable to metal plates; but more especially to a certain artificial composition of stone, which can be spread on metal, wood, or stone plates, nay, even on paper or cloth ; and which proves, in every respect, a perfect substitute for the Solenhofen stone. The great number of experiments which, in the course of four years, I made with this composition, have thoroughly convinced me of its utility and value, and that it possesses all the good qualities of the stone, without its inconveniencies. The fragility of the Solenhofen stone, renders it necessary to have very thick plates for printing. If the size is that of a common folio sheet, its thickness must be at least one inch and a half, to prevent its breaking in the press. If the stone is to be frequently ground and re-polished, its thickness must be at least two inches, and then it may be re-polished nearly 100 times. The weight of such a stone is between twenty and thirty pounds, sometimes more, and it takes up a considerable space. In a large establishment, where a considerable number of stones are used, and where it is often requisite to keep them for a long time, in order to be able to take off copies as they are wanted, this inconvenience is of great moment.

If the stone plates are sufficiently thick, the danger of their

breaking in the press is not so great; though this will some-times happen from mismanagement, from warming them, and from sudden frost, especially when they have been previously wet. Besides, as these stone plates are not to be found every where in equal excellence, the charge of conveyance renders them very expensive.

All these defects are obviated in the artificial stone compo-sition, the principal advantages of which are the following :—

1, The composition stone plates are much cheaper than the natural ones.—2. Their weight is very inconsiderable, a plate of folio size scarcely weighing four ounces.—3. One hundred of these plates, laid one upon another, do not occupy more room than a single stone.—4. The resistance of these plates to the strongest press, is superior to that of stone, copper, and even iron plates ; as their elasticity, without the least alteration of their surface, withstands the greatest imaginable pressure, if they are properly managed.—5. The drawing on these plates with prepared ink, as well as the engraving on them, is easier than on real stone plates ; the latter operation is particularly well calculated for these plates.—6. The charging and printing of these plates is greatly facilitated, and the pressure of the press need not be so strong as for real stones ; for the artificial stone plates receive and give out the printing ink with greater fa-cility.—7. Lastly, they are particularly suited for all kinds of fac-similes; so that by the mere application of a fresh im-

pression upon another plate, a perfect fac-simile of the original may be obtained. This property of composition plates will, one day, be of great importance in stereotyping books, and other common printing work.

These, and many other advantages, which will be detailed in the second part of this Treatise, render, without doubt, this last invention one of the most important in the whole compass of chemical printing; in spite of all that incompetent critics, without sufficient knowledge of the nature of the invention, may urge against it. I have had the honour to exhibit specimens of my composition stone, as well as the whole process of printing from it, before the Royal Academy of Sciences, and the Polytechnic Society for Bavaria.

Owing to my different engagements, and principally to the composition and publication of this Treatise, I have hitherto been unable to establish myself a manufactory of these artificial stone plates. This, however, I now hope to accomplish in a short time; and all may then, by actual trials, agreeably to my directions, convince themselves of the truth of my assertions.

This invention will, no doubt, greatly facilitate, every where, the introduction and application of Lithography; and I am proud to see that, even in its present shape, it is known and exercised in a great part of the civilized world. In England and France it was first introduced by Mr. André, and it has

lately been revived in London by Mr. R. Ackermann, of the Strand, and in Paris by Count Lasteyrie, both of whom have employed it in various publications. At Berlin, Mr. Von Reiche opened a lithographic establishment, upon a large scale ; at St. Petersburgh, it was practised several years ago, and at present it is more particularly cultivated by Baron Schilling. Even in Philadelphia, and what is still more astonishing, in Astrakan, Lithography is already introduced ; and, as I understand, is in a flourishing state.

God grant that it may soon spread all over the world ; that it may prove useful to mankind, and contribute to its improvement ; and that it may never be abused to any dishonourable or wicked purpose ; and I shall then never cease to bless the hour in which I invented it.

END OF THE THIRD SECTION, AND OF THE HISTORY.

PART II.

ART OF LITHOGRAPHY,

CONTAINING

Instructions in the different Branches and Manners

of this new Art.

ART OF LITHOGRAPHY,

&c. &c.

PART II.

Introduction.

LITHOGRAPHY is a branch of a new method of printing, differing in its fundamental principles from all other methods now in use, and known by the name of Chemical Printing. All the other methods of printing, hitherto known, might be divided into two branches; the one multiplying the original by elevated forms, the other by engraved forms. To the first branch belongs the common letter-press printing, where the letters and signs are moulded in a composition of metal, or in wood, in such a manner that those lines and points which are to receive the colour, and be printed, are elevated; while the rest of the plate, which is to remain blank on the paper, lies deeper. The wooden blocks, for calico-printing, are of the same description.

Under the second branch may be included all the different

methods of engraving on copper or tin, as well as calico-printing from copper-plates or cylinders.

The manner of taking impressions, or the printing, is, in the first branch, effected in the following way :—The types, which are all of equal height, and therefore form an equal surface, are repeatedly touched in all the parts of the surface by a printing ball of leather, filled with horsehair, and sufficiently charged with black or coloured ink. The ball, from its firmness and elasticity, touches only the elevated spots, which it covers with the adhesive liquid colour, so that in the proper press an impression may be easily taken off. The same manipulation, with some modifications, is employed in calico-printing from wooden blocks; the block is charged by being put upon a ball or cushion covered with colour, then applied to the calico, and by a moderate blow of a hammer, the impression is obtained. A process, directly the reverse, is observed in the copper and tin printing; for here, in order to charge the engraved lines with colour, the whole plate is first covered with colour; then the surface is wiped off and cleaned with rags; and, as they do not enter into the engraved furrows, the colour remains in them, and by the strong pressure of a press, by which the paper is forced even into these narrow furrows, the desired impression is obtained.

It is evident that in both these methods of printing, the charging the types or plates with colour, by which the im-

pression is obtained, depends entirely on mechanical principles, *viz.*—that, in the letter-press printing, the colour adheres only to those places that come in contact with it ; and, in the copper-plate printing, to those from which it is not wiped off.

The chemical process of printing is totally different from both. Here it does not matter whether the lines be engraved or elevated ; but the lines and points to be printed ought to be covered with a liquid, to which the ink, consisting of a homogeneous substance, must adhere, according to its chemical affinity and the laws of attraction, while, at the same time, all those places that are to remain blank, must possess the quality of repelling the colour. These two conditions, of a purely chemical nature, are perfectly attained by the chemical process of printing ; for common experience shews that all greasy substances, such as oil, butter, &c., or such as are easily soluble in oil, as wax, bitumen, &c., do not unite with any watery liquid, without the intervention of a connecting medium ; but that, on the contrary, they are inimical to water, and seem to repel it. The principal dissolving and uniting liquid for the above-mentioned substances is alcali, which, by proper management, forms a sort of soap, soluble in water.

Upon this experience rests the whole foundation of the new method of printing, which, in order to distinguish it from the mechanical methods, is justly called the chemical method ; because the reason why the ink, prepared of a sebaceous matter, adheres

only to the lines drawn on the plate, and is repelled from the rest of the wetted surface, depends entirely on the mutual chemical affinity, and not on mechanical contact alone.

It might, perhaps, be objected, that in the other methods of printing, the colour adheres to the lines which are to be printed, from the very same cause, as it is a well-known law, that water and oil adhere to all bodies in a perfectly dry state. But the case is not the same with fluids and their mutual effect, and this constitutes the essential difference between the former and this new method of printing. A dry plate would every where imbibe the colour; but the surface of the plate being sufficiently wetted, it takes the colour only on those places that are in a state the reverse of wetness. The repelling, therefore, of the *colour*, from all those places that are to remain blank, is the novelty in the whole process.

It is not, however, sufficient, in order to print chemically, to make certain spots of the plate greasy, and others wet; water of itself being, when applied to most of the substances, used for plates, of insufficient power to act as a means for repelling the colour from all the places on which it ought not to be. In silicious and porcellaneous substances, such as glass, china, and clay slate, pure water might be sufficient; but then the slight power of adhesion, and tenacity of the greasy ink, when applied to these plates, is another obstacle to the taking a considerable number of impressions from them; however, in case

of necessity, this obstacle may be removed, in part, by the use of very hard substances which soon dry, such for instance as linseed-oil varnish, mixed with a great deal of sulphate of zinc. But in those substances which powerfully attract the ink, as for instance, metals, wood, calcareous stone, artificial stone, paper, &c., it is necessary to prepare the surface of the plate so, that in those places which are to remain blank, it may reject, as if from aversion, the colour ; and, consequently, entirely change its nature.

Repeated experiments have convinced me, that it is possible to discover preparations for all the substances belonging to this class, and of which I shall more minutely speak in another place. The chemical process of printing is not only applicable to stone, but likewise to metals, &c. ; and Lithography, therefore, is only to be considered as a branch of the more general chemical process of printing.

Amongst the different materials applicable to this new method of printing, the calcareous slate occupies the first place. It possesses not only a strong tendency to combine with unctuous substances, and to retain them obstinately, but it likewise possesses the power of absorbing bodies of a different nature, such as aqueous fluids; so that the stone, thus impregnated with them, will repel oleaginous and unctuous bodies.

This excellent quality, the cheapness and facility with which

these stones could be procured in Bavaria, the advantage of their being easily rendered fit for use, determined me to overlook the few defects or inconveniencies they presented, such as their heaviness and occupying much room, and their not unfrequent difference in quality, and induced me to use them as the principal material for my various experiments, the successful result of which has now established this my invention as a new art.

Having so far treated of the elements and character of this new method of printing, and having explained the names and fundamental principles of it, it still remains for me to say a few words on the subject of its utility.

The merit of every new invention consists in the advantage resulting from it for sciences, arts, and manufactures ; it may not, therefore, be improper to inquire what advantage in this respect, has been derived from the art of Lithography ; and to ascertain in what points it is preferable to the other methods of printing hitherto known.

There is no invention, in this sublunary world, which unites in itself all the advantages and all the excellencies that might be wished. Lithography does not constitute an exception to the remark. It may, indeed, be said of the art of Lithography, that neither type, nor copper-plate printing, can be dispensed with in consequence of its invention ; though it is not im-

possible that, by farther improvement of the presses, it may one day combine the advantages of the other methods of printing, with those which are peculiar to itself; but at present the facility and quickness of composition, the equality and correctness of the single letters, which can be obtained in type-printing, give to this art a decided superiority for many purposes. Some subjects, however, that hitherto have been executed by types, such as circulars, bills of exchange, invoices, cards, and addresses, &c., can be executed by means of Lithography, more quickly and in greater perfection than by types.

With regard to copper-plate printing, it is to be presumed that, upon a more general introduction of Lithography, only two methods will remain in use, viz.:—The line engraving, and the etched manner, which is afterwards finished by the needle and the graver. Here, however, the talent of the artist ought to be taken into consideration, for a more experienced artist may, even in these manners, produce something equally admirable on stone, as on copper. The same may also be said of the manner of dotted engraving, as it was practised by the late Mr. Bartolozzi, or our eminent Mr. John, in Vienna, and many eminent artists in England, whose delicate style in that mode of engraving will not likely be rivalled by lithographic art.

All the various other methods of copper-plate printing must yield, without question, the palm to Lithography;

especially when we consider the easiness of the manipulation, the comparatively short time required to take impressions, and the number of impressions that can be struck off. Thus, for instance, all sorts of writing can be done easier and more quickly on the stone with the needle, as well as with the greasy ink, than could be done by the most experienced engraver. For maps, and other topographical plans, Lithography has, therefore, a decided superiority, as they can be done on stone in greater perfection, and in much less time, than would be requisite if done on copper. Another advantage which stones possess over copper is, the greater facility in the printing of the former, for which less technical skill is required, while copper printing is attended with very considerable difficulties. Many persons, for instance, are of opinion that the German printers do not equal those of Paris and London; but the laying on the colour on the stone requires so little time, that the printing, especially large plates, from stone, can be done much more quickly than printing from copper. Besides this, corrections can be made with more ease on stone, than on copper or tin.

From this it is evident that all sorts of drawing or writing, which hitherto have been done on copper or tin, and in which the utmost fineness, expression, and clearness, or, in short, the greatest possible technical perfection, is not absolutely requisite, can be done by Lithography in a more cheap and easy way, and may be multiplied in a comparatively very short space of time;

and it has been generally observed that drawings of the less excellent artists, appear to greater advantage on stone, than on copper.

Even this advantage would be sufficient to establish the usefulness of the new art; but there are besides several other methods that are altogether peculiar to it, and cannot possibly be imitated by type, or copper-plate printing. Of these I shall notice here only, first, the chalk manner, by which every artist is enabled to multiply his original drawings; and, secondly, the transfer manner, by which every piece of writing or drawing with the greasy ink on paper, can be transferred to the stone, and impressions taken from it. This last method may, one day, be of great utility to public offices, and the public at large.

These are the principal advantages, which, according to my firm conviction, Lithography possesses; and every impartial observer of this art will, no doubt, share my opinion. After these preliminary observations, I hasten to the description of the art, and its different branches or manners.

PART SECOND.

SECTION I.

GENERAL RULES AND EXPLANATIONS.

CHAPTER I.
OF THE STONES.

Description and Qualities of the Stones.

THE species of Stones which has hitherto been exclusively used at Munich, for the purposes of Lithography, is a sort of *calcareous slate*, found in the country from Dietfurt to Pappenheim, and along the banks of the Danube, down to Kellheim; from which last place the name of Kellheim Stone-plates has been derived, as in former times they were principally taken from thence. The quarries at Kellheim seem at present to be exhausted, and the traffic in this article has its centre in the village of Solenhofen, in the districh of Monheim, three leagues from the town of Neuburg, on the Danube, where almost all the inhabitants are stone-masons. The country there abounds in this species of stone, so that for centuries to

come no want of stones is to be feared. When the ground is uncovered to the depth of from ten to fifteen feet, these stone-plates appear in horizontal strata, which at first are of very inconsiderable thickness, often not thicker than paper ; and for that reason, and their want of consistency, cannot be used for any lithographic purpose.

The Solenhofen stone, in its chemical decomposition, consists of lime and carbonic acid. In nitric, muriatic, and other acids, it can be almost entirely dissolved, and the carbonic acid escapes in the form of gas. As most of the marbles are composed of the same substances, one might be induced to believe that marble-plates could equally be used for Lithography ; but the unequal and dark colour, and the frequent veins and fissures in these sorts of stone, are a considerable obstacle. Notwithstanding this, I have often used select pieces of light-coloured marble for several purposes of Lithography, and their greater hardness renders them very useful ; the Solenhofen stone, however, in general, is much to be preferred, on account of its equal and light colour, and greater cheapness.

Since the art of Lithography has risen to considerable celebrity, attempts have been made to discover the same species of stone, or one resembling it, and possessed of the same qualities, in other countries ; and in England, France, and Italy, as well as of late in Prussia, these attempts have been successful. And, upon the whole, it is more than probable, when we consider

the immense quantity of carbonate of lime, which is found on so many places of the surface of the earth, that the same species of stone might be frequently discovered in slates of one, two, or more, inches in thickness, or in larger masses, which might be cut into plates.

It has been observed, that all the strata are not of the same good quality ; sometimes even the stones of the same strata are very different. If good and perfect work is to be produced, it is important to select sound and suitable stones, and to take none but those of the first quality from the stone-masons, who very well know how to distinguish them.

A perfect stone ought to be of the following description :—

1st, In point of thickness. The thickness must always be in proportion to the size of the stone. Small stones resist the force of the press, without breaking, when of less thickness than great ones ; nevertheless, even small stones ought not to be thinner than one inch and a half, neither should they be thicker than two and a half inches, as the thickness renders them so very heavy and unmanageable.

In general, the best thickness of a stone is from two to two and a half inches.

2d, In point of substance. Some of the stones are of a

softer nature, some of a harder ; sometimes the same stone on one side is soft, on the other hard ; and sometimes it happens that it is composed of several unequal strata : this latter circumstance is no material objection, if the stone is sound in other respects. Generally speaking, the harder sort of stones are the best for all the different manners, provided their substance be uniform, and not interspersed with white spots and points, as is frequently the case ; for then they are not good for any manner, where clearness and neatness are required. The rubbing down and polishing of these stones is very difficult, as the white and softer spots are more affected by the polishing material, and create hollows. Besides they have the following inconveniencies :—

a, In writing with the pen on a stone of this description, the pen, in going over these deeper spots, gets entangled, and the lines loose their clearness.

b, In drawing with chalk on them, it is very difficult to produce uniform shades, as the deeper spots do not give out the chalk so well as those which are more elevated ; in fact, the grain will not be equal.

c, In engraving with a needle on them, it happens that the needle enters deeper into the soft spots, whereby the lines become broader, and the drawing loses its elegance : and in etching, the soft spots are likewise more affected.

Soft stones, if not very thick, are very apt to break under the press; but they are easily engraved on, as they offer less resistance to the needle. The impressions from them are generally very black, as they retain more colour; but the printing is rather difficult, as they are very apt to soil, nor do they give the same number of impressions as the hard ones. The softest sort of Solenhofen stones has commonly a yellowish appearance, or mixed white and red, or it has frequent yellow veins.

The best and hardest stones have often small defects, such as small invisible holes, veins, and fissures; those which possess these defects, must be carefully avoided. Veins of very small dimensions like hairs, single spots of greyish or yellowish colour, incrustations of fishes, herbs, &c., which sometimes occur, are not essential defects; and it is very seldom that we find a stone of the size of a common sheet of paper, free from all these defects, which can only be discovered after the polishing of the stone.

3. In respect to the size. The size of the stone must differ according to its use. A small drawing, it is true, may be printed from a large stone; but, in many cases, the construction of the press renders it necessary that the stone be not much larger than the drawing; nevertheless, the stone at its two extremities, where the printing is to begin and to end, must be at least one inch larger than the drawing, otherwise there would be no room for the setting of the scraper, as will

be more fully described hereafter. For small articles, such as cards, addresses, &c., it is advisable to take stones of the size of an octavo sheet, and for this purpose larger stones, which on account of partial defects, cannot be used for large drawings ; or those that have been broken may frequently be cut down to this size.

It is material, for the good construction of the press, that every stone, on its four sides, be cut at right angles, and perpendicularly, as in this shape they can be best fixed into the press.

The stones, notwithstanding their hardness, are very brittle; and a single stroke of a hard body often causes, even in the thickest stone, a fissure, which, sooner or later, proves fatal. This, therefore, as well as the falling or striking against them, must be carefully avoided.

It is this quality of brittleness which regulates the manner of splitting the stones into different forms and sizes. For this purpose a small instrument of hard steel, weighing about one ounce, is used ; it has the form of a common chisel, not very sharp, and is attached to a long thin handle, of two or three feet in length ; the stone is then placed hollow, and in the line where the separation is to be effected, strokes with the mallet, at the distance of one inch from each other, are applied. This, in most cases, is sufficient to divide the thickest stones ; but, as the sides of the stone do not always form a true perpendicular to

the surface, it is sometimes necessary to dress them afterwards with a sharp chisel. This process of dividing, though very simple, requires some experience and skill ; as a single stroke, applied to a wrong place, often causes a fissure in an opposite direction. It is, therefore, by no means advisable to divide a plate after a drawing has been made upon it.

The Rubbing Down and Polishing of the Stones.

The Stones, as they come from the quarry, even if they have been rubbed down there, are not always fit for use, and require to be first carefully polished. In order to do this, a strong iron or brass ruler, called a strait edge, is necessary ; this is applied in various directions to the surface ; if it is possible to look under it, this is a sign that it does not touch in every place, and that there are still hollows in the surface. In order to remove these, the prominent parts of the surface must be rubbed with a coarse grained sand-stone (or pumice-stone, if not too expensive) and water, till the ruler applied in all directions touches the surface in every point of its line. When this is done, the stone thus prepared is placed on a strong horizontal table, and thinly covered with fine sand, mixed with a spoonful of water ; to this a little soap may be added, as it facilitates the polishing and augments the action of the sand on the stone. Another stone is now put on the surface of the first, and

moved up and down in different directions. At intervals fresh sand and water must be applied ; and thus two surfaces are polished at the same time, and rendered perfectly level and even. In moving one stone upon the other, care must, however, be taken not to exceed the surface of the under one, otherwise the upper stone takes a concave, and the under one a convex figure. To avoid this, the best way is, to exchange the stones frequently, so that the under one may at one time be the moving stone, and the upper at another time ; or to take two stones of different dimensions, and to use the smaller one as the moving stone. From time to time the stones must be wiped with a sponge, and examined by the ruler, till at last they are found perfect. By a little experience it can be easily ascertained by the touch, whether a stone is sufficiently polished or not, for as long as there is any unevenness on its surface, a certain resistance is felt, which sometimes is so strong, as to prevent the movement of the upper stone. Two stone plates, in this state, if left to dry, adhere so strongly together, that no power can separate them, without injury to one or both of their surfaces. The only means of separating the stones in this case is, to introduce the blade of a common knife as deep as possible between them, and to give a few gentle strokes with a mallet on the upper side, upon which they will separate instantly.

In the beginning of the act of rubbing down and polishing the stones with sand, innumerable small furrows, occasioned by the grains of the sand, may be discovered on the surface ; but

the process of polishing one stone with another entirely takes them off, and the surface then presents a perfectly smooth level. If, upon close examination, no traces whatever of these almost imperceptible furrows can be discovered, and the rule touches the surface in all points of the line of contact, and in all directions, then the stone may be pronounced perfect and fit for use. It would, however, be presumptuous to believe, that by any process a perfect mathematical level can be obtained ; if the surface only approximates this, and the unevennesses do not exceed the thickness of a sheet of Bank post-paper, it is quite sufficient.

This process of polishing, here described, is by far the best and most expeditious, and requires less skill and experience than any other method. The elegance and purity of the impressions, and the ease or difficulty in printing the plate, depends very much upon the perfect state of the polishing, which therefore ought to be done with the greatest diligence and exactness. This is the first preparation and polishing of the stone; if afterwards they are to be used for drawing, they require another particular preparation, which differs according to the different methods, as shall be hereafter more fully described.

The Assorting of the Stones.

After a stone has been prepared in the manner just described,

the nature of its substance, as well as its defects, can be clearly seen, from which it may be ascertained to what sort of use it is best adapted. Stones of unequal hardness may be laid by for coarse pen-and-ink drawings ; stones of uniform hardness, but unequal colour, are fit for fine pen-and-ink drawings, and for the engraved, as well as for the transfer manners. The purest, best coloured, and hardest stones must be selected for chalk drawings.

The stones may be preserved in any place not too damp, nor too much exposed to cold in winter. A dry cold does not hurt the stones, but if they are damp, and afterwards freeze, they are apt to break ; or if exposed to a constant damp, they are apt to attract saltpetre and other substances that injure the surface. A stone, if taken from the storehouse for use, ought first to be kept a few days in a dry room of moderate temperature.

CHAPTER II.

Of INK, CHALK, ETCHING-GROUND *and* COLOURS.

The Chemical Ink.

THE ink, known by the name of chemical ink (a more appropriate denomination, from its constituent parts, *viz.*, unctuous and bituminous substances, and an alkali, would be fat or alkalic ink), is one of the principal and most important requisites in a lithographic establishment. It is used for writing or drawing immediately on the stone, or for covering the surface of it, like etching ground, or for transferring drawings, executed on the paper, to the stone. The principal qualities of this ink are, its filling the pores of the stone, in those places to which it is applied, with an oily greasy substance, and, farther, its resisting the action of aqua-fortis and other acids.

I have observed in another place, that different mixtures without number of this ink may be prepared and found useful for different purposes, according to the fancy and inclination of the artist. Having, however, made so many experiments on this important subject, I feel justified in recommending the following different compositions as the best and most perfect for the different purposes :—

Chemical inks may be divided into two principal species, *viz.*, one for drawing on the stone, of a thicker nature ; and another for transferring drawings to the stone, of a more liquid substance.

The best compositions, of the first species, are the following :

1. White bees-wax by weight 8 parts
 Soap ... 2
 Lampblack 1

N. B. This ink is not used for drawing or writing on the stone, but for covering those places, which the aqua-fortis is not to affect. If it is desirable to have it thick, burnt wax may be added at pleasure. This is obtained by exposing wax to such a degree of heat, as to cause it to take fire, and let it burn till the quantity is reduced to one half.

2. Wax............................... by weight 12 parts.
 Common tallow 4
 Soap 4
 Lampblack 1
3. Wax12
 Shellac 4
 Soap 4
 Lampblack 1
4. Tallow 8
 Shellac 8
 Soap................................. 4
 Lampblack 1

5. Waxby weight 8 parts

 Shellac... 4

 Mastic... 4

 Soap... 4

 Lampblack 1

6. Wax ... 8

 Tallow ... 4

 Shellac ... 4

 Soap ... 4

 Lampblack 1

7. Wax ⎫
 Gum Guaiacum ⎭12*

 Tallow ... 4

 Soap ... 4

 Lampblack 1

8. Wax ... 6

 Shellac ... 4

 Tallow ... 2

 Mastic ... 3

 Venetian Turpentine 1

 Soap ... 4

 Lampblack 1†

* Wax and gum guaiacum are melted together in equal quantities; the part that does not become liquid is then removed, and of the remaining composition, twelve parts, as prescribed, are used.

† There is no material difference between the seven last compositions; those into which shellac enters remain a longer time liquid, but are more difficult to prepare. It

Manner of preparing the Chemical Ink.

All the different ingredients of the composition of the ink, except the soap, of which only one half is taken, are put together in an iron saucepan, and exposed to a strong fire till the whole of the mass ignites. When the quantity is reduced to one half, the saucepan is carefully covered, or put into a pailful of water, to extinguish the flame and cool the substance.

The reason why only one half of the soap is added is, that the alcali, in the violent heat, unites better with the other substances. As in this process it loses its power, and is saturated with carbonic acid, which renders it less fit to dissolve the greasy substances, it is best not to add the other half of the soap till after the burning, and to keep the composition over a coal fire, at such a degree of heat as is sufficient for the dissolution of the soap. This done, a small quantity of the composition may be taken on a clean knife, in order to ascertain whether it dissolves easily in cold water. If the soap is good, the prescribed quantity is always sufficient; but if the alcali

is not necessary to be very strict in the proportion of the different ingredients, except in the soap and lampblack. Soap, in general, must be the fifth, and lampblack the twentieth, part of the whole. Too much soap renders the ink too slimy, and too much lampblack occasions it to run upon the stone.

in it is not strong and pungent enough, a small quantity of soap may be added, till it is seen that the ink easily dissolves in water. The lampblack, which must be of the finest quality, and previously burnt on the fire in a close vessel, till yellow smoke no longer issues from it, must now be added to the composition, stirring it constantly all the while. When all has been well mixed, and worked up till it gradually becomes cool, the composition is then taken out of the saucepan, when any shape may be given to it. Most of it ought to be made into small cylinders or sticks, and in this dry state it is preserved for occasional use.

Here it is necessary to add the following general observations :—

1. Under the denomination of soap, is understood the common soap prepared from tallow and soap lees ; venetian, or oil soap, is not so good for ink, as it renders it more slimy when dissolved in water, and does not resist so well the action of aqua-fortis.

2. For colouring the ink, there may be used, besides lampblack, indigo, blue lake, vermilion, and red ochre, and various other colours, provided they do not alter the nature of the soap, which will be the case if they consist of neutral or other salts. The lampblack, if not previously burnt as above-mentioned, contains a great quantity of pyroligneous acid, which unites

with the alcali, neutralizes it, and thus prevents it from dissolving the greasy substances. It is, therefore, very material to burn or roast the lampblack, before it is used, over a strong fire, by the action of which the acid escapes in the form of a yellow smoke.

Another sort of black is preferable to this burnt or roasted lampblack. It is prepared from animal grease or wax, or from a composition of ox tallow and gum penzoe. For this purpose the tallow is melted and poured into a common lamp with a cotton wick ; then the lamp is lighted and placed under an iron or brass plate, on which the black collects. From time to time black is scraped off with a knife, and preserved in a covered vessel, till the necessary quantity is obtained. This black is very fine and mild, and so strong, that with one ounce of it as much can be done as with three ounces of the common lampblack. The ink prepared with this black, is particularly fine and liquid.

In general it is to be observed, that the greater the quantity of lampblack used in the composition of the ink, and the blacker the ink is, the more it is apt to run on the stone, and to produce thick and coarse lines. The smaller the quantity of lampblack in the ink, the finer the lines are ; but, as it is not so visible, it is more difficult to work with it.

3. For dissolving the ink, distilled water is best ; pure rain-

water; or, if this cannot be had, pure soft river-water, will do in case of need. If the rain-water is old and putrid, the solution is apt to become thick and slimy.

4. The igniting and burning of the ingredients is not absolutely necessary, but it contributes much to render the ink of a superior quality for use.

5. It is only when shellac enters into the composition, that it is necessary to burn the ingredients well, as this substance does not fully dissolve, except in a very considerable heat.

The shellac, which in China and the East Indies is prepared by an insect belonging to the genus of the bee, possesses the quality of melting in a moderate heat, but does not dissolve in any sort of animal grease, as tallow, butter, oil, wax, &c., if not previously freed from the acid which belongs to it ; and this can only be done by a violent fire. If shellac is melted with oil or grease, it remains, at first, at the bottom of the vessel ; if the heat is increased to such a degree as to ignite the ingredients, it begins to swell and to cover the surface in the form of a spongy mass. The heat still increasing, it dissolves at last entirely. As soon as it has entirely dissolved, it is time to take the vessel from the fire, and to cover it well, in order to extinguish the flame.

6. None of the above-mentioned compositions of ink, can be kept long in the liquid state, as in a few days it becomes slimy, and unfit for use. It is, therefore, better to preserve the ink in a dry state, in which it does not experience any change for years ; and to dissolve a small quantity of it as often as required, by rubbing it down in a clean vessel or cup ; if a sufficient quantity is thus obtained, a few drops of water may be added, and, by rubbing it with the finger, it will soon be dissolved. The ink is then fit for immediate use.

7. In dissolving the ink in water, it is material to obtain the necessary degree of liquidity. A good ink must not contain undissolved particles, and ought to be of the thickness of cream or oil ; if it is too thick, it is difficult to work with it ; if too thin, it does not resist the aquafortis. A very few trials are sufficient to teach the student a correct proportion in this. A good artist will do well to prepare, every day, a sufficient portion of ink ; if, during the work, it becomes too thick, as sometimes will happen, the addition of one or two drops of water will remedy this sufficiently.

These are the general observations on the use of the chemical or alcalic ink ; some other particulars shall hereafter be mentioned in the description of the different manners.

Hard Ink of Borax.

———

Besides the sorts of ink already mentioned, it is advisable to prepare a store of the following, the use of which shall be described hereafter in its proper place.

No. 1. Shellac · 4 parts.
Borax · 1
Water · 16

The shellac and borax are put in a clean vessel, two-thirds of which are filled with water ; it is then exposed to the fire, where it must be kept boiling for an hour ; as much of the water as evaporates must, from time to time, be added. If the greater part of the shellac is dissolved, the vessel is taken from the fire, cooled, and the contents of it filtered through a clean piece of linen, to separate the undissolved parts of the shellac from the solution. This can be preserved for years in a well-closed bottle. In order to give it the necessary colour for use, part of it must be boiled in an iron or copper ladle, till it becomes of the consistency of honey ; then lampblack, or any other colour, is added, and the whole well shaken and mixed with water ; the black or coloured ink is then fit for use, and may be kept in a well-corked bottle.

Liquid Ink.

———

Mr. André, of Offenbach, used a sort of ink, which can be preserved for years in a liquid state. According to my experience, it is not so good for very fine drawings, as some of the above described compositions ; but for music and writing it does very well, chiefly on account of its great durability.

Shellac · · · · · · · · · · · · · · · · · · · · · · · · · · · · 12 parts.
Mastic · · · · · · · · · · · · · · · · · · · · · · · · · · · · · · 4
Soap of Ox-Tallow · · · · · · · · · · · · · · · · · · · · · 1
Pure crystallized sub-carbonate of Soda · · · · · · · 1
Lampblack · 1

These ingredients are mixed with water, exposed to fire, and boiled till all is well dissolved and united, which is greatly facilitated by frequent stirring. The boiling is continued till the whole of the water is evaporated, then fresh water is added and boiled a second time, till all is dissolved again ; the liquid is then filtered through linen, and preserved in a well-corked bottle. If the ink is too thick to admit of the filtering, it can easily be made thinner by adding a sufficient quantity of water to it. The same thing can be done, if, during the use, it thickens too much.

Ink for transferring Drawings or Writings from Paper on the Stone.

All the different compositions of ink hitherto mentioned, are for immediate use on the stone. But, if the drawing or writing is to be made on paper, and from thence transferred to the stone, they will generally be found too hard, unless heated stones be used ; but as this is rather difficult, it will be more advisable to use the following composition :—

Shellac ························· 3 parts.
Wax ····························· 1
Tallow ·························· 6
Mastic ·························· 5
Soap ···························· 4
Lampblack ······················ 1

The manner of preparing this ink is the same as that of hose already described, and it can be preserved in its dry state for years. In order to ascertain if it is fit for use, the best method is, to dissolve a small quantity of it in water ; if it retains a certain viscousness, it is good. If, by passing the stone under the press, with a moderate pressure, it does not come off uniformly, and in all places, it is a sign that it is too

hard, and this may be remedied by adding a small quantity of butter or vegetable oil ; but this cannot be done, without melting the whole over a moderate fire. If, on the other hand, the lines in the transfer expand and become broader, it is a sign that the ink is too soft. The temperature of the room, or even of the atmosphere, has a great influence in this respect, and it is necessary to use a harder or softer ink accordingly.

Hard Etching Ground.

Besides the Chemical Ink in the different manners of Lithography, another substance is sometimes used for covering the stones, which resists the action of aqua-fortis, and is known under the name of Etching Ground, as it differs very little from that which engravers use for their copper-plates. It consists of the following :—

Wax ································12 parts.
Mastic ··································· 6
Asphaltum ····························· 4
Colophony······························ 2
Tallow ······························· 1

All these ingredients are melted together on the fire in an iron saucepan, and exposed to the heat till the asphaltum be entirely dissolved. After this, the mass is left burning, till it

is reduced to about two-thirds ; then, by covering the pan with a cover fitting it exactly, the flame is extinguished. If the whole is cooled, it is taken out, formed into different shapes, and preserved for use.

A good etching ground can be obtained from mere wax, if it is left boiling and burning till nearly five parts of it are consumed.

Soft Etching Ground.

In some manners of Lithography, it is requisite to have another sort of etching ground, which possesses the quality of not entirely covering the surface of the stone, so as to allow the aqua-fortis to act uniformly on many points of it, and to affect the stone ; or which, if it even resists the aqua-fortis, by a slight touch can be so far removed, as to admit the aqua-fortis to the stone in a greater or lesser degree, and produce a tint in imitation of aquatinta. This description of etching ground is prepared in the following manner :—

No. 1. Thick varnish of Linseed-Oil 1 part.
 Tallow . 2 parts.
 Both ingredients well melted together.

No. 2. Wax 1 part.

Tallow 5

Varnish of Linseed-Oil.................... 3

Likewise well melted together.

The use of this composition will be hereafter described, in treating of aquatinta, *&c.* It is good to prepare a small store of both compositions.

Etching Colour.

Under this denomination I mean a sort of printing colour, which possesses the quality of resisting the aqua-fortis, if the stone is impregnated with it. In many cases it is of great use, and even indispensable ; it is, therefore, good to have it likewise in store. It is composed of

Thick Varnish of Linseed-Oil.............. 2 parts.

Tallow 4

Venetian Turpentine..................... 1

Wax 1

All well melted together, then four parts of lampblack added to it, and preserved in a well-closed tin box.

Lithographic Chalk.

Chemical, or greasy Chalk, is a composition which, in its dry state, can be applied to the stone like Spanish or French chalk, and different sorts of drawings may be made with it. The chemical ink above described, if dissolved in water, enters the surface of the stone, and impregnates the spots where it enters with grease. The chalk has the same effect on the stone, only the degree in which it penetrates and sticks to the surface, is not the same as in the case of the ink.

The compositions by which different sorts of harder or softer chalk can be produced, are innumerable; but as almost all bituminous substances give less perfect compositions, and wax and soap form the principal ingredients in it, it may not be superfluous to communicate the following recipes:—

No. 1. Wax 4 parts.
 Soap 6
 Lampblack 2

The wax and the soap are melted together, then the lampblack is added; the whole is well rubbed down on a hot iron plate, then put into a saucepan and exposed to the fire, till it returns once more to a liquid state. It is then poured out on a stone

plate, well impregnated with oil, so as to form a cake of the thickness of the eighth part of an inch. The mass, if cooled, is cut into small slices, and fit for use.

No. 2. Wax 8 parts.
Soap 4
Lampblack 2

The wax is first burned till reduced to about one half, then the soap is melted with it, and the same process takes place as in the case of No. 1.

No. 3. Wax 4 parts.
Spermaceti............................. 4
Soap 4
Lampblack 2

The first three ingredients are melted together, then the lampblack is added, and the whole treated as above.

No. 4. Wax 8 parts.
Spermaceti............................. 4
Soap 4
Lampblack 2

The wax is reduced by burning to one half, then the spermaceti and soap are melted with it, and treated in other respects as above.

No. 5. Shellac · 4 parts.

 Wax · 8

 Soap · 5

 Lampblack · 3

The Shellac is first dissolved in the wax by exposing the substances to a moderate heat ; the rest as above.

No. 6. Shellac · 4 parts.

 Wax · 8

 Tallow · 2

 Soap · 5

 Lampblack · 3

The same manner of preparation as above ; after the Shellac is dissolved the tallow is added. This chalk is somewhat softer than the former ; the two following sorts are of the same description.

No. 7. Wax. · 8 parts

 Tallow · 4

 Soap · 6

 Lampblack · 3

The wax, tallow and soap are melted together, so as to ignite till a third part of it is consumed ; then the lampblack is added.

No. 8. Wax.. 2 parts

Tallow .. 6

Minium or red lead 2

Lampblack 2

The wax, tallow and the minium are heated over the fire, under continual stirring ; till the minium be dissolved in scum, and changes its red colour to a brown one ; then the lampblack is added and well rubbed down, the whole is then heated again, poured out and cut into sticks.

These compositions I have ascertained by a great number of experiments, to be the best for a good chalk, and it is advisable to prepare a store of all or at least of most of them. The before-mentioned different sorts of chemical ink differ immaterially, and therefore may be used promiscuously ; but every one of the specified sorts of chalk gives, when used, another kind of what is called grain, and the judicious application of these to different sorts of drawings, greatly contributes to their ex-cellence and good appearance. The greater or less degree of roughness of the stone prepared for chalk-drawing renders it necessary sometimes to make another choice of chalk, and all the deep shades can more easily be produced by soft chalk than by hard ; for outlines and very light shades, on the contrary, the latter sorts are preferable.

The lampblack, used for chalk, must previously be burned

or roasted, otherwise it causes hollows in the cake ; the same will happen, if the mass is poured out too hot on the stone, in that case the melting it over again is indispensably necessary.

Chalk, containing a considerable quantity of shellac, if exposed to damp air, is apt to become very soft ; it is therefore better to preserve it in well-closed boxes or bottles.

The Printing Ink.

The manner of preparing Printers' ink in large quantities is so very difficult and dangerous, that it is not advisable for any one, who has not made it his particular study, and already acquired some experience respecting its preparation. If the experiments and lithographic printing are not carried on upon so extensive a scale, as to require one or two hundred weight of oil varnish in the year, it is better to purchase small quantities ready made.

The manner of preparing oil varnish, by boiling and burning the oil, is a process too well and too generally known to mechanics to require a detailed description here. It will, therefore, be found sufficient to mention only those qualities of a good varnish, that are requisite for the different purposes of Lithography.

Three sorts of oil varnish are generally used for lithographic

printing, which might be denominated the thick, the middling, and the thin varnish ; of every one of which there ought to be a store in a good establishment.

The thin varnish is produced by reducing the oil, by means of boiling and burning, to about two-thirds of its original quantity ; it is of the thickness of common honey, but does not draw stringy.

In the middling sort of varnish, the oil is reduced to one half ; it is of the thickness of very old honey, and admits of drawing stringy to the length of one foot and more.

In the thick varnish the quantity of the oil is little more re- duced than in the former ; but it draws stringy to the length of three feet, and possesses the greatest degree of viscosity.

The oil varnish is the principal ingredient in the printing ink ; if well prepared, is dries very easily of itself, without any other ingredient to promote the drying being boiled with it ; on the contrary, this ought to be avoided, as the colour prepared with a varnish of this description, is very apt to stick on the prepared parts of the stone, and thereby soil the stone, and spoil the impressions.

In order to prepare the printing ink, it is necessary to add a sufficient quantity of lampblack to the varnish, for which

purpose the fine burned lampblack is likewise preferable to the common.

The greater the quantity of lampblack mixed with the varnish, and the more closely both ingredients are united, by grinding them with a muller on a stone had for that purpose, the better the colour will be for the use of Lithography, care must, however, be taken not to add too much lampblack ; so as to make a dry paste of the varnish, as it will then be very difficult to bring it on the roller. Some experience and trials are necessary to teach the right proportion, which depends very much on the thickness of the varnish, and cannot be well described.

In treating of the different lithographic manners, the respective requisites and composition of the printing ink, best appropriated to each of them, will be more particularly described, and the ingredients specified that must be added, in order to render the colour more black, or promote its drying. In general it may be observed here, that the places covered with ink or chalk on the stone, take the ink easier if it is thin and liquid ; but, on the contrary, if the ink has too great a quantity of lampblack, and is very thick, the danger of soiling the surface of the stone in those places that are prepared to reject the ink, is not so great ; but on the other hand, fine lines and points are very liable either not to take it, or to disappear entirely. The impressions with it are, when the designs take

colour, generally very clear; but the charging of the roller is rather difficult, and the press requires a greater force.

Besides lampblack, all other sorts of different colours may be mixed with oil-varnish, as will be more fully described in treating of coloured impressions. Even in making a black colour, sometimes ivory black is used instead of lampblack; or, in the engraved and aqua-tinta manner, Frankfort black.

Repairing Colour.

It not very unfrequently happens, that lines too faintly drawn do not resist the aqua-fortis, and are entirely obliterated; or that, by the unskilful management of the printer, fine lines are rubbed away. In both cases faint traces of remaining grease may still be discovered, but they are too faint to take colour. In order to repair these defects, the following very simple method may be used, that is, to charge the stone repeatedly with the colour hereafter described.

The repairing-colour is composed of very thin oil-varnish, in which a quantity of litharge, or minium, or white lead, is dissolved by boiling, and to which a sufficient quantity of lampblack is added. It may often be expedient to add to the lampblack a small quantity of well-pounded sand, or pumice-stone.

The varnish requisite for this colour may be thus prepared. Take a quantity of the thinnest varnish, expose it to the fire till it ignites ; add then a quantity of well-pounded minium, (for instance, one ounce to sixteen ounces of varnish,) or any other oxide of lead, and stir it till it is well mixed together.

Another sort of repairing-colour can be prepared by mixing the common printing colour with vegetable oil, tallow, and a very little soap. Both of these colours are very apt to adhere to any places which have an inconsiderable degree of grease in them, and renders them fit again to take the printing colour. The precautions, which it is necessary to observe to prevent the soiling of the whole surface, will be explained in another place.

CHAPTER III.

Of ACIDS, *and other* COMPOSITIONS, *to* PREPARE *the* STONES.

Qualities of Acids in general.

THE expression " *To prepare the Stone,*" may properly designate every sort of preparation for the different manners of drawing or printing ; but, in Lithography, it has always been understood to designate, by preference, that process by which the stone receives the quality of repelling the colour on certain distinct places.

Most people who have occupied themselves with Lithography still maintain the opinion, which, for a long time, was my own, that the etching with aqua-fortis, or any other acid, prepares the stone, and that the subsequent application of gum only adds to it. But numerous experiments have now convinced me of the contrary. The gum-arabic, and some other similar substances, are the principal means of preparing the stone ; and, by the acid, the stone is only rendered more disposed to admit it. The sulphuric acid, which changes the surface of the stone into gypsum, is the only acid that prepares the stones without gum ; but its application is limited to very few manners.

The stones used for Lithography consist, for the most part, of calcareous matter, perfectly saturated with carbonic acid. Now most of the acids, and even some of the neutral salts, have a nearer chemical affinity to the lime, than the carbonic acid united to it ; as soon, therefore, as another acid comes into contact with the stone, the carbonic acid is liberated, and escapes in the form of air, while the lime of the stone unites with the other acid. If aqua-fortis, vinegar, &c., is poured over the stone, a number of bubbles immediately rise, (which is nothing else than the carbonic acid,) and the liquid appears as if boiling, more or less, according to the degree of its concentration. This boiling lasts till the acid is entirely saturated by lime.

Another effect of this operation is, the dissolution and removal of a part of the surface of the stone ; but if some spots of it were previously impregnated with grease, which resists the action of the acid, these, of course, remain untouched, and in their old state ; so that if the stone, after the act of etching, is wiped, these spots are imperceptibly prominent, while the whole surface of the stone appears more or less sunk, according to the quantity and strength of the acid applied.

If the stone is covered with grease, but not so closely as to counteract entirely the action of the acid, this latter gradually penetrates and etches the grease away, particularly if it remains a long time upon it, and possesses sufficient strength. On this circumstance, that a thin cover of grease may be

removed partially or wholly, as may be necessary, by the action of acid, is founded the manner of preparing stones for pen and ink drawings, or some manners of aqua-tinta, by washing them with oil or soap-water.

Another and very important effect of the acid on the stone is, that besides etching away the surface of the stone, it gives a fine polish to it, which renders it so smooth as to be a safeguard against the sticking of the colour on these prepared places. If, therefore, a stone upon which a drawing is made, has been etched by an acid, it may, as long as it remains wet, and the colour is not too forcibly put on, be several times charged and printed. However, this apparently fine polish is, by no means, sufficient to allow the printing for any length of time, with security. The polish is only then perfect when the stone, after the etching, has been washed with a solution of gum-arabic. If a stone that has only been etched, but not washed with gum, becomes dry, or if it is only negligently touched with the linen rags impregnated with colour, and other greasy matter, it is apt to soil and take colour. As a proof how little etching with acid prevents the subsequent adhesion of grease, I shall mention, in another section, several cases where the stone is first etched, and then drawn upon with dry as well as liquid ink.

The principal effects, which acids in general manifest on the stone, may be comprised under the following heads :—

1. They do not affect those places that are properly covered with grease.

2. They penetrate more or less, if the grease is very thinly put on.

3. In those places where they touch the stone, they dissolve parts of it, and remove them.

4. They give a brilliant polish to the stone, which facilitates the printing, but is not of long continuance, and disappears by the frequent wiping of the stone.

5. They do not prevent the subsequent adhesion of greasy substances, as soon as the stone etched by them is become dry again ; so that a place which previously has been entirely prepared by acid and solution of gum, may, by a repeated etching, be rendered fit to receive colour. In the subsequent pages, various applications of this method will be noticed.

6. Lastly, Acids have the property of creating a rough surface in prepared and frequently-printed stones, (especially if their original polish produced by the etching has given way to that produced by frequent ablutions ;) the reason of this is, that some spots are more, and some less, affected, by which small pores are produced, and the printing ink is very apt to adhere to them. This circumstance, as will be more fully

stated in another place, renders particular caution necessary, when prepared stones, of which impressions have already been taken, are to be cleared from accidental spots of grease, or other defects ; as, by unskilful management, these defects may be increased, and the drawing totally spoiled.

The different Acids.

Aqua-fortis, or nitric acid, muriatic acid, vinegar, tartarous acid, malic and oxalic acid, have all nearly the same effects ; aqua-fortis and muriatic acid are generally preferred, on account of their cheapness.

Sulphuric acid, or oil of vitriol, in a very weak solution in water, is of great use, if a strong etching acid is not required ; where this is the case, it cannot be used, as this acid in dissolving the surface of the stone, changes it into gypsum, which covers the stone, and prevents the acid from acting any more on it. If, for instance, a solution of one part of sulphuric acid and twelve parts of water, is poured on a clean polished stone, it produces a violent effervescence, which, however, lasts but a few moments ; as soon as its action subsides, one might be inclined to suppose that the acid was perfectly saturated with chalk ; this, however, is not the case, for if the same acid is put on a fresh stone, it has just the same effect upon it as on the first.

If the acid is wiped off the stone, and its surface, when dry, is well rubbed with a flannel, it takes a most perfect polish, and it may be cleaned from the colour with as much ease as copper-plates. This polish, however, does not remain long, as the crust of gypsum, which is very thin, is soon worn off. In the engraved manner, however, where, during the engraving, proofs must sometimes be struck off, this process may be most advantageously resorted to.

All the acids already mentioned possess the quality, if applied to a stone already prepared and used for printing, of producing a rough surface upon it. It appears that the gum arabic unites in some places more, in others less, intimately with the surface of the stone; and, in proportion as it does this, the acid, if a second time applied to the prepared stone, has in some places a greater, in others a less, perceptible effect upon it. The bubbles, which on the application of the acid make their appearance, may likewise contribute to this roughness, as they prevent its equal and uniform action. This phenomenon is still in a greater degree apparent in the citric acid, or in a solution of alum in water. Apply a few drops of lemon-juice, or dissolved allum, to a stone prepared with aqua-fortis and gum; let it get dry, and then cover the stone, or the part of the stone, where the acid has dried, with grease or colour; then wipe off the colour with a wet rag, and it will be seen that the stone becomes perfectly clean and white, except on the spot where the alum or lemon-juice has been applied. This spot will be found to have taken

the grease, as if it had been covered with chemical ink. The same effect, only in a less degree, is produced by all other acids.

The following observation may here be in its proper place :— It often happens that, through negligence, bad colour, or unclean linen rags, the stone is soiled, or takes colour in places where it ought not to do so, especially near the margins, as these dry most quickly, and are more exposed to the touch of greasy hands, or other accidents. Spots soiled in this manner, are generally cleaned by rubbing them with gum-water, and a clean flannel ; sometimes, however, especially if the ink is soft, this process does not succeed, and then there is no other remedy than to prepare the stone afresh ; in which process, however, great care must be taken, to avoid the rough surface just mentioned, as this would only increase the evil. It is therefore greatly preferable, in this case, to rub down the margin of the stone with pumice-stone, till the spots are gone, and to apply the acid and gum only to the spot so rubbed down.

Another way of removing such spots of grease is, to immerse a piece of clean flannel in pure aqua-fortis, and to rub them over with it, which makes them instantly disappear ; care, however, must be taken not to let a drop of the aqua-fortis fall on the drawing, as this would be infallibly spoiled by it.

Another precaution, which, in all the processes of removing

greasy spots from the stone, ought not to be neglected, is, to prepare them with gum after the acid has been used ; and as long as this is not done, the greasy spots which have apparently been removed, will soon re-appear, and take colour as before.

The gum may be mixed with the aqua-fortis, but then it cannot be kept longer than a day, as it soon loses on the stone its preparing quality.

The following rules ought particularly to be attended to :—

1*st*. If a stone prepared with acid, but not with gum, has been for a considerable time in use by the printer, the ink penetrates more or less, according to its quantity and degree of liquidity, into the stone ; which, however, preserves its surface, as it has been prepared, though it becomes more apt to soil. In this case, therefore, it is necessary to give the stone a slight preparation of gum, which entirely prevents the grease from again adhering to it.

2*dly*. As the gum acts only on the uppermost surface of the stone, and by frequent wiping off is gradually diminished, it is of consequence, in order to preserve the surface, to renew from time to time the preparation with gum. Twice a day is quite sufficient: this, in fact, must be done when the printer leaves off work to go to his meals, as the stone ought never to get dry, without having a coat of gum on it.

3dly. For the same reason, and on account of the great delicacy of the surface, a prepared stone ought never to be violently rubbed with any greasy matter, as this injures the surface, and renders it liable to imbibe the colour.

4thly. If a stone, through long and frequent use and printing, is deprived of its gum preparation, it is, as before-mentioned, very apt to soil. It is therefore advisable, as often as the printing of a stone is discontinued, to give it a fresh dressing with gum, before it is laid by. If this has not been done, and the plate is to be printed again, it must be carefully washed with pure water, or with a very weak solution of aqua-fortis, (one part of aqua-fortis to 500 parts of pure water,) and then prepared afresh with gum. The omitting of this precaution, has often entirely ruined the stone.

5thly. The gum can prepare only a stone that is perfectly clean, and to which aqua-fortis has previously been applied. If, therefore, the surface of the stone has any trace of grease, it is not affected by the gum, and, in spite of every preparation with it, will take colour.

6thly. If the grease on the surface has been removed by acid—in the using of which the greatest possible care is required, as the strength necessary to remove the greasy spots will, if permitted to come in contact with the drawing, remove that likewise—the gum can act, and the stone becomes perfectly prepared.

7thly. The rubbing down of the stone, is not sufficient to render the stone susceptible of being prepared by gum alone; for, even after the rubbing down, it may still contain some spots where the grease has penetrated, and which are liable to soil, in spite of the gum; this, however, can be partly prevented, if the solution of gum is made very thick, and mixed with a small portion of aqua-fortis.

8thly. From these observations, the following conclusions may be drawn :—

By the repeated printing from a stone, it happens that the colour penetrates, to a considerable depth, into the interior of the stone. If the same stone is to be used for another drawing, it ought to be rubbed down till all the traces of the grease have disappeared; this, however, takes too much time, and would render the stone considerably thinner. It is only, therefore, generally rubbed down till it becomes perfectly smooth and level. In this case, it is necessary to prepare it well with strong acid, otherwise (if, during the subsequent process of printing, it loses the preparation,) the whole of the former drawing might re-appear on the surface. And against this there is no remedy.

If the stone is soiled in the middle of the surface, the best manner of cleaning it is to wash it with a few drops of oil of turpentine, and the same quantity of gum-water, and to wipe

it well with a clean flannel. If in this manner the spot is not removed, the stone must be prepared afresh. As this preparation, however, is different according to the different manners, it will be described when treating of them.

If a greasy substance has penetrated deep into the surface, where it ought not, it will always be very difficult to remove it without injuring the whole. Drawings in the chalk manner are particularly difficult to correct, after the stone has been prepared and printed. The lines that are to be altered, it is true, may be scraped off by a sharp instrument; but then the difficulty is, how to re-prepare these spots thus deprived of their prepared surface: if the acid used for this purpose is weak, it is not sufficient; if strong, the delicate parts of the drawing may be injured by it.

In order to remedy this inconvenience I tried repeated experiments, to discover an acid composition with the quality of not producing a rough surface when applied to a stone already previously prepared. This I believe myself to have discovered in the phosphoric acid, especially if mixed with well pounded gall-nuts.

The water, in which phosphorus has been preserved for a considerable time, becomes acid and affects the stone very strongly. But phosphoric acid is better obtained by burning phosphorus and collecting the smoke. This process, however, is somewhat expensive.

A few drops of any sort of acid, if poured on a clean well polished stone, affect the whole surface of it; if this is well wiped off, the stone washed with soap-water, or chemical ink, and, when dry, cleaned again from these greasy substances by some drops of oil of turpentine,—then the stone, if washed with water and passed over with a roller charged with colour, will take this colour in all points of its surface, even in those affected by the acid. If gum be mixed with the acid, the result still remains the same. The conclusion to be drawn from this phenomenon is, that soap-water (as well as all alcalis) annihilate the effect which the acid and gum produce on the stone, and again render it susceptible of taking all sorts of greasy substances on its surface. If phosphoric acid has been used, the washing with soap-water must be repeatedly applied. If gallic acid be mixed with the phosphoric acid, it resists still more powerfully the action of the soap-water. In general, gallic acid, mixed with any other acid, resists more strongly the soap-water. This observation led me to the discovery of some particular manners of lithographic printing, which are to be described in another place.

Gum Arabic, as the principal Ingredient for preparing the Stone.

A few drops of gum arabic, dissolved in water, if applied to a well polished stone, produce the effect, that the spot thus wetted will not take colour, as long as it remains wet. As soon

as it becomes dry, the colour adheres to it, but is easily wiped off with a sponge and water. From this it appears, that gum alone prepares the stone, or in other words, imparts to it the quality of rejecting the colour or printing ink. If, however, the acid has been previously applied to the stone, this quality gains in durability.

In both cases the uppermost surface of the stone only is affected, and the least accident may annihilate the effect it has had upon it. On this principle rests the engraved manner of lithographic printing. If therefore a well-polished stone is suffused with a solution of aqua-fortis, then prepared with gum and well dried, it may in this state be covered with printing ink or any other fat body (soap and alcalic compositions except-ed,) without the risk of injuring its prepared surface. The more it has been washed with gum, the greater is the security against the penetrating of the fat substances.

During the printing, where the stone is always kept wet, the washing with gum is not absolutely necessary ; but as the surface through repeated wiping and cleaning soon loses its preparation, it is advisable, under certain circumstances, to mix the ink, or even the water used for wetting the stone, with gum ; this shall be more clearly explained hereafter.

Some other substances, as for instance, the gum from cherry and plum trees, the sap of some other plants, sugar and all

slimy substances, as the white of an egg, for instance, have a similar effect to that of gum arabic on the stone; the gum arabic, however, is always preferable, as its effect is far more certain and powerful.

The partial preparation of the Stone.

Under this head I intend to communicate the result of my experience on the subject of a very important phenomenon in Lithography, which frequently occurs and embarrasses beginners in the art—I mean the imperfect or partial preparation of the stone; that is, where the stone shows a great inclination to receive the ink, but in fact receives it only in parts. A few illustrations will, I presume, make this more intelligible.

a. If a drawing has been made with chemical ink on a well polished stone, and is afterwards bit in with acid and gum as usual, charged with printing ink, and impressions taken from it; if, when the ink is applied to the stone, the places to which it adheres are rubbed with a wet finger and with a certain degree of pressure, the colour may be rubbed off; but the places thus rubbed off, do not by the subsequent application of the roller and ink, easily take colour again, and the difficulty is in the ratio of the degree of pressure which has been used in the rubbing, and the tenacity of the printer's ink. The drawing on the stone will seem to have suffered no alteration, and appear as black as in its original state, if cleaned and washed with water,

but as soon as the roller is passed over it, the rubbed places reject the ink; in some instances this defect may be removed by the applicaion of the proper means, but in others they prove entirely ineffectual.

The surface of the stone by this sort of rubbing is entirely cleaned from grease, and takes a kind of polish, which, though the chemical ink has penetrated into the interior of the stone, prevents the printing ink from adhering to these spots. This polish, however, is not of long standing, and, as will be here-after explained, may be entirely removed.

b. The same thing may happen when the drawing is made too delicate and bit in by too strong an acid, which in some degree injures the lines; in this case it also prevents the ink from adhering to the drawing if applied by the roller.

c. Another kind of imperfect or partial preparation is, when the stone in some places or on its whole surface shows an incli-nation to take the ink, or to soil; if this takes place on the whole of the surface, it is known by the expression,—The stone has taken a tint.

This phenomenon may arise from very different causes; either from a greasy substance in the stone having been brought to its surface, or from the preparation of the surface having been partly injured or altogether effaced.

This leads us to the following observations :—

1*st*. By merely rubbing the stone with pure water, a sort of preparation can be given to it, when a suitable substance is employed in the rubbing. The preparation is indeed very imperfect, but it can easily be made perfect by means which shall be explained hereafter ; and the degree of imperfection depends on the hold which the substance employed in rubbing takes of the stone. Linen and cotton act less powerfully ; wool and hair, or silk, or wet leather, produce a stronger effect. Even the printer's ink, when it consists of very firm varnish, or has a good deal of lampblack in it, can with water give, by means of strong friction, a preparation and polish to the stone. The effect is still increased when Frankfort black or pulverised charcoal is mixed with the ink, and the stone is kept extremely wet.

2*dly*. The imperfect preparation is produced more effectually and quickly if gum or similar substances are mixed with the water.

3*dly*. Such preparation is still more effectual, if a weak acid is added. A strong acid would render the preparation perfect, but at the same time injure other places, or create a rough surface on the stone.

4*thly*. By rubbing the stone with sand or pumice-stone, a partial preparation may likewise be produced, which by the application of gum may be changed into a perfect one. The

circumstance is deserving of particular attention, that a stone injured by rubbing, may be restored to its former state (that is, rendered fit to receive the ink) by a gentle rubbing down with pure water. If, for instance, a stone, drawn and prepared in the elevated manner, has by improper management been reduced to a state in which it does not take the ink in all places covered by the drawing, it is only necessary to rub it gently down with water and fine sand, or to wash it with oil of turpentine, till all the printing ink is removed from the surface, and afterwards to put it in a vessel with pure water. Then let it be gently rubbed down with clean pumice-stone, so that the traces of the grease, that have penetrated into the interior of the stone, are not injured, and in the following manner it may be restored to a perfect preparation, so as to give impressions as clear as the first taken from it. Take a small quantity of the etching colour, before described, on a clean rag of linen or cotton ; pass it gently several times over the stone in the water, and it will be seen that all the places covered by the drawing take the printing ink again, even if the elevation of the drawing produced by the acid be entirely lost by the rubbing down. The stone may afterwards be prepared afresh with a weak acid and gum, and will be altogether fit for printing.

Great care ought to be taken in this process, *first*, to have the pumice-stone entirely free from greasy substances, as these in the act of rubbing would adhere also to those spots that are to remain white ; *secondly*, not to employ any degree of pressure in passing the etching colour over the stone, for being almost

entirely without preparation or gum, it would in this state be liable to soil; and, *lastly*, not to let the stone become dry before it is perfectly prepared by acid and gum.

The result of this process led me to an experiment, by which I ascertained, in the most satisfactory manner, that a gentle degree of rubbing the stone with printing ink, if mixed with a little tallow, produces the effect of changing the partial or imperfect preparation of the stone to a perfect one, and of restoring all injured parts of the drawing to their former clearness; while, on the other hand, a stronger degree of rubbing with leather, wool or strong ink, renders the stone, thus immersed in water, incapable of receiving the printing ink. The first method may be advantageously applied to restore an injured drawing, the latter to remove all sorts of soil or dirty spots. If the soil is on such places as were before perfectly clean and duly prepared, it will be entirely removed; but if the grease, that has penetrated into the stone, has only lost its superficial preparation, the effect is only partial, and the stone must subsequently be washed with a weak acid and gum. The importance of this observation is evident, as by the application of the same process, perfectly contrary effects may be produced; and I venture to say, that no one can boast of being perfectly initiated in the art of printing from stones, who has not a perfect and clear knowledge of this manipulation, which cannot be obtained without a great deal of attention and practice.

5thly. It has already been observed, that a repeated ap-

plication of alum, or citric acid annihilates the prepared state of the surface. The same is effected by soap and alcalic compositions, as likewise by the chemical ink, if it contains a sufficient portion of alcali.

6thly. The laying-by of the stone, and leaving it untouched for some time, produces very material and often opposite effects. When a stone is reduced to the state, that some injured spots of the drawings do not print any longer, if water is poured on it, it does not remain on them but runs off; which is the best criterion for determining that they still contain greasy substances, though not strong enough to attract and retain the printing colour. If in this state the stone is put by and not printed for a few days, it will, if afterwards charged with colour by means of the roller, take the colour as well as in its perfect state. On the contrary, if the places that are to remain white on the stone, have been soiled, this defect, as above observed, may be easily removed by oil of turpentine and gum water, though it usually soon re-appears; but if after being thus cleaned, the stone can be spared for a few days, and is washed with gum and left untouched during that time, it entirely loses its tendency to soil.

The cause of these phenomena is, in the first case, that the grease which has penetrated deeper into the stone, gradually collects again on the surface, by which its quality to imbibe and print the ink is restored; and, in the second case, that the

comparatively small quantity of grease, that constitutes the stain, gradually expands and penetrates into the stone so much, that it loses its soiling effect. The truth of this last assertion is rendered still more evident by the fact, that linseed oil and the varnish prepared from it, when exposed to and dryed by the air, loses its greasy quality and rejects the ink altogether. This experiment led to the discovery of an artificial substitute for the stone, or stone-paper, which at the end of this work, will be fully described.

7thly. The preparation, by rubbing down the stone in its wet state, is directly opposite to that effected by rubbing it with dry and greasy substances, by which imperfectly or partially pre-pared stones are rendered capable of receiving the ink, but which in perfectly prepared stones produces only a partial or imper-fect preparation. As every quality of the stone may be made in-strumental to the production of good impressions, or by improper management may prove the cause of miscarriage ; so in this case, by the judicious application of the dry rubbing, injured spots may be restored, or by the injudicious application of the same process the clean places may be soiled. Of both I shall treat more in detail in another place.

Short Recapitulation of the foregoing.

———

The art of preparing the stone, being one of the most important

points in Lithography, it will not be superfluous, I presume to collect the whole of what has been said respecting it into one view, by which the nature and cause of all the phenomena may be better elucidated :—

1. The calcareous slate consists in its texture of numberless pores, equally capable of imbibing greasy as well as watery substances.

2. These substances have the quality of adhering to the particles, that constitute the stone, but can be easily separated from them, so long as the nature of the stone is not altered. This alteration is effected by sulphuric, tartareous, and phosphoric acid.

3. Water evaporates gradually from the pores, when the stone dries ; but gum and other slimy substances do not evaporate.

4. Greasy substances gradually penetrate into the interior of the stone, and can by no means be separated from it, except by removing the surface of the stone as far as the grease has penetrated ; this may be done by rubbing it down or by the application of acid.

5. Printing ink cannot adhere to the stone, so long as it contains a sufficient quantity of water. In general, it adheres

only faintly to the calcareous surface, and does not get a stronger affinity to it, till its pores are filled with a greasy sub-stance, to which the ink by its natural resemblance tends to unite.

6. This affinity or adhesion of the printing ink only takes place, when the external greasy colour (which is put on by the roller) can touch and unite with the grease in the stone. If this communication be interrupted (which is the case, when the ink has penetrated too deep into the stone and has left the sur-face) the stone does not take colour unless this communication be re-established.

7. The interruption of this communication takes place when the ink, by force or by wet rubbing, is removed from the surface, or when a substance that closes the pores comes in contact with the stone.

8. The more the pores are rough, sharp, or angular, the easier the colour adheres, at first only mechanically to the surface of the stone; but gradually when all the moisture in the stone has evaporated, it enters deeper into the interior of the stone, and unites with it and fills the pores. To coarse-grained stones a greater quantity of colour adheres, whence it sometimes happens that, in some lithographic manners, a too highly-polished stone, though it appears perfectly black when charged with colour, does not give strong im-

pressions ; but stones, of a softer grain, generally give strong and black impressions, especially if the ink is not too thick.

9. The effect of the acid on the stone is to give to the surface a higher polish, and to contract and fill the pores. This renders the stone incapable of receiving and retaining the ink.

10. A well-polished stone, prepared with ink and gum, can, by a repeated application of these ingredients, be rendered rough on its surface, and incapable of receiving ink. The prepared surface is thus destroyed, and the communication between the grease in the interior of the stone, and the ink applied by the roller, is re-established ; this, however, entirely depends on the degree of the application of this process.

These are the most essential general observations I have to communicate. When treating of the different manners of Lithography, the particular application of these general rules will be more fully explained.

CHAPTER IV.

Of the NECESSARY INSTRUMENTS *and* UTENSILS.

IN Lithography a great number of different instruments and utensils are requisite, and occasionally wanted. I will, however, confine myself here to a description of those which are exclusively made for lithographic purposes.

The Steel Pen.

This is one of the most necessary and important instruments in Lithography, and simple as the manner of manufacturing it is, it still requires a great deal of attention and skill ; for on the good quality of the pen the clearness of all writing and drawing on the stone greatly depends; and without a good pen, the skill of the best artist may be entirely thrown away. It is, therefore, important to the artist to be able to prepare his own pen, and to repair it. For coarse writing, the common steel pen which is used for ruling may be sufficient, but in finer work it is not so.

The manner of preparing them is as follows :—Take a common watch-spring, not too small and not too large, (an eighth or a sixth part of an inch is the best size,) clean it from grease by rubbing it with sand or chalk, then put it into a clean cup, filled with a solution of equal parts of water and of aqua-fortis, and let the spring be wholly covered with the solution. The aqua-fortis will affect the spring; then let it remain in it till about three-fourths of its thickness is consumed, and it becomes as pliable as a slip of paper. During this process the watch-spring must, from time to time, be taken out and well wiped, as this renders the effect of the aqua-fortis more uniform. If the steel is not throughout of the same quality, it is unequally affected by the acid, and becomes corroded in some places, before the necessary degree of thinness is obtained. The cause of this, however, I sometimes discovered to be in the aqua-fortis. If some elevated spots, or little holes, can be discovered on the pen, it is a sign that it is not well prepared. Sulphuric or muriatic acid may be used instead of aqua-fortis.

A person, who writes a light hand, may have his pens as thin as they possibly can be made ; but for a heavier hand, they must be stronger, otherwise the writing will appear uncertain and trembling.

If the spring has attained the necessary degree of thinness, it must be taken out of the cup, well wiped off, and cleaned with sand ; then cut, with a good pair of scissors, into pieces

two inches long. They must then be bent or hollowed into a semi-circular form ; this is best effected by putting them on a flat stone, and hammering them with a small hammer, such as watch-makers use, the points of which must be rounded ; if a few sheets of paper are put under it, the operation will be greatly facilitated. Another manner of proceeding is, to cut a semi-circular furrow in a stone, to put the piece of steel spring into it, and to rub it well with a steel instrument with a round point, till the spring at last takes the same semi-circular form. The degree of bending differs according to the different hands ; if the curvature is very inconsiderable, the pen has more re-semblance to a brush, and scarcely opens, even if pressed down with force ; but the more it approaches the semi-circular form, the wider it opens if pressed. Experience and practice are here, as in every thing else, the best guides.

After this the pen must be cut ; to effect which let a fine slit, of the length of one-twelfth of an inch, be made in the midst of the watch-spring by means of a fine pair of steel scissors ; then, on both sides of it, let as much be taken off gradually as is necessary to give to the point of the pen the proper form. It is best not to take off too much at a time, otherwise, it often happens that it bends to a wrong form, and to cut from the point of the pen towards its handle.

In a good pen the two points must be of the same length, so as to touch the stone uniformly, if held in the proper position.

If this cannot be completely done in the cutting, it must be done on a fine hone.

A new cut pen is sometimes too rough and affects the stone, gets filled with dust at the point, and does not spread the ink. This, however, generally ceases with the first lines drawn on the stone, and it often arises merely from the unskilfulness of the draftsman. If the points of the pen lose their proper form, they may be mended by bending ; this, however, requires experience.

The two points of the pen ought to touch one another at their extremity, but not for the whole length of the slit, as this would prevent their free movement ; it is, therefore, no defect if one can see through the upper part of the slit. Some even, in order to effect this, are in the habit of cutting a small piece out of the upper part of the slit ; this, however, is very difficult, requires a very fine pair of scissors, and often spoils the whole cutting of the pen.

For drawing straight lines, common steel pens with a screw may be used, if properly adjusted and prepared for the purpose. But in most cases, as, for instance, in making the back ground of a drawing, consisting of straight lines laid crossways, it is better to use such a steel pen as has been above described ; for the others are too apt to get filled with dust, and then they either refuse to give out the ink, or produce lines of disproportionate thickness,

by which the whole drawing is spoiled. Of all the different operations occurring in pen and ink drawings on the stone, none is more difficult than to draw very fine and straight lines by the rule. I found that for this purpose a steel pen, elastic only in a slight degree, and the points of which were cut so as to touch the stone very equally, answered best. It scarcely need be observed here, that the pen must be held so as to touch the rule not with its flat front which contains the ink, but with one of the smaller sides.

The Brushes.

Brushes are used for various purposes in Lithography, such as cleaning, biting in, and colouring the stones. In this place, however, we speak only of those fine camel-hair brushes used for drawing or writing on the stone. For this the finest sort of miniature brushes (sables) are used, but they must previously be prepared for this particular purpose. For producing lines of unequal thickness, the brush in its natural state is quite sufficient. Lines of equal thickness, however, can scarcely be produced with it, and it must for this purpose undergo the following preparation. The brush is laid on the table, its hairs separated with a knife, then, on both sides, about the sixth part of an inch is cut away; the other side of the brush is then turned up, separated, and the hairs on both sides are cut away. This is continued till no more than ten or twelve hairs remain in the

middle, of their original length. These remaining hairs ought neither to remain too close together, nor yet too far asunder ; so that they may keep well together when the brush is filled with ink, but not adhere so closely as to prevent the ink from passing between them. With a brush well prepared in this manner, the finest drawings can be made, fully equal to the best engravings.

For coarser drawings, coarser brushes may be used, or more hairs may be left standing in the middle.

The Etching Needles.

These instruments are only used in the etching and engraved manner, and must be made of the best and hardest steel. Needles of the form which engravers use, are the best ; at Munich pentagonal drills, such as watch-makers use, are sometimes employed ; they are fixed into a piece of wood, then shaped like lead-pencils, so that only a small part of the needle projects. They can thus be more easily sharpened, if necessary. For thick lines that require a certain pressure, stronger needles are used. For making very fine lines, chiefly in different directions, the needles are best when ground to a round shape.

The Drawing and Copying Machine.

For copying drawings very accurately and in an inverted sense upon the stone, they use at Munich a Pentagraph, so contrived that the stone is fixed horizontally above the drawing, with its surface towards it. The engraving needle is directly opposite to that, which is conducted by the hand over the lines of the original, and produces on the stone a perfectly similar but inverted drawing. These machines may be had from Messrs. Liebherr and Co., at Munich. This able artist has invented another sort of copying machine, by which drawings of any size may be copied on the stone in their original size, or any other size, and either inverted or not, as may be thought proper.

Various necessary Utensils.

The principal utensils are—A table for rubbing down and polishing the stones ; a chest for the biting in and preparing of the stones ; some rules ; a drawing table ; and instruments for writing music, and for drawing the lines for the notes.

The table, for rubbing down and polishing the stones, must be particularly strong and level, in order to resist the pressure necessary for this purpose ; and must have a contrivance, by which the stones can be well fixed upon it. If it is to stand in

a room, it will be well to have a hole in the midst of it, through which the water can escape, and be collected in a proper vessel. Its sides may be guarded by a rim or border, to prevent the sand and dust from soiling the floor.

The vessel for biting in and preparing the stones is a quadrangular chest, well covered with pitch in the inside ; it has a hole in its bottom, through which the liquid used for this purpose flows and collects in a vessel placed beneath, out of which it may be repeatedly poured over the stone. It must be of sufficient size to receive all sorts of stones ; but they must not touch the bottom, which may be prevented by nailing a small piece of wood across it.

Besides the common rules, it is advisable to have one of a peculiar construction ; it should be five inches broad, and half an inch in thickness at one end, and the sixth part of an inch at the other : a small piece of hard wood should be glued on the thinner side. This rule serves to repose the hands upon while drawing on the stone, particularly in those manners where the stone must not be touched with the hand. Great advantage may be derived from having a rim all round the table, on which the rule may rest ; and from introducing in the midst of the table a projecting platform on a pivot, by means of which the stone can be turned in every direction.

A music pen is a small tube of brass or silver, the mouth of

which forms the dot of the musical characters and is capable of containing a sufficient quantity of chemical ink to make about twenty dots, without taking fresh ink. In order to prevent their taking too much ink, a fine wire is fixed in the middle, and the extremity is carefully ground to a horizontal plane. In case of necessity, a small round piece of wood may serve the same purpose; but this has the inconveniency of requiring more frequently a fresh supply of ink, though beginners generally give it the preference.

We shall afterwards explain in what manner the small brushes are to be used, when we come to treat of the splashed manner.

Colour-cylinders or rollers, and printers' balls, are used for charging the stones with printers' ink. The latter are quite the same as those used in printing-offices, consisting of leather filled with horse-hair, and form a large ball. The former are wooden rollers about four inches in diameter, covered with flannel or woollen cloth, rolled three or four times round, and then very carefully covered with calf's skin. The leather must be sewed together with silk thread, and not with linen or cotton, both of which produce spots on the stone. The leather, before the cylinder is covered with it, ought to be wetted. It is adviseable to possess a moderate number of these cylinders or rollers, as in using them they imbibe much water, lose their elasticity, and cease to give good impressions; and it is, therefore, necessary

when they become wet, to lay them aside for dry ones. When put by, let them be hung up perpendicularly and free all round, by which means they will very soon get into good order again. These cylinders have handles on each side, about four inches long, and one inch in diameter, to which are fitted tubes of thick leather for the handles to run in; otherwise the printers would soon blister their hands, and the rollers would not deliver the colour so equally and regularly without them. The degree of pressure on the stone in using the roller, must neither be too heavy nor too light, and it must vary according to the nature of the design, the stone, or the ink. Experience and practice alone will be the best instructor here. In preparing the paper for printing, it is necessary to observe the following directions :—Choose hard paper, such as vellum, drawing, and other sized paper; dip one sheet out of every six sheets in water, and put it between the five dry ones ; and when your paper is thus arranged, put it into a book-binder's or other screw-press for eighteen or twenty hours at least, when it will have received the proper moisture requisite to enable it to receive the impression.

In preparing unsized paper, such as plate-paper, one sheet out of every twelve is dipped in water, and proceeded with as above.

CHAPTER V.

The PAPER.

THERE are three different sorts of paper, principally used in Lithography, *viz* :—1. The transparent paper ; 2. The blotting or soft paper ; and 3. The printing paper.

The Transparent Paper, and the Art of transferring Outlines to the Stone.

The principal use of transparent paper is for the tracing of drawings, in order to transfer them to the stone in the common manner, or by way of retracing them. If good, it must possess the following qualities : 1. It ought to be perfectly dry, so as not to soil any drawing if put upon it ; 2. It ought to be perfectly transparent, so that the most minute parts of the original can be seen and retraced ; 3. It ought to be capable of taking ink or black lead without running or leaving intervals. The best sign of its good quality is, when a small camel-hair brush with Indian ink, or in case the drawing is to be immediately transferred to the stone, with the soft chemical ink, can be used upon it.

When the tracing is thus completed, the other side of the paper ought then to be rubbed with red chalk or black lead, and fixed upon the stone ; and all the outlines must be marked on the stone with a tracing needle, which however should not be too sharp and pointed. If the needle is too sharp there is reason to fear that it will hurt the surface of the stone.

The red chalk or black lead, with which the other side of the tracing is covered, must be wiped off carefully, otherwise the lines thus traced will become too thick and clumsy. Each side of the paper, either that on which the tracing is made or the other, may be covered or rubbed in with red chalk, according to the way in which the drawing is to be transferred to the stone *. In some cases it is necessary to transfer the drawing immediately from the tracing paper to the stone, without using the tracing needle; and then the tracing must be made with a soft black-lead pencil, placed for about one minute between two damp sheets of paper, and afterwards placed on the stone and passed through the press. If the outlines are drawn with chemical ink, your drawing may be at once transferred to a polished stone. In this case the paper must be prepared with a thin starch, and a small portion of gamboge, and it is then

* It is hardly necessary to observe that only the outlines, and not every line in the minuter parts of the drawing, ought to be copied; for notwithstanding the greatest care in tracing them on the stone, it would be impossible in many cases to avoid confusion. Experience will here prove the best instructor; and a good artist wants only a very few outlines to produce a copy bearing a perfect resemblance to the original.

called prepared transfer paper, but in preparing this paper it must first be fastened with gum round the edge on a board or a strainer ; the latter mode is by far the best, and will allow it to dry much more quickly.

In very small tracing, it is sometimes advisable to use gold-beaters skin instead of transparent paper, of which it possesses all the good qualities.

The Blotting or Soft Paper.

This sort of paper is used partly for the purpose of cleaning the stones, but principally as a covering for the paper which is to be printed. If a sheet of paper is to be printed on both sides, as, for instance, in music, writing, &c., it often happens that some portion of the ink of the impression adheres to the paper upon which it is put, with the side already printed ; and it becomes, therefore, necessary to avoid using the same sheets again, as it would spoil the clean impression ; and for every new impression a new sheet of blotting paper ought to be used. This blotting paper must not be coarse, for in that case it would produce inequalities or even holes in the leather in the printing frame, or in the rollers and scrapers. It is also advisable to have a good quantity of it in store, to afford a supply till the sheets which have once been used become dry again. To pro-

mote the drying it is advisable to hang them up on lines fixed at some distance under the ceiling of the room, upon which the wet sheets can be easily exposed to the warm air of the room.

The Printing Paper.

All sorts of paper are not equally fit for Lithography, and in general it may be said that this new art is in this respect very much like letter-press or copper-plate printing ; the paper adapted for the latter, is also the best for the stone, provided it has no grains of sand or other hard substances in its texture. Such inequalities have a very unfavourable effect upon the impression, but more especially upon the leather over the printing frame, and on the roller or scraper.

It is, therefore, necessary to examine the paper previously by holding it against the light, when all those inequalities in the texture will easily be seen. In general, a fine thick uniform paper, either half sized, (or even not sized at all,) is deemed the best for copper-plate printing ; the same may be said of Lithography, though it is still possible to take fine impressions from sized paper. I have often seen impressions on sized paper much superior to others on printing paper. The wetting of the paper is of great consequence here ; copper-plate printing paper is the best of all papers for Lithography. There is a sort of English vellum paper, of a bluish colour, and perhaps too much

sized; I could not obtain impressions on it, though I took the utmost pains to procure them. This sort of paper it is extremely difficult to wet; every sheet required to be wetted separately, and when the water came in contact with it, it shrunk into innumerable wrinkles. Some similar sorts of Dutch paper present the same difficulties, for they do not easily take the colour if not wetted to a certain degree.

I cannot here omit mentioning a circumstance which, if neglected, would render all the exertions of a beginner perfectly fruitless. There is a certain sort of paper used for printing, which is very fine and white, equal, but a little rough on its surface, and of a peculiar smell, partly resembling that of honey, partly that of uric acid; it bears generally the name *Rupnel frères,* and is of French manufacture; this paper possesses the quality of destroying the prepared surface of the stone, and consequently of entirely spoiling it. Perhaps I may succeed one day in discovering a remedy for this inconvenience, but at present I have not leisure to make the necessary experiments. This sort of paper can only therefore be used for that manner of printing, where the paper is not wetted at all. It is presumed that the singular quality of this paper arises from the chemical process of bleaching it; in fact, all papers chemically bleached are more or less destructive to Lithography, and particularly where vitriol and muriatic acid is used for bleaching. Swiss papers, I find, are the best adapted for Lithography, being the purest or the least adulterated. A similar effect is produced

by some sorts of coloured paper, if the colour contains a considerable quantity of alumine or a preparation with soap ; in this case, however, the effect may be easily accounted for.

The Process of wetting the Paper.

It is not always necessary that the paper for lithographic printing be previously soaked or wetted ; in some instances it is even necessary to use dry paper, as in printing vignettes upon paper which is to be used afterwards for writing ; but in most cases the printing paper ought to be previously wetted, by which process it becomes softer and more apt to take the colour. It might be thought from what we before stated, as to the taking of the colour being prevented by wetting, that liquid in general prevented the colour from adhering to the paper ; experience, however, teaches us that it has a quite contrary effect, and that it greatly promotes it. But this is no exception from the general rule ; and upon closer examination, every principle laid down in the case of the stones, applies here in its full force. Paper, perfectly clean and not sized, if thoroughly soaked in pure water, does not take any colour, like a prepared stone ; but the water, which acts here, is not a sufficient means for preparing the paper ; by an adequate pressure it is entirely extracted from the paper, which is thus rendered dry, and takes the colour more easily, as the

preventing cause is removed, and the pressure of the press promotes the adhering of the colour.

Should the pressure, however, not be sufficiently strong to free the paper entirely from the water, the water will still act in its colour-repelling quality, and render the impression imperfect. The dryer the printing-colour or ink is, the more it is counteracted by the water, and, consequently, the greater must be the pressure of the press.

Long and continued experience has convinced me of the truth of the following observations :—

1. Every sort of paper, if not impregnated with grease, may be prepared by water, in the same manner as the stones, so as not to take any colour. In clean unsized paper, water is quite sufficient ; its preparing quality, however, is greatly increased by mucilaginous gum-like acid substances.—2. But in order that a sheet of paper so prepared may not lose its colour-repelling quality, every sort of pressure upon it must be avoided.—3. The oil-colour or printing ink must be very thin and liquid, for if too thick, it takes off with it small particles of paper.

These observations, applied to the theory of printing, lead to the following conclusions :—1. The paper used for taking impressions, ought never to be too wet ; as, in this case, even the strongest pressure cannot remove the water entirely.—2. If the

paper is too wet, the printed parts have a tendency to adhere to the stone, and break when taken away, which spoils the whole impression. This is most apt to happen when the pressure of the press is not very great. When the scraper or the stone are not quite level and even, those parts that are not sufficiently pressed, are very liable to be torn off, as they are not yet quite free from water.—3. If, therefore, the colour or printing ink is very strong and dry, the paper need not be wetted much, partly on account of the tearing, partly not to create greater obstacles than necessary.—4. Paper too much wetted expands in the act of printing, and causes the impressions to be distorted and unequal. At the same time the too great quantity of water prevents the colour from penetrating into the interior of the paper; and in the engraved manner, or when the stone is strongly charged, it is particularly apt to expand on the surface of the paper, and give a double impression.—5. The quality of the water makes no great difference in the process of wetting, provided it is clean and not putrid; in the last case, it renders the paper rotten and unsound.—6. Nothing but experience can teach how much the paper ought to be wetted, different papers being so different in their qualities, and the size being frequently of the most material consequence. In general, in well-sized paper, one soaked sheet may be necessary for five dry sheets; but in unsized paper, one soaked sheet will do for ten or twelve sheets.

The wetting of the paper is best effected in the following

manner :—Two or three dry sheets are put upon a level board ; then another sheet is immersed in water ; when the water has run off a little, this wetted sheet is put upon the others. Eight or ten sheets of dry paper are then spread upon it; another sheet, wetted in the above-mentioned way, follows; then again the same number of dry sheets; and so on, till the quantity of paper to be used for printing is exhausted. A smooth level board is put at the top, and, if necessary, a stone plate over it. After half an hour's time the pressure is raised to several hundred weight, or the paper is compressed in a common press by means of a screw. In this state it must remain at least twelve hours, before it is fit for printing ; if time permit, 24 hours would be better. For the aqua-tinta manner it must be more wetted ; six dry sheets for one wet sheet will then be the proper proportion. Paper of very strong size is best wetted if every sheet, or at least every other sheet, is passed over by a wet sponge. Sometimes it is necessary to put the wetted paper on the other side, in order to remove the wrinkles on it. This is done by dividing the paper into two heaps, and putting alternately some sheets of the one upon some of the other ; by which means the points of contact are varied, and the wrinkles levelled. In some sorts of paper, the common manner of wetting letter-press printing paper may be adopted, *viz.*, drawing a whole quire at a time through the water, and putting one quire upon another. This process, however, requires great experience, otherwise the paper takes too much wet. The wetted paper must be left for some time, in order to be thoroughly

penetrated by the liquid, but not too long, as it is then liable to become putrid and spotted. If the wetted paper is left too long without being loaded by weight or pressure, the margin of the paper becomes dry, and in printing makes folds, which spoil the impression, and can only be removed by wetting again the whole sheet. The reason of this is, because wetted paper expands, and as it drys shrinks again. In those manners of Lithography in which several stones are used for one drawing, especially if they are of great size, dry paper only can be used, otherwise the marks would not coincide perfectly. With a great deal of care and management, even in wetted paper, an equal degree of expansion may be produced ; but this requires much experience, and, therefore, is not to be recommended to a beginner. In general, tolerably good impressions may be obtained upon dry, but unsized paper, (except in the aqua-tinta manner), but the pressure of the press must be twice or three times stronger, which exposes the stones to the danger of breaking under it, if they are not sufficiently thick.

CHAPTER VI.

PRESSES.

———

A COMPLETE description of all the lithographic presses hitherto used would fill a work more voluminous than the present, and require a great number of drawings, which would infallibly add to the price of the publication, without adding to its utility ; for I have already ascertained that even clever artisans cannot, from the most minute drawings and description, construct a perfect machine. Models ought to be procured either from Munich, or from any other place where the art of Lithography is practised. In order, however, to render this Course of Lithography as complete as possible, I shall here give succinct descriptions of the best lithographic presses. I believe no press has yet been invented, which is not far from the perfection which might be wished for. The press, of which I laid a model before the Royal Academy of Sciences at Munich, in which the charging of the stone is done by the machine itself, and which could also be worked by water, or any other power, has not yet been constructed on a large scale ; so that I shall avoid giving any opinion as to its value. I think myself bound to declare, that I deem it one of the most essential imperfections of Lithography, that the beauty and quantity of

the impressions, in a great measure, depend on the skill and assiduity of the printer. A good press is likewise an essential requisite ; but an awkward printer, even with the best press, will produce nothing but spoiled impressions. Till the voluntary action of the human hand is no longer necessary, and till the impression can be produced wholly by good machinery, I shall not believe that the art of Lithography has approached its highest perfection. I myself am determined to carry into execution, sooner or later, my ideas on this subject, and to communicate the results to the friends of the art.

Qualities of a good Press.

The observation has often been verified that drawing, or writing, looks better on the stone, than impressions from it, even on the finest paper. This may arise partly from the colour of the stone, which softens the whole by a half tint, and renders the drawing more delicate and pleasing to the eye : an impression, taken on yellowish stone-like paper, greatly resembles the original drawn on the stone. The reason why impressions on white paper do not look so well, is, that the colour does not generally come equally off from the whole surface. The possibility, however, of effecting this, is well proved by many perfect impressions. If the stone is carefully prepared and worked, it will take the ink cleanly and uniformly. The printer, however, may put too much or too little ink on the stone, according as

the ink is too hard or too soft, without being aware of it till the impression is taken off; and even if the stone is properly charged with ink, the printing paper, either from being too wet or too dry, may imperfectly take the colour. All these are circumstances which have an essential influence upon the beauty of the impression, and it is impossible to give general rules as to the quantity of ink to be taken, for this must vary according to the different manners of Lithography. In most lithographic presses, the pressure is produced by the scraper. This is a thin piece of hard wood about one inch thick, (usually pear-tree, plane, or box); the edge with which the pressure is produced, is not thicker than the twelfth part of an inch, and by the action of the press it is violently pressed against the leather of the frame, under which the printing paper lies upon the stone. In some presses the scraper is passed over the whole surface of the stone, or it rests immoveable, and the stone passes under it; so that the pressure of the scraper successively acts upon the whole surface of the paper. In this sort of scraper-press the impression is not, therefore, produced at once, and perpendicularly, as in the letter-press; but successively as in copper-plates; with this difference, however, that in the copper printing-press a cylinder rolls over the stone, and in this press a rubber or scraper is drawn over it. The scraper acts with a very considerable power, sometimes of three tons and more, upon the leathern frame placed over the printing paper; and it being necessary that, notwithstanding this heavy pressure, it should slide over the leather; it is evident that a great friction must

take place; and though the leather is carefully strained over the printing frame, and even rendered more slippery by grease, it cannot fail to be considerably stretched by the passing of the rubber. This stretching is communicated, in some measure, to the paper under it, and effects a distortion in its parts, by which all the lines of the drawing, in the direction in which the rubber passes over it, become a little thicker. If the leather is of good quality, well strained in its frame, and sufficiently greased, and if the soft paper under it is not too wet, the above-mentioned distortion is very inconsiderable, and in writing or larger drawings, scarcely perceivable; but in very minute drawings, or in highly-finished chalk drawings, where the space between the single lines or points is scarcely visible, the smallest extension or distortion of the paper, is sufficient to fill them entirely, by which the whole impression is totally spoiled. This inconvenience can only be remedied by straining and greasing the leather carefully; by not overcharging the pressure of the press; by frequently changing the soft paper; and particularly by putting a piece of good silk taffety between the soft paper under the leather; for by this means the adhering of the leather to the paper is prevented, and, consequently, all distortion or moving of the paper. The taffety, however, must be changed from time to time, as soon as it begins to get wet. If the scraper, by careful planing, is made perfectly parallel to the stone, the pressure of the press need not be by any means so great, and all extension or distortion of the paper is avoided. I have often observed that one scraper,

even of the same wood, takes a more perfect polish than another, and slips more easily over the leather ; this ought likewise to be attended to. Besides the inconvenience of extending or distorting the paper, the rubber has another imperfection, *viz.*, that of being easily injured, or even spoiled, if small hard bodies occur in the paper. If in this manner an inequality is produced on the edge of the stone, no subsequent impression can be perfect, as a certain line will be less printed than the rest, all over the stone. As soon, therefore, as such a line is observed in the impressions, the scraper must be taken out and planed afresh, and carefully adapted to the surface of the stone. In fine drawings of artists, which are commonly printed on very fine paper, this seldom happens ; but in works where coarse printing paper is used, it very frequently occurs. I proposed to remedy this inconvenience by having scrapers of brass ; but as these slide with less facility over the leather, produce a greater friction, and consequently a greater expansion of the paper, I covered them with a piece of strong paper, which, before it was worn out, served me at least for 300 impressions. The pressure of a metal rubber, as it yields still less than wood, is more powerful than that of a wooden one ; it has, however, this inconveniency, that no stone can be printed with it, of which the surface entirely corresponds to the edge of the scraper ; while a wooden one, in case of necessity, can be adapted to the stone, by planing off a little on those places where the pressure is too great.

From the statements we have hitherto made, it appears that

a perfect lithographic press must possess the following qualities :—1. It must not alter the position of the paper, or distort it when in the act of printing. 2. It must press uniformly upon all parts of the stone, and, consequently, give impressions free from all defects.

The other qualities, which are not less desirable, lithographic presses have in common with letter press and copperplate presses ; as for instance :—3. The press must be strong enough to give sufficient pressure. 4. With this quality, it must also have the greatest possible quickness and expedition, and, 5. be easily worked so as not to fatigue the printers too much. All these qualities, I venture to say, have not yet been found united in any one press ; and we were satisfied with approximating in some instances, according to the different sorts of work, to something like perfection. I make no doubt, however, that in the course of time, this obstacle will be removed likewise, when Lithography, from the rapidity of its progressive improvement shall be honoured with the attention of the most skilful mechanics, who, however, if they wish to produce any thing distinguished, must first begin to study the technical part of Lithography.

Application of Letter and Copper-plate Presses to the Purposes of Lithography.

When we examine attentively the process of Letter-press and

copper-plate printing, we discover an essential difference between them, which has a material influence on the impression produced. The types of the letter-press are elevated, the copper-plates are engraved. It is evident that the former do not require so great a pressure as the latter, to produce an impression ; and, therefore, the construction of the presses for these two manners are so different, that the press used for the one could not serve for the purposes of the other. Lithography uniting both manners, the elevated as well as the engraved, the most natural way would be to preserve the principles of both sorts of presses as much as possible, and to form a new construction* out of both.

In letter-presses the pressure acts in a perpendicular direction and simultaneously upon the whole surface of the sheet. The copper-plate presses act only upon a single line of the plate at a time, and the impression is produced successively, the plate passing through the two cylinders lengthwise. As in the former, the force acts upon the whole surface, it is evident that

* In general, all the lithographic presses hitherto used are of a description similar to this, borrowing the successive mode of printing from the copper-plate presses, and the construction of the printing frame from the others. This union would be still closer, if one were to construct a common Letter-press, having a cylinder or rubber fixed in the tympan of the Press, depressed by a screw, and this cylinder moving in the common way by means of a lever over the stone. It is almost certain, that an experienced artist might contrive such a press, which undoubtedly would be most advantageous, as the construction of a letter-press admits of considerable quickness, and common letter-press printers could easily be taught to use these presses for the purposes of Lithography.

each of the single parts of it receive only a small part of that force; in the latter, the force being limited to a small part of the plate, every part of it, in succession, is acted upon by the whole force of the press. From this it might be concluded, that letter-presses are most adapted to the elevated manner of Lithography, and the others to the engraved ; some particular circumstances, however, render an alteration necessary in both, before they can be used. In the common letter-press printing those parts only of the types that must be printed, are exposed to the pressure, which do not fill the 4th part of the surface ; the rest is so low as to offer no resistance at all to the pressure. But in the stone the elevation is so inconsiderable, that the surface offers a resistance in the printing four times greater. It would, therefore, be necessary to produce four times greater pressure than in a letter-press, in the case of a stone plate. By the most accurate calculations, a stone plate, of the size of a common folio sheet, requires a pressure of from 25 to 30 tons to be printed horizontally, and such a pressure nothing but a very thick stone placed carefully upon a horizontal foundation, is able to resist. In this case, if the stone were rubbed down with equal care on both sides, and if a cement could be discovered, by which the stone could be passed upon the foundation as easily as taken from it, I believe that the common letter-press might be most advantageously applied to Lithography, at least to the elevated manner of it*.

* The science of mechanics offers more than one contrivance, by which a force may be greatly increased, without requiring a greater exertion on the part of the

Besides the additional expedition in printing which would be obtained, the printers would be in less danger of spoiling the impressions by any movement or distortion of the paper, which, by the smallest negligence in placing the frame upon the stone, so frequently happens in the common lithographic presses. A common copper-plate press increases the evil of displacing or distorting the paper on the stone ; this is generally caused by the efforts which the cylinder or roller makes, to seize the stone and paper and pass it underneath ; but as soon as this is the case the paper is no longer extended or distorted, at least not so perceptibly as to produce an effect upon the impression, for the cylinder or roller passes over the stone without any sort of friction. This inconveniency is remedied by a contrivance, as shewn by the annexed drawing, of fixing standing blocks against the fore and hind ends of the stone, by which means the roller is raised so as to pass along the stone 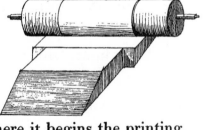 at a perfect level with the point where it begins the printing. But as, on account of the process of putting on the colour, it is necessary to remove the roller a good distance back on the slanting block ; this requires great exertion on the part of the

workmen, but in general such a contrivance is an obstacle to quickness and expedition in working. To remedy this, I should advise, in the present case, the making the lever longer, and the employing of additional workmen to assist the printer in working it. The extra expense occasioned by this would be amply repaid by the additional number of good impressions produced.

printer, and causes considerable loss of time. The best con-
struction of all would certainly be the following :—Let the
upper cylinder be placed so high, that the stone without touch-
ing it can be introduced under it; and when this is done let
the press be set to the usual degree, by means of a lever worked
by the foot. Let the principal construction be taken from
a copper-plate press ; let the upper cylinder with its two pivots
be attached to two iron levers, each of which, by means of a
screw, of an inch in diameter, may be attached to a piece of
wood. Each of these wooden pieces may be covered with tin,
and by means of two screws, raised or lowered. This is neces-
sary in order to give more or less force to the press. The two
other ends of the lever to which the cylinder is fixed, may be
moved up and down, so as to allow the cylinder to move in a
similar sense. Let two springs, or two weights, be so contrived
that the cylinder with its levers may continue always raised, and
in order to press it sufficiently down on every impression upon the
stone, let an iron bar pass through both side-frames of the press,
from which two pivots should project, so as to depress the levers
at least two inches, when the bar is turned the fourth part of a
circle, or 90 degrees. The cylinder being about the middle of
the lever, it may be depressed about one inch deep, which is
quite sufficient to leave space enough for the stone to be intro-
duced under it without difficulty, and as soon as this is done,
the greatest force may be given to the press. The upper cy-
linder ought not to be more than half an inch distant from the
stone, for the rest of the space is required partly to fill the

space arising from the elasticity of all the parts, and partly as a reserved space, to give still greater force or stress to the press if necessary. On one end of the iron bar, let there be a lever, attached by a connexion-rod to a pedal. This pedal may be so contrived as to move up by itself. If the power to be obtained by the press is to be sixty or more hundred weight, the connexion-rod must not be attached immediately to the pedal, as it is necessary to raise the force by a second lever, attached to the side of the press. It will not be necessary to raise the foot so high, as the two pivots of the great bar describe a circle, and are so placed as to produce the greatest effect of power at the last moment, when the pressure is acted upon by the greatest counterpressure; and as the distance of the weight towards the centre continually decreases, while that of the force by which it is raised is immensely increased. Care must, however, be taken, not to increase too much the elasticity of the lever which presses downwards, as it would require too long a motion of the pedal. It would be tedious to dwell longer on the description of the press; mechanics will understand me, and, perhaps, improve upon my project. In my opinion, a press of this construction would have the advantage of avoiding the expanding and distorting of the paper; of producing a very great pressure; of admitting of cloth, or what printers call blankets, which contributes greatly to the beauty of the impressions, particularly in the engraved manner, and of rendering it easy to manage, and produce a great number of impressions in a short space of time: this last cir-

cumstance is the more important, as it generally renders the impressions more beautiful. In order to secure the stone from breaking under such a press, the following precautions ought to be taken.—1. The stone must be rubbed down equally horizontal on both sides.—2. The two rollers of the press must be turned perfectly cylindrical, so as to be of equal thickness throughout. The board upon which the stone rests, must be likewise horizontally true, and of equal thickness, but that thickness must not exceed half an inch. In passing through the press, the board is violently compressed; the more, therefore, the pressure falls on the middle, the more it takes a concave form, and this is sometimes the principal cause of the breaking of the stone. If the cylinders are perfectly true, and the stone perfectly level on both sides, it is impossible to break the latter by passing it through the former, without a board under it; if this, however, is very thin, it has no sensible effect.

Enumeration of Lithographic Presses hitherto used.

Most proprietors of Lithographic Establishments have endeavoured to invent presses for their purposes, which each of them constructed according to his own principles; but, upon the whole, all were scraper or cylinder presses. I myself have formed more than twenty projects, some of them more, and some less, useful; but as very few of them have been executed on a large scale, I am myself at a loss to say which of them is the best: it

frequently happens that the best contrived plan, by the fault of an unskilful workman, is so disfigured in the execution as to be entirely useless. My object here is only to enumerate the best presses which have been hitherto invented, and applied to the purposes of the art. The sorts of presses which are commonly used at Munich, are—the upright Lever Press— and the Cylinder, or Star Press.

The latter denomination is generally given to it by the workmen, because a star wheel is usually applied instead of a lever.

I am besides acquainted with the Cylinder Press, as used by Mr. André, and that of Mr. Steiner, at Vienna. Mr. Müller at Carlsruhe, and Mr. Ackermann at London, have, as I am informed, contrived presses with paper-cylinders ; the construction and composition of which are, however, unknown to me.

The upright Lever Press, commonly called the Pole Press.

This was the first press which I applied with advantage to Lithography, and it is still in use in establishments, for printing all work which requires great dispatch. It would be the most perfect and easy press of all, if its pressure could be raised to more than six hundred weight, without exposing the

printer to an immoderate exertion ; and for that reason it is not easily applicable to very large stones, or such as require a great pressure. For pen and ink drawings, of the size of a common folio sheet, it is excellent ; and with two workmen, one to put on the ink, the other to work the press, twelve hundred impressions may be taken by means of it in one day.

In this press the pressure is produced by an upright lever, from six to ten feet in length, to the under part of which the scraper is fixed, and the upper part is suspended from the spring of an elastic board. This board is fastened to a pedal, by which it can be depressed so as to act with its usual force when the scraper passes over the stone. The board fixed over the press must be elastic, so as to rise at least one inch, as the scraper in passing over the stone, describes a segment of a circle. The pressure, therefore, at the two ends of the stone, is not so intense as in the middle, and particular attention in the selection of the wood is requisite, to obtain a spring that possesses sufficient elasticity, as well as sufficient strength. I have generally found that a board of young pine, properly seasoned, six feet in length, eight inches in width, and from one and a half to two inches thick, best answered my purpose. It is very difficult to meet with a good spring-board; and I have often observed that two presses, of the same construction, were very unequal in their action, solely owing to the difference in the degree of resistance of the board. This board must be of a very elastic nature, not easily liable to warp or twist; but when

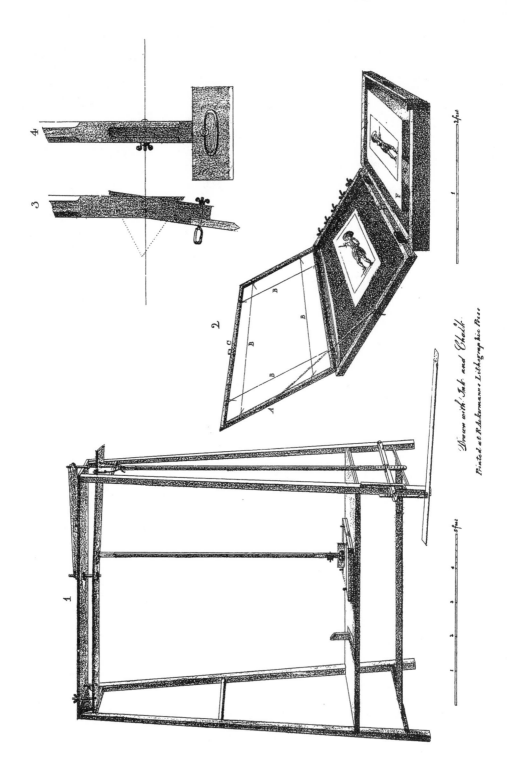

Drawn with Ink and Chalk.

Printed at R. Ackermann's Lithographic Press

by the action of the pedals it bends downwards to a certain degree, it must yield at the same time at least an inch upwards, to allow the scraper to make its circular motion on the stone. At this moment great attention on the part of the printer is required, as he has to prevent the scraper, in sliding from the middle to the end of the stone, from passing too rapidly over the leather, especially when it has been fresh greased. The pole of the scraper consists of two parts, the shortest is about sixteen inches long, to which the scraper is fixed by a screw. The other part may be as long as the construction of the press allows; and the longer it is the more perfect will be the effect of the press, as the line described by the scraper approximates more to a straight line, has a more equal effect, and can be worked with a considerably smaller power.

The annexed print *(fig.* 1,) represents this press as prepared for taking an impression. *(fig.* 2,) The frame or box enlarged and laid open. A, a slight frame, by means of which and the strings B B B B, with a small spring C, the paper is fastened in its position on the leather D, which leather must be kept tight by means of the screws E. F, the stone, which must be fixed in the box with the wedges G. When the frame is shut or put on the stone, the paper ought not to touch the stone, but to be at least half an inch distant from it. But as soon as the scraper is put on, (for which purpose it is necessary to divide the scraper pole into two parts,) and the press is acted upon by the usual degree of pressure, the leather with the sheet of

paper put under it descends to the stone, and by the scraper passing over it, receives the impression. If the paper touch the stone when the frame is shut, the impression will be entirely spoiled. As soon as the two parts that compose the pole of the scraper are in one straight line, so as to form together only one rod, the spring-board, by means of the pedal, is depressed, and the printer draws the scraper over the leather of the printing frame towards himself. Here I must not omit to add the following observations :—

1. The two constituent parts of the pole must be so linked together, by means of a double joint hinge, *(fig.* 3,*)* as to bend in the manner of a joint ; but when drawn to a straight line, and acted upon by the spring-board, they must preserve their perpendicular position, and not bend themselves, *(fig.* 4.*)* It is, therefore, advisable so to unite the parts that they may deviate rather from the straight line, and incline a little to the inside.

In printing, the rod ought to be seized by the printer as low down as possible, in order to keep the two parts of the pole always in its right line. The printer ought to press with his whole force against the table upon which the press stands, in order to get a firm hold, for without doing so, he would scarcely be able to move the scraper.

2. If a very great power is required, the opposite workman, by pushing, may greatly assist the other.

The scraper is a piece of hard wood, of which the length must be regulated according to the size of the stone, four inches high, and one inch thick. Where it touches the leather, it ought to be planed obliquely, so as not to be thicker than one twelfth of an inch at the extremity. It must be planed so as to touch the stone in every part of its surface, rounded off a little, and fastened to the pole by a strong screw, or bolt, to allow it to be moved in all directions over the stone, which does not always lie horizontally, either, as frequently happens, from its being of an unequal thickness, or from the press not standing upon a true level. If the scraper is well constructed, it can easily be adapted to the position of the stone, even when the pole does not fall perpendicularly upon the stone, which it is not always possible to effect.

It is advisable to have scrapers of different dimensions in store for every press. Lever-presses are usually so contrived, that the printing-frame may be placed higher or lower, according to the thickness of the plates ; in this case, a higher or lower scraper must be selected. But if a store of shifting boards, of different degrees of thickness, are kept, this double change will not be necessary, and the printing-frame may remain always in the same position. Only when the scraper, by frequent planing, becomes too low, it will be necessary to raise the stone by means of shifting boards, in order to avoid the necessity of pressing the spring-board too far downwards, by which it would lose its elasticity.

The connexion of the spring-board with the pedal below, is effected by a slender rod, attached to the board ; which rod, at its lower extremity, is joined to a lever. This lever is, by means of a piece of iron, connected with the pedal. In this piece or plate of iron are several holes, for the purpose of raising or lowering the pedal, in order to produce the necessary degree of strength.

The leather in the printing-frame should be of strong calf skin, or young ox hide ; it must be carefully strained, and its upper surface, where the scraper moves, must be greased from time to time.

At the outside of the frame two iron plates ought to be sunk in the wood, with holes through them at short distances, capable of receiving small thumb screws, which are necessary to fasten two iron cross bars that regulate the extent of the space over which the scraper moves.

The Cylinder Presses.

When Professor Mitterer opened his Lithographic Establishment for the use of Sunday Schools, he was of opinion that the lever-presses required too much human exertion, particularly in those cases where a considerable pressure was requisite. He, therefore, endeavoured to construct a more convenient and easy sort of press, which he called his Cylinder, or

Star-Press; it has been altered, but not essentially improved, by others; and has been adopted in most lithographic establishments both in and out of Bavaria. The cylinder-press might be called an inverted lever-press, for Mr. Mitterer took the first idea from this sort of press; the impression is produced by a scraper, but the scraper does not pass over the stone, but remains immoveable, and the stone passes underneath it, by which contrivance it bears some resemblance to a copper-plate printing press.

This press has a cylinder of from ten to twelve inches in thickness, of the best seasoned oak, with iron axles at the two extremities, moving in brass sockets. A strong frame or box, in which the stone is fixed, passes between the cylinder and scraper. The scraper is attached to a long lever, raised by a proportionate counterpoise. When the stone is charged with the ink, and the paper fixed in the printing-frame, and put on the stone, the scraper is lowered by means of the lever; a strong iron hook attached to the lever, now lays hold of a sort of machinery connected with the pedal, by means of which the lever can be pressed down to the necessary depth; the cylinder is now turned round by means of a star or cross, such as copper-plate presses have, and the printing-frame passes under the scraper as far as is necessary for the impression. For this purpose two strong straps are attached to the lower part of the box which contains the stone, revolves round another cylinder at the extremity of the press, which forces the stone forwards.

If the pressure is not too strong, a single workman may draw the stone under the scraper; but in order to facilitate this operation when the stones are large, and a stronger pressure is requisite, a corresponding star, or cross, is contrived at the other side, so that the other workman may give his assistance. It is scarcely necessary to add, that the other precautions above mentioned as to the equality of the lever, straining of the leather, &c., must be carefully attended to, in order to obtain perfect impressions.

Another more simple press called the Hand-Press, is also much used, which is remarkably handy for small and middle-size stones. It is much the same as the one last described, but less in size, and instead of a star, or cross, it has a hand lever; and instead of two straps, it has only one that comes from the centre of the box, passes over a wheel of twenty-eight inches diameter, to which the hand lever, of about three feet long, is fastened; and by the lifting it up, the box with the stone from under the scraper is forced forward. This is a very handy press for artists and amateurs. *See Drawing*.

Some other Lithographic Presses.

The Cylinder Presses of the Lithographic Establishment at Vienna, would certainly be of the greatest advantage for lithographic printing, if they had greater power. They are constructed as follows:—The stone and printing-frame are fixed

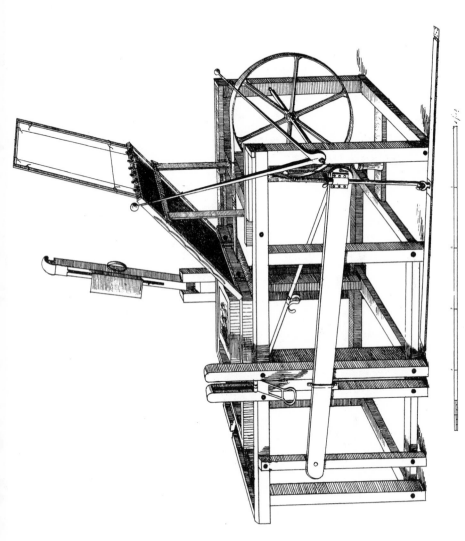

Pen and Ink Drawing

on a table ; instead of leather, the frame is covered with felt. To produce the impression, a cylinder of brass, eight inches in diameter, is rolled over it. But as this cylinder, though perfectly solid, would not produce the requisite pressure, two iron rods are attached to the pins of the cylinder, which pass through the table, and have cases filled with iron or leaden weights suspended to them. The space, however, seldom allows the application of more than five or six hundred weight, which, in most cases, does not produce a sufficient pressure for clear and perfect impressions. These presses would be greatly improved by being raised a little higher, to gain more space underneath ; or if the levers could be made to pass through the floor of the room, by which means space enough might be obtained to add a weight of two tons and a half, or more, without fatiguing the workman too much in turning the cylinder. The press of Mr. André, of Offenbach, greatly resembles the one in question, only the cylinder is much thinner, being but three inches thick, and is not pressed upon the stone by a weight, but by a corresponding cylinder under the table. It admits, as well as the former, of great expedition ; but very considerable pressures cannot be obtained.

Thus, I believe, I have communicated all that is necessary relating to presses. Had I given even the most minute description of every particular, it would not be sufficient for those who do not understand machinery ; and the sensible mechanician will, by a few words, be enabled to understand the whole nature of the invention.

At the close of this Chapter I wish to add, that, by collecting together my ideas, and the results of my experience respecting this subject, and applying them to one single point, I have, by some successful experiments, been led to believe that I may soon succeed in obtaining such a Lithographic Press, as shall leave no wish unsatisfied. If my hopes are crowned with success, it will give me particular pleasure to give a complete description of the press to my friends, or to supply them with exact and well-constructed models of it.

END OF THE FIRST SECTION.

SECTION SECOND.

Of the DIFFERENT MANNERS *of* LITHOGRAPHY.

———

THE different manners of Lithography may be divided into two principal branches, *viz.*, the elevated and the engraved manners. In the first, all those parts of the stone that are covered by a greasy ink, resist the action of the acid poured over the whole surface of the stone, by means of which the other parts of the surface become corroded ; they stand, there-fore, higher than the latter, as elevated from the plane surface of the stone. In the second manner, all those lines or parts of the drawing or writing which are to give the impression, are engraved into the surface of the stone by means of a sharp needle, or bitten into it by the action of an acid. Each of these manners has a decided difference of character. The elevated manner possesses this advantage over the engraved, that it admits of greater expedition in taking the impressions, and allows a greater number to be taken before wearing out ; besides it is much easier for the artist, especially in chalk drawings. The engraved manner, on the contrary, admits of

greater nicety and expression, and in some particular cases is of more easy execution to the artist.

In general, therefore, it is difficult, if not impossible, to say which of these two manners is the most advantageous, as this will depend, in a great degree, on the subject, and the feeling of the artist.

CHAPTER I.

The ELEVATED MANNER.

————

THE different subdivisions of this branch of Lithography
are—1, the pen, or hair-brush, drawing—2, the chalk manner—
3, the transfer manner—4, the wood-cut manner—5, the
scraped manner—and 6, the sprinkled manner.

§ 1. *The Pen, or Hair-Brush, Drawing*.

————

This is one of the principal manners of Lithography ; and,
perhaps, the most popular of all ; as it is applicable to many
purposes of common life. It not only imitates all sorts of
writing and printing, and in many cases even surpasses them
in elegance, but it is also applicable to all drawings where the
nicety of a well executed copper-plate is not required. The
expedition of the execution, and the short space of time in
which a number of impressions can be produced, highly re-
commend it. It requires but little penetration to foresee that,
at some future time, when more attention shall be paid to it
by experienced and clever artists, it will be used for the higher
productions of art.

But advantageous as this manner is, it has hitherto been only used for writing and music ; and it is difficult to persuade people of its excellent qualities. A circumstance, apparently trifling, is the cause of the small success of this manner with artists. I have met with but two persons who, from the very first day of their study, could reconcile themselves to the use of the steel pens, used for drawing on the stone, and were able to write with them ; these were my brother Clement, and a gentleman of the name of Börner ; all other artists, without exception, had more or less to struggle with difficulties, which generally exhausted their zeal and patience at the end of a few days. In another part of this work, I have already explained the manner of producing these pens; and I shall, therefore, proceed immediately to the description of the manipulation of this manner. Here it is not necessary to be very nice in the selection of a stone, for even stones of a less perfect description may be used for it without risk. The harder and finer, however, a stone is, the better it is for it. If the stones have previously been used for other drawings, it is necessary to rub them down till all vestiges of the former drawing disappear. It is immaterial what substance is used in rubbing down the stone, provided it becomes perfectly smooth, so that the pen meet with no impediment in drawing or writing upon it. In order, however, to produce clear lines on the stone, a farther preparation is necessary, by which the spreading of the ink on the surface is effectually prevented. One part of weak oil, dissolved in three

parts of spirits of turpentine, forms a mixture, with which the well polished and well dried surface of the stone ought to be washed; the stone ought then, as quickly afterwards as possible, to be carefully wiped with clean linen, or blotting paper, so that only a very thin coat of the mixture may remain on it, and it will then be rendered easily accessible to the aqua-fortis. This must be done some hours before beginning to draw, partly in order to avoid the strong and disagreeable smell of the turpentine, and partly because immediately after washing the stone it does not receive the ink from the pen so well as it does afterwards. Time does not annihilate the effect of this preparation, and it may even take place some months before using the stone; which, in this case, requires only to be well cleaned from dust by a brush, a precaution that must be repeated several times during the day, while at work on it, otherwise dust will get into the pen.

A second manner of giving this slight preparation to the stone is, however, upon the whole, preferable.

This manner consists in carefully washing the stone with a strong solution of soap and water, and then drying it; and in order to clear the stone from the alcali which this solution contains, I generally wash it a second time with pure water, which ought to be carefully wiped off. The greasy parts of the soap now adhere to the stone, free from all alcali. The solution of soap must not be too weak, otherwise it is immediately de-

composed, and leaves too great a quantity of grease on the stone, which afterwards prevents the complete action of the acid, and consequently spoils the whole drawing. In order to avoid this, I would advise beginners to wash the stone even after using the solution of soap-water, with the before-mentioned composition of turpentine and weak oil, and to clean it carefully afterwards.

It must not be believed that this preparation is immaterial, for long experience has convinced me that even the proper composition of the ink, is not of greater consequence than the proper preparation of the surface of the stone, and covering it with a proportionate coat of grease ; for without this, clean and strong impressions cannot be produced. The stone being thus prepared, a sketch of the drawing may be made on it by means of a blacklead pencil, or by tracing, or even by transfer. It is necessary to dust the stone well, otherwise it will be difficult to draw on it with the steel pen. The sketch being made, it is necessary to rub down the stone with fine dry sand ; without, however, injuring the drawing, merely to take off all superfluous grease, which in the act of etching would resist the acid too much. The manner of transferring the sketch to the stone by means of transferring ink, is, in some cases, so eminently advantageous, that it well deserves to be particularly studied. If a fear should be entertained of extinguishing entirely the lines by rubbing them with sand, the object may be equally obtained by making a few impressions on blotting paper, which

also takes off the superfluous grease; and the sketch, before being transferred to the stone, may be printed a few times on paper, by which process it equally loses any superfluity of grease. Sometimes a second transfer of a sketch on paper already used for this purpose, may be wished; this may easily be obtained, or a fresh impression of the stone will serve the purpose; but the same precautions, respecting superfluous grease, ought to be taken. I have elsewhere treated of the use of pen and ink in drawing on stone, and I shall not, therefore, here repeat my observations.

The drawing or writing with the chemical ink being completed and revised, so that no corrections or additions may afterwards be necessary, the biting in or preparing of the plate, may be commenced; care, however, must be taken, that the whole of the drawing be perfectly dry, otherwise it would not resist sufficiently the action of the aqua-fortis. The first lines of the drawing are generally dry before the whole is finished, but the last lines are not for a short time after. An experienced eye will easily observe when the necessary degree of dryness is attained, by the look of the ink, which is less brilliant when dry than when wet. It does not injure the plate in the least, if after the drawing is completed, it is left for years without being etched, provided it is well secured against dust and dirt. The biting in of the stone may be done in two different ways, *viz.*, by a flat varnish brush, or by effusion. The first has this advantage, that it is the easiest, but can only be used for coarse productions; for by the act of drawing the brush over the stone,

the finer lines might possibly be injured. Long experience and practice, however, often overcome these difficulties ; and the finest drawings may be bitten in by rubbing them over with a broad camel-hair brush. This manner has another advantage, it removes all uncleanness left on the stone by repeated corrections. The composition used for this purpose consists of three or four parts of water, and one part of aqua-fortis ; in this composition let a fine broad brush of fox or badger hair be immersed, and passed over the stone in a uniform manner. It is necessary to immerse the brush frequently, as the aqua-fortis soon loses its force, and thus some parts of the stone would be left without the necessary preparation. After the operation, the brush must be well washed, otherwise it will soon corrode. The second way of biting in is used in the case of very fine drawings, especially when they are not strongly expressed or drawn with ink of a soft composition. To give this preparation, a box pitched and well secured, is necessary, in which the stone is placed upon two transversal pieces of wood, and a composition of aqua-fortis, mixed with twenty, thirty, or forty parts of water, is poured over it. It is of little consequence how many parts of water are mixed with the aqua-fortis. If it is very weak, it must be the oftener poured over it, and in greater quantities. The action of it is likewise very unequal, according to the greater or less degree of hardness of the stone ; and in this manner the degree of preparation depends very much on the circumstance of the points and lines being more or less fine, as the coarser lines can bear a stronger acid than the fine ones. If an aqua-fortis of the same strength is always

used, a few experiments will be sufficient to teach the exact proportion and strengths of acids. In order to distinguish whether the stone be sufficiently bitten in, it is advisable to look over its surface against the light, when it will easily be seen whether all the lines are elevated a little above the rest of the surface; if this is not the case, the aqua-fortis mixture must be poured over it again. If the coat of grease produced by the first preparation is entirely etched away, and clean water equally adheres to all parts of the surface; if no spots or uncleanness arising from corrections are to be seen, then the stone is perfectly bitten in, and will produce clean and strong impressions. Sometimes it may be etched a little more than this, for the sake of the greater facility in taking impressions, and in making corrections, if necessary; this will depend, how-ever, on the fineness of the lines. In very fine drawings, especially when made with the brush, the necessary degree of biting in must not be exceeded, as the finest lines and points are very liable to be injured. Coarser writing or drawing, as for instance music, admits of a high degree of etching or biting in. In no case, however, is it advisable to make the lines too prominent, as they then soon become too sharp, take too much colour, and this fills the intermediate spaces between the lines. Some artists are too nice in determining the necessary degree of strength of their aqua-fortis, in order to produce a perfect and uniform action on their stone; this, however, is neither necessary nor material; if a great quantity of aqua-fortis is not possessed, what has been poured already over the stone,

may be used again with the desired effect. The stone being thus well bitten in, it ought to be washed once more with clean water, in order to take away all superfluous acid, and prepare it for a covering with a solution of gum arabic in four or five parts of water ; this may be done immediately after the biting in, or the stone may be first left to dry, in order that the finest points which have, perhaps, been a little too much acted on by the acid, may get fixed sufficiently to the stone before they are washed again. In drawings made with the pen, this precaution is unnecessary ; but in hair-brush or chalk drawings, it is of great utility. When this preparation with gum-water is completed, the stone should be left untouched for some minutes; then a few drops of water, and also a few drops of oil of turpentine, should be poured on it, and perfectly spread all over the surface ; and then by means of a woollen rag, the whole drawing may be wiped off. If the ink is very hard, and has long been on the stone, it will be advisable to take more turpentine, as it will then adhere more closely to the stone. This done, let the stone be immediately charged with printing ink. The object of this operation is to render the stone more capable of taking the ink uniformly, so that even the very first impressions may be perfectly clean. If the original drawing ink is left on the stone, it gets generally dissolved by the printing ink, which is much softer ; and the stone being thus overcharged with too great a quantity of colour, the impression will be spoiled, as under the press the ink spreads very much over the surface. It is necessary to charge the stone with ink

immediately after its being rubbed with turpentine, as the latter is very apt to evaporate, the consequence of which is that the stone does not easily take the colour. The putting on or charging of the printing ink is, in this manner, effected as follows :—A clean linen or woollen rag is soaked in pure water, and afterwards well squeezed, so that little water remains in it. With this the whole surface of the stone is well wiped, so that it may every where be slightly wet. After this a well charged printing roller is passed several times over the stone. It is necessary to raise the roller frequently in passing it over the stone, in order to vary the points of contact. To put on the ink uniformly, it is advisable to hold at first the handles of the roller very firmly, to press it well on the stone, and to pass it in a somewhat oblique direction over it ; afterwards it is passed a few times without great pressure, by which operation the superfluous ink, if there should be any, is likewise removed. It is not advisable to repeat the passing of the roller too often, as the stone then gets dry, and is liable to be soiled ; if this should happen, however, it must be carefully wiped with a wet rag, till it is again perfectly clean. If this is neglected, and the stone gets thoroughly dry, it will be very difficult, if not impossible, to clean it again. In order to avoid this danger, it is usual with beginners to wet the woollen rag a little now and then ; this, however, produces other inconveniencies ; as all the fine lines are soon wiped off, and the roller gets so wet, that it will not produce a good impression, till it is sufficiently dry again. For this reason, I would not advise beginners to use sponges

instead of rags, as they leave too great a quantity of water upon the stone ; in other respects they are very well adapted for this purpose ; some practice will soon teach the proper use of a sponge in this way. Some printers mix the water, with which they wash the stone, with a little gum, and some drops of aqua-fortis ; others mix it with small beer. I am, however, of opinion that all these mixtures are useless, provided the stone be well prepared, and the printer's ink be of good quality. Pure water I have always found the best in this particular manner of Lithography. But respecting the ink, which in pen drawings, or in the elevated manner in general, produces the best impressions, I am at a loss to give a general and universal rule. The following are the results of my manifold experiments :—
1. The stronger the varnish or burnt oil is, which enters as an ingredient into the ink, the cleaner it will keep the stone. 2. The same thing happens, if it contains a great deal of lampblack. But in both cases the finer lines may easily be damaged, and too much lampblack produces lines of too great strength and breadth. 3. The dryness or liquidity of the ink must correspond to the strength of the pressure. The dryer the ink is, the greater must be the pressure. Thin or weak oil is no impediment to fine and clear impressions, but then the pressure of the press must not be too great ; and particular care must be used in putting on the ink with the roller. 4. Very solid varnish, or strong burnt oil, generally produces very fine lines ; but if once it gets into the intermediate spaces between the lines, it cannot easily be removed by the motion of the

roller, but produces an uncleanness which continually increases, and finally entirely spoils the stone. If a strong ink begins to adhere to the stone, there is generally no other remedy than washing the stone well with gum-water and turpentine ; which, however, if too often repeated, injures the preparation, and spoils the clearness of the impressions. 5. Soft ink is more liable to produce broad lines, but this is easily remedied after such impression, by the washing of the plate. 6. Soft ink requires a more damp or a better soaked paper, than strong ink. 7. Both soft ink, and dry and strong ink, if not provided with a sufficient quantity of varnish or strong burnt oil, are liable to shade, and thus produce soiled impressions. By the expression " shade," I allude to the following phenomenon. If, for instance, a drop of oil falls into a basin filled with water, part of it will immediately spread all over the surface of the water, and produce rainbow-like colours. The law of gravity does not seem to be the only cause of this phenomenon ; on the contrary, it would appear, that though the oil does not mix with the water in greater quantities, yet that a slight affinity between them produces this spreading of a drop of oil. Varnish, whether thick or thin, possesses the same quality, only in a less degree. Before the ink can be put on the stone, it is necessary to wash its surface with water. After the ink is put on it, a considerable quantity of water still remains on the surface. Now if the ink contains too great a quantity of weak varnish, or oil, it will draw towards the water-drops nearest to it ; so that every line and every point gets a sort of feebly-coloured

margin, not unlike a shade, and from the resemblance, this defect of the colour is called shade. As this effect is not produced instantaneously, but gradually, it is not easily discovered if the impression is made immediately after the putting on of the ink ; and, therefore, it is not so great in the lever-press, as in the slower cylinder-press. If, however, the exact quantity of water has been used in wetting the stone, so that at the moment when the roller has passed over the stone, the water is entirely consumed, there is no fear of shading ; and, if all other requisites have been properly attended to, very clean impressions may be obtained. But as this moment cannot always be easily seized, and as the stone is apt to soil as soon as it has passed, it requires great experience to avoid this defect, and it is therefore advisable rather to mix more lampblack with the ink, in order to deprive the varnish of its excessive elasticity. 8. If by mixing a great quantity of lampblack with the varnish or strong oil, the ink is deprived of its fluidity, the defect of shading is avoided, but other inconveniencies may arise from it ; as for instance, the finer lines, especially when rubbed off in some degree, do not very easily take a very strong ink, and other places retain too great a quantity of it, by which unequal impressions are, of course, produced. On the other hand, an impression made with too much lampblack, is more apt to soil, than another where the varnish predominates in the ink. It likewise never gets so black as the ink which has less lampblack, and does not produce, in the elevated manner, very black and strong impressions, because the lustre of the varnish renders

the colour much more brilliant. These considerations induced me to endeavour to invent a proper composition, not liable to shade, yet still compatible with a greater fluidity of the ink ; the experiments which I undertook for this purpose, have not yet been crowned with perfect success ; but I still entertain the hope of attaining my object at last, being convinced that the common varnish or burnt oil, when mixed with greasy and bituminous substances, loses, in a great measure, its quality of shading. An addition of a very small quantity of Venetian turpentine communicates a greater fluidity to the ink. The following composition, however, is much to be preferred :—Six parts of linseed oil, two parts of tallow, one part of wax, melted together, till they produce a substance like the common oil varnish or strong burnt oil, and of the same thickness. 9. The internal quality of the stones, and the degree of temperature, has likewise a great influence upon the impressions ; and the composition of the ink must be regulated accordingly. In very hot and dry weather, a stone, especially when of a porous nature, has much less internal humidity than in wet and cold days, especially if it has been preserved in a dry place. In this case the water, with which the stone is washed before every impression, evaporates almost instantaneously, or at least in some spots, so that it is very difficult to put the ink on the stone ; the best expedient is, to use in this case a stronger and dryer ink ; or to soak the stone, before it is printed, for some hours in pure water, so that it may imbibe a sufficient quantity of water. 10. If it is intended to promote the drying of the

ink, which is sometimes necessary when the impressions must soon be pressed or bound, it is advisable to mix a little pulverized minium with the ink. Pulverized litharge is still more efficacious, but only a very small quantity of ink can be mixed at a time with it, as in less than an hour it gets so solid as to be unfit for use ; even the ink mixed with minium can only be used for the day when it is made, for it is afterwards liable to soil.

These are the principal results of my experience respecting the ink for pen-drawings, and generally for the elevated manner.

With respect to the process of printing pen and ink drawings, I have the following observations to make. Even if the stone has been well and uniformly charged with good ink, the subsequent impression may, nevertheless, be spoiled in different ways, *viz.*, if the paper is put on too early ; if it has not the necessary degree of dampness, in proportion to the quality of the ink, and the degree of pressure ; if the degree of pressure, and the consistency of the colour, are not in the correct proportion ; if the roller is not equal ; or if the leather is not sufficiently stretched.

The following points must, therefore, be strictly attended to :

1. The paper must not touch the surface of the stone, till

the impression is effectually made by the scraper or roller ; for as in this peculiar manner some parts are elevated, the paper is soiled by the least contact, especially if the ink is of a soft nature. It is not, therefore, advisable to put the paper on the stone, as some do, but it ought always to be fixed in the printing-frame, at least a quarter of an inch distant from the stone. In order to retain it in this position till the roller presses it on the stone, a second smaller frame should be contrived within the larger, which, by means of strings or springs, may retain the paper close to the leather. It cannot be denied, that, even when the paper is put flat on the stone, very good impressions may be obtained; but then great care must be taken not to alter in the least the position of the paper, and to prevent any folds in it, and it requires more time, and does not admit of positive accuracy. If two printers work together, the one may fix the paper in the printing-frame, while the other puts on the ink ; and then we may always be sure that the impression will be made on the exact place where it should be. 2. The soaking or wetting of the paper is in this manner of no very great consequence, provided it be not too wet, for then the impression spreads, and becomes thick and unequal ; and if the paper is too dry, it adheres to the stone, as above-mentioned. In general it may be said, that the degree of wetness must correspond to the degree of dryness of the varnish ; the softer the varnish, the more the paper may be wetted. For unsized Swiss paper, I take one wet sheet to nine or ten sheets, which serves well for tolerably dry, or very dry, ink.

As the soaking is only used to give the necessary degree of softness to the paper, it is evident that it must vary according to the quality of the paper, and this must be learned by experience. 3. As to the pressure of the press, it has already been mentioned that, with very dry ink, it must be greater; and with soft ink, it must be considerably less. 4. The degree of pressure must also vary according to the quality of the scraper or cylinder; if this is not very equal, and well adapted to the stone, the pressure must be greater; for sometimes the defects of the scraper are so remedied. The sharper the edge of the scraper is, the clearer and more perfect is the impression, because its full power is then condensed into a smaller space. But the scraper usually soon loses its sharpness, and then the loss of power must be supplied by greater pressure of the press. 5. If the leather is not sufficiently stretched, the impressions are never perfect and clean; particularly if the ink is soft, and the paper very wet. It is, therefore, necessary to stretch the leather from time to time, and to grease it well with tallow. The paper, which is put under the leather, must likewise be exchanged with other paper, from time to time.

Thus much as to the printing of the pen and ink drawings; I advert now to another point of great importance, *viz.*, the correction of defects or mistakes made in the drawing or writing, which, in different manners, must be differently treated.

It seldom happens that a drawing, or piece of writing, is

quite faultless when finished ; and it would be a great inconvenience to the art of Lithography, if accidental defects could not be mended, or corrected. There are two different modes of making corrections ; 1st. when the defects are discovered before biting in ; and 2d. when they are only discovered after the first proofs have been taken.

In the first case, before the stone is bitten in, the corrections may very easily be effected. It is then necessary to remove those particular spots where the defects are, and to put the correction in their place. Sometimes the defects are discovered as soon as made, and before the ink gets dry, and in that case they may be rubbed off with the finger ; if the ink is already dry, recourse must be had to oil of turpentine. In both cases, it is necessary to be very careful in wiping off the ink, that it may not afterwards resist the acid too much, but be entirely taken off by it, and that the subsequent correction with chemical ink may be the better effected. If only some small points are defective, they can be scraped off with a pen-knife ; and those places where some superfluous lines only are to be taken away, without substituting others in their room, may also be scraped off or rubbed down with pumice-stone.

The second kind of correction, after the biting in of the stone, is a little more troublesome, though not very difficult. In this case, however, there is a material difference between the mere removal of a defect, and the substitution of something new in

its place, or the addition of something to the drawing, which had been omitted ; and there is also a material difference between an alteration of great extent, and one which merely comprises a few lines or points.

If a part only of the drawing is to be erased, it may be sufficient to make the erasure with a penknife. If the erasure is of considerable extent, it will be advisable to rub it down with pumice-stone, and then prepare it again with a composition of six parts of water, to one of aqua-fortis, and one of strong gum, applied by means of a hair-brush ; but in this operation great care must be taken not to touch the adjacent spots, as they would be liable to be affected by the aqua-fortis. If in place of that which has been erased, something new is to be substituted, this may be done in the following manner :—Let the stone be charged with colour, then washed with gum-water, but very slightly ; after this, let it be left to dry, and then let the defects be carefully rubbed down with pumice-stone. This done, the corrected drawing may be substituted in place of the other with chemical ink, which, when dry, must be bitten in, and afterwards carefully prepared with gum-water.

Where something that has been entirely omitted is to be added, the same process nearly must be followed. If the addition is of no very great extent, it will be sufficient to rub down the stone in the spot where the addition is to be made, and then add the omitted parts with chemical ink, which, for

fear of spreading, ought to be very thick. If the addition is of considerable extent, the spot must be rubbed down, washed with soap-water or spirits of turpentine, and then treated as before.

Should, however, the number of corrections be so great as to extend all over the surface of the stone, it will be better to make a new drawing at once. As, however, in some cases it may be preferable to correct the plate, I shall here communicate a very useful method, which I once used in correcting a great geographical map, where numerous additions and some alterations in the tracts of the roads were to be made. The stone was charged with colour, and all defects were then scraped off, or rubbed down; the whole surface was now washed several times with diluted aqua-fortis,* and then with a great quantity of fresh water, in order to take off all acid, and at last the stone was allowed to dry. In this state I was enabled to insert with the pen all the additions and alterations. After the ink had become perfectly dry, all the newly-drawn spots were bitten in by a little stronger aqua-fortis with a small hair-brush, in order to produce the necessary elevation, with-

* This was done partly in order to prepare the places that had been rubbed down for the biting in, but principally in order to communicate to the stone a greater disposition to take the chemical ink. It is nearly impossible to draw on a stone already prepared with gum and bitten in, on account of the running of the ink, which takes place even after it has been cleaned with water. The gum creates a certain alteration on the surface of the stone, which can only be taken away by repeated biting with weak aqua-fortis.

out which the lines that were not bitten in would have been liable to spread. This done, the whole surface of the stone was washed several times with aqua-fortis sufficiently diluted, and then with pure water. The stone was left for some hours to dry, in order that the ink in the finest lines, which, perhaps, by the repeated biting in had been too much affected, might settle and fix itself afresh. Lastly, the plate was washed with gum-water, and printed off.

Besides these two manners of making corrections or amendments before and after the biting in, sometimes a third is necessary, *viz.*, when the stone, from improper management during the printing, becomes defective; as for instance, when such spots as ought to remain white, take ink; or when some spots are rubbed off, or have been spoiled by the biting in, and refuse to take colour; sometimes both defects occur at the same time. I shall here explain, in a very few words, the manner of remedying these defects. If the surface of the stone is soiled, which is not unfrequently the case, in the margins, the soil may often be removed merely by the application of gum-water, and spirit of turpentine; if this, however, should not be sufficient, the soiled spot must be wiped with a piece of linen dipped in diluted aqua-fortis, or rubbed with the finger, but very carefully, in order not to damage the drawing. If the soiled spots can possibly be rubbed down without injuring the drawing, this method ought to be adopted in preference to all others. But if some spots are wiped off, or injured, through

the acid, so as to refuse to take the ink ; this may, in many cases, be remedied by the application of a soft ink : as soon as the stone has imbibed sufficient grease, harder ink may be used : sometimes this defect may be remedied by merely exposing the stone to the open air. In some cases it may be advisable to immerse the stone in a pail of clean water, and to rub on the grease under the water with a linen rag. If this operation has not the desired effect, recourse must be had to rubbing, for which the necessary instructions have already been given, and which can be done with oil, or with clean stones and water. It is, however, a sign of the inability and inattention of the workmen, or of defective instruments, when such defects often occur ; and, without computing the loss of time occasioned by the corrections, they require besides so much attention and skill, that one can never be sure of a favourable result ; so that in most cases it will be better, perhaps, to make a new design altogether, and carefully to avoid committing the fault by which the first was spoiled.

When the stone is put into the press, it will be necessary to wash it carefully first of all with water and turpentine, if more than one day has elapsed since the stone has been last printed ; this is done in order to make it take the ink more uniformly, and to render the impressions more perfect. The stone must be fixed in its place by means of wedges. During the printing, the following points ought to be particularly attended to— uniform repartition of the water, and of the ink, on the surface

of the stone ; repeated rolling of the ink-roller on the stone, by which the ink is always kept in its proper state ; and the utmost expedition and rapidity. The advantages of changing the rollers occasionally, has been mentioned in another place.

The pencil hair-brush drawing does not essentially differ from the pen and ink drawing ; its greatest difference consists in the circumstance that hair-brush lines never can be of the same strength as lines with the pen. A pencil hair-brush drawing, therefore, does not bear the biting in so well as a pen drawing, and for this reason, must be very delicately treated with acid. Much depends on the quality of the hair-brush, and the chemical ink which is used. Sometimes an ink which is excellent for the pen, and gives the finest lines, is not equally suitable for the hair-brush, as the latter retains the ink better than the pen does ; the ink, therefore, must be more liquid for the hair-brush. A most excellent ink for hair-brushes is prepared in the following manner :—Take two parts of clean white wax, and one part of good tallow soap, melt both together ; make no more than half an ounce at a time, as the ink will lose its good quality when it gets old ; it cannot be preserved for more than a few days. Let these two ingredients be well rubbed together with a knife on a tepid, but not warm, stone, and mixed with a few drops of water ; then divided into small pieces, and diluted with rain-water. As soon as the water begins to dissolve the mixture, let a small quantity of lamp-black be added, and well mixed with it, till it gets solid. Let a

quantity of this ink, sufficient for present use, be rubbed in a clean cup, and diluted with rain-water, till it is fit to be used. Though a great portion of this mixture consists of soap, it will remain liquid for a long time, even after its solution in water, and forms the best ink for hair-brush drawings ; but it would be very unfit for the pen, as it runs too much. In preparing this ink, it will be even better not to mix the two ingredients over the fire, as by this process the ink becomes thick and dry. With respect to the hair-brush drawing, the ink must be more liquid ; whereas in pen drawings, a too great liquidity of the ink must be carefully guarded against, by composing it in a different manner, and by washing the stone with soap and turpentine. It is evident that, for hair-brush drawings, it is not necessary to furnish the stone with a thin coat of grease. For some lines and points the pen is best adapted, whilst for others, on the contrary, the pencil or hair-brush suits best ; as for instance, curved lines or very fine lines running across thicker ones ; so that in some cases it is better for the artist to unite both manners, and in this case it would be necessary to wash the stone with soap-water, and then to rub it gently with dry sand, which does not injure its quality for the pen, and makes it more fit for receiving hair-brush lines. For the subsequent biting in, the acid must not be taken very strong.

In case a hair-brush drawing, for the greater facility in printing, is to be etched till the drawing becomes elevated ; it must at first be bitten in, but very slightly, and, as usual, prepared with gum, and well charged with good etching colour.

In this state the stone ought to be left for some time, in order that the etching colour, or chemical ink, may settle, and be fit to resist the action of the aqua-fortis; then let the stone be bitten in a second time, till it attains the wished-for degree of elevation. After this, let the stone be washed with water, prepared with gum-water, and left to dry. This last operation serves to fix and retain all the fine lines; it may then be printed like a common pen drawing. If a drawing is completed with the pen and hair-brush together, the following method must be observed, in order to be quite sure that even the finest lines, however delicately put on, are not injured by the biting in.

Take the well-polished stone, wash it several times with diluted aqua-fortis, (forty parts of water to one part of aqua-fortis;) then pour a sufficient quantity of pure water over it, to take away the remaining acid, and leave it to dry. On a stone thus prepared, it is easy to work with the pen, or with the hair-brush; but for each of them take the proper ink. The drawing being completed and dry, let the stone be washed over with weak gum-water. After the lapse of some minutes, it may be charged with etching colour, and treated as before mentioned.* The biting in for the second time, serves only to

* In order to be quite sure that the etching colour on the stone is strong enough to resist the action of the aqua-fortis, it is advisable to use both a strong and a soft colour. Let the strong colour be first put on the stone, then let it be wetted again, and let a roller with soft colour, which can easily be prepared from the strong by adding a small quantity of tallow, be passed several times over it. These two coats of strong and soft colour, will resist the action of the strongest aqua-fortis.

obtain good impressions, and is not indispensably necessary ; but the stone is less liable to be injured when twice bitten in, and, consequently, when the drawing is a little raised ; as the ink is then less inclined to spread sideways, or to penetrate into the stone. As the sheets are printed, put one upon another, till some hundreds are obtained, when they may be removed, in order to make room for others. Great care must be taken not to press these fresh impressions too much, for in that case the colour of one sheet is very apt to soil the sheet immediately above it. In the elevated manner, the danger of soiling or communicating the colour, is not so great as in the engraved manner ; because in the former the design is imprint-ed into the paper, whereas in the latter, on the contrary, the design projects on the surface of the paper, and is therefore more exposed to soiling ; and as it is highly desirable to preserve the impressions clean, one cannot be too attentive in this particular. In case both sides of the sheet are to be printed, the point for consideration is, whether or not the work requires such dispatch that the reverse must be printed immediately, without waiting till the first impression be perfectly dry. In the first case, a sheet of blotting, or waste paper, perfectly dry, must be put be-tween each impression ; in the second case, it will be better to hang up the sheets after one side is printed, and soak them again a few days afterwards ; when, if the ink is well prepared, it will not come off any more, and it will not be necessary to put a sheet of blotting paper over it. When the sheets are per-fectly dry, they must be pressed for some time in a common

press, for the sake of elegance; or, if an opportunity offers, it will be better to have them hot-pressed : in case they are not yet perfectly dry, a sheet of waste paper ought to be placed between each of the impressions. These precautions must be attended to in all the different manners of Lithography.

§ 2. *The Chalk Manner.*

The greasy chemical ink, in its liquid state, not only penetrates into the stone, communicating to those places to which it adheres a disposition to receive the printing ink, but it may be used likewise in its dry state on the stone ; and if cut into small slices, pointed at the end, this dry ink serves for the same purposes as black lead, or French chalk, on the paper. If the stone is well polished, all the lines thus produced will be much sharper, and more distinctly delineated, than those drawn with liquid ink on the stone. The chalk, however, loses its point too soon to admit of great nicety, or the imitation of pen-drawings ; but if the stone is only roughly polished, so that its surface resembles rough drawing paper, the impression from such a stone, instead of clear and distinct lines, will exhibit a number of points, coarser or finer, according to the degree of force used in the drawing, which will have nearly the same appearance as French chalk on paper ; and by which this manner assumes a character different from that of common pen-drawings. The use of chalk being familiar to almost every artist, it does not require

much practice to use the chemical chalk-ink immediately on the stone. He has, besides, no difficulties to surmount, (such, for instance, as often occur in pen and ink drawings,) and may give the utmost scope to his genius. Many highly-finished drawings have sufficiently convinced the Public, that this manner is susceptible of the greatest degree of perfection ; and that by means of it, the character of a drawing may, in a great degree, be imitated ; and whoever has an opportunity of inspecting the works of the eminent Bavarian artists, mentioned at the end of this Treatise, will, I hope, be convinced of the truth of my assertion. Another of its advantages is, that drawings can neither be executed in soft ground on copper, nor on paper, in less time than a design in chalk on stone. All these circumstances justify the conclusion that the chalk manner is a clear addition, and considerable acquisition to the art ; and that every artist who attempts its improvement, will confer a great benefit on the Public. I am not, therefore, afraid of incurring the displeasure of my readers, if in the description of this style I shall be somewhat more circumstantial and explicit than I have hitherto been, or might seem necessary; as this manner only differs from the preceding, in the treatment of the drawing.

For the chalk manner, hard and clear stones must be selected. They must be entirely new, or if they have been already used, they must be rubbed down till all traces of ink or chalk which had penetrated the surface of the stone, have dis-

appeared; so that we may be sure they will not take ink, though the stone be only slightly bitten in. The stones being rubbed down to a level surface, they must be prepared rough-grained ; that is, their surface must be granulated with innumerable small equidistant elevations, in order that the chalk may not produce sharp lines, but rather lines of small points, which it will do when used on a well-grained stone, without filling their intervals. This preparation is effected in the following manner :—

Put a small quantity of the finest gravel-sand* on the surface of the stone; take another plate of the same stone and size, and rub them in all directions over each other, changing occasionally the position of the stones, by placing the top one undermost, and *vice versâ*. This operation may be done either with dry sand, or with the assistance of water. Soap-water is still better, and the stone will become of a finer grain by it. But in both manners, the dry or the wet, experience and a particularly fine and uniform kind of sand, is necessary, to produce a perfect preparation, to avoid fissures or scratches, and to obtain an equal and fine grain. The longer the stone is rubbed, without the addition of fresh sand, the finer will the grain be ; but if too fine, the number of impressions will be very limited. A coarse grain does not admit of very delicate and fine drawings, but for designs of a larger scale it is preferable

* The best sand of this kind comes from the neighbourhood of Frankfort.

to all others. In general, much depends on the judgment of every artist, who must select the sort of grain he thinks best calculated for his drawing, and this must guide the person who prepares the stone. I am even of opinion that, for some subjects, it would be advisable for the artist's own self to prepare his stones, and in different places to use different grains, which could be done by means of smaller stones; in the foreground, for instance, a coarser grain would produce a good effect, and contribute to the general beauty. Upon the whole, I must observe, that the finer the grain is, the more it approaches to perfection, but it is also more difficult to print than the coarser grain.

As soon as the stone has got its rough preparation, and is properly granulated, it must be carefully freed from sand and dust. The best way is to pour clean water over it, and to wipe it off with a spunge or clean rags. It is very essential to remove all the fine dust arising from the rubbing with sand, because this fine dust would afterwards prevent the chalk, in the finest and most delicate shades, from penetrating to the stone; which, in the biting in, would infallibly spoil the whole stone. The stone being now well cleaned and dry, the drawing ought to be sketched upon it with black lead or red chalk, or the sketch copied on it from tracing-paper; it may even be transferred upon it, only in this case the sketch made with transferring ink, must be printed previously on other paper, in order that it may lose its excess of grease, and not spoil the stone. The

outlines must be drawn as fine and delicate as possible, in order not to carry too much grease on the stone, by which means the outlines would appear also in the impression; for chalk-drawings do not bear so much acid as pen-drawings.

For making the drawing, a greasy chalk, the preparation of which has been fully described, page 125 is used. Some practice will easily teach the artist which of the different sorts of chalk is most fit for the different drawings. Every artist almost has his own manner of drawing; one works in lines, another more in shades. In very fine and delicate tints, where the chalk should scarcely touch the stone, I would recommend stumps made of paper, or leather, such as are used by artists and students in drawing with chalk on paper. In the darkest parts, if necessary, the white intervals may be filled up and stipled in with chalk or ink, and where transparency and evenness are required, the assistance of fine pointed, as well as blunt, etching needles, will produce all the gradations of tints that can possibly be wished for*. The union of pen or hair-brush

* The most tiresome thing in chalk-drawings is, the being frequently obliged to point the chalk. In order to avoid this, some artists employ a lad to point a store of chalk pieces. The point, however, of a piece of chalk, may be preserved for a very long time, by using a piece of coarse paper; and, as soon as the chalk begins to lose its point, by rubbing it in a slanting direction over it. A blunt chalk is at times equally useful, as some subjects require a more delicate, and others again a blunter, point; but all this must be left to the judgment of the artist. I am in hopes of being able to contrive an instrument, the mere pressure upon which will be sufficient to point the chalk. If another artist should be fortunate enough to get the start of me in inventing a similar instrument, he will be justly entitled to the thanks of all those

drawing with the chalk manner, in order to give sharp touches with the chemical ink, is often productive of the best effect. There is also a very easy and expeditious manner of drawing very small subjects, such as vignettes for almanacks, &c., in a very short space of time, viz., by executing the outlines and darkest shades with the hair-brush, and the rest with the chalk. Mr. Strixner, a celebrated artist, has employed the sable-brush with the greatest success, in making the hair in his drawings; and the chalk manner has the peculiar advantage, that one can obtain single white lines, by scratching with a sharp etching-needle through the spots which are more or less covered with chalk. With the same good effect, in some cases where the drawing admits of it, whole spots may be uniformly covered with chalk, and the lights can afterwards be scraped in with a fine knife, or tool for that purpose. But on all these subjects no uniform rule can be laid down; the judgment of the artist must here serve as his guide. If some mistakes have crept into the drawing, or if some spots have become too dark, or have run together and form a blot, the etching needle may be used to render the shades lighter. But if the defects are more considerable, and if a great part of the drawing must be altered, the whole of such parts may be washed out with turpentine, and after the stone is well cleaned, and has had suffi-

who use chalk; for, to produce fine drawings with more ease, is one of the principal desiderata in this manner. The chalk must, at present, be pointed with a very sharp knife, and not towards the point, but from the point towards the handle, otherwise it is very liable to break.

cient time to dry, the correction may be substituted. The same effect is produced when the defective part is well rubbed with dry, or even with wet, sand, and then well cleaned with water; erasures with the penknife are not advisable, as they would spoil the grain. After the drawing is completed, it is requisite to leave the stone for a day, in order to allow the chalk to penetrate thoroughly. The drawing may be left for any length of time before it is etched in, without any bad consequence. The etching is effected by pouring the acid over it, which must be very weak. In general, to one part of aqua-fortis, one hundred parts of water, may be taken, and this acid ought to be poured several times over the stone. As it is of great importance in this manner not to exceed the necessary degree of etching, I would advise all beginners to try some experiments, in order to convince themselves of the effect and power of the aqua-fortis, and to be able to determine how many times it must be poured over the stone, to give it a proper degree of etching. The biting in, therefore, must be no more than necessary; and it will be advisable to bite in the darker shades a second time by means of a flat hair-brush and stronger aqua-fortis, till you obtain the necessary elevation. Wash the stone with pure water after the biting in, and let it be thoroughly dried before it is prepared with gum-water.

When the stone is prepared, it is not advisable to wash it immediately with oil of turpentine, but let it first be filled in with a weak colour. When this is done, the stone may be cleaned with

turpentine and gum, and filled in with a stronger ink. In the first filling in of the stone, the surface of it must be touched as gently as possible with the sponge in wetting the stone ; otherwise the most delicate touches are liable to be wiped off, before they have taken ink, and it will afterwards be very difficult to recover them again. But if, in spite of every precaution, the more delicate parts of the drawing have been injured, the best way to remedy the defect is the following :—

Wash the stone with gum-water, and wipe it with a dry clean rag, till it gets perfectly dry ; then take a flat instrument of steel, or pallet knife, well polished and smooth. Pass this instrument over the defective spots, gently pressing in all directions, but so as to touch only the elevated spots ; then let a little grease, such as linseed-oil varnish, be rubbed over them, and immediately after washed away with gum-water. After this preparation, all the parts which before did not take ink, will re-appear in their primitive clearness, when the stone is filled in with ink.

A second manner of correction is the following :—Fill in the stone with strong ink, wash it well with pure water, and leave it to dry. Then draw the injured spots anew, taking care that the chalk is properly managed, and touch no other points but those that want correction. This manner of correcting drawings is so easy, that an attentive printer may recur to it without fear of spoiling the drawing. In another

place, I shall treat more amply of the manner of correcting very defective stones.

The printing of a chalk drawing is the most difficult process in Lithography, and requires an attentive and experienced workman ; for as the single points composing the drawing are so very near to one another, the least spreading causes them to unite, and to form one blot. On the other hand, these very imperceptible points are very apt to be injured, or entirely rubbed off. They require a soft ink, while the coarser parts again require a stronger ink to prevent them from spreading ; so that one might be disposed to believe that it was impossible to produce a perfect impression from a chalk drawing. Experience, however, teaches us, that it is very possible to produce a good impression, provided the following points be carefully attended to :—*a*, the proper degree of soaking the paper—*b*, the proper degree of wetting the stone, so that it may neither have too much, nor too little, water upon it ; for, in the former case, the fine points will not take the colour well ; and in the other, the stone is apt to get soiled—*c*, the stretching of the leather sufficiently, and greasing it repeatedly ; and great attention must also be paid to the lining of the leather in the inside with good sound paper, or silk—*d*, good ink, well prepared, and not having too much lampblack in it—*e*, fine and very dry rollers—*f*, a sufficient pressure of the press ;—and, lastly, *g*, great expedition and quickness in printing : this

last circumstance contributes essentially towards producing fine impressions, as the stone must not be too dry, but retain a sufficient degree of moisture. In general, all precautions which have been recommended in treating of pen and ink drawings, are also applicable to chalk drawings, only much more care and experience are required. Besides the blotting of the darker parts, one of the most common defects of chalk drawings is, that by a fault in the printing they get a tint, which, like a black veil, spreads all over the stone, or that they lose their character and keeping, and appear monotonous, when the shades spread and become black and heavy. The first defect is caused by biting in too feebly, or by the oil used for the varnish in the ink being rancid, which disposes the ink to adhere to those parts of the stone that, like the adhering-colour, are prepared of varnish and litharge, and consequently spoils the stone entirely. The same thing happens when the ink contains soap, which some printers mix with it, to enable them to fill it in more easily ; or when minium is mixed with it, which does not dissolve entirely, and transforms it into adhering colour. Paper prepared with alum, or of Kiener's manufactory, of which I have spoken elsewhere, produces the same defect. The same thing is to be apprehended when the stone by frequent use has, in part, lost its preparation, and is afterwards cleaned with rags, or a sponge, soiled with ink. The second defect may arise from various other causes. I have observed that the stone may become monotonous in two different ways. When a chalk drawing is suffered to get dry

after the printing, and is not sufficiently washed with gum-water, and the ink adheres to the points of the drawing, particularly if the stone is of a soft nature, it will spread laterally in all directions, and produce a monotonous impression ; and even when the stone is sufficiently prepared with gum-water, the ink will spread, at least in the interior of the stone ; and as soon as by frequent printing the very thin prepared surface is worn off, the grease, hitherto concealed in the interior, will appear and soil the stone. Both these defects of the chalk drawings, *viz.*, the acquiring a tint, and becoming monotonous, may be avoided, or at least corrected, by using, for some time, a stronger ink. But if this should be of no use, the following treatment will produce the desired effect :—Fill in the stone with ink as strongly as possible, put it in the vessel or trough used for biting in, and pour over it once or twice a weak solution of aqua-fortis, wash it well with pure water, and prepare it then with a solution of gum. Great care must be taken in using the aqua-fortis, and it must be very weak, so that the acid may scarcely be perceptible, otherwise the fine lines run a risk of being injured. If the defect can be repaired at all, without undergoing a thorough correction, this is the best and only way of doing so ; and if properly gone about, it will not injure the drawing. I would, therefore, advise the use of this method, even with good stones, when they are to be printed again after a long interval. Many chalk drawings I have bitten in or etched twice, in order to make them stand longer. This second biting in has the advantage of admitting of many

corrections. This has induced me to devote my particular attention to this subject, and I hope that if by the following rules, the result of repeated experiments, I have not attained the desired object, I have at least pointed out the way in which, in this material point, the wished-for perfection may be reached.

When an engraver has nearly finished his plate, he may take a proof, in order to judge how his work succeeds; and it will then be always in his power to correct it, if he deems this necessary; the too dark shades can be rendered lighter; when they are not of sufficient strength, his needle enables him to render them stronger, and more expressive. All these advantages were considered as belonging exclusively to the art of engraving, and as being a desideratum in that of Lithography; and the artists in this latter art, were satisfied with seeing the impressions of their drawing just as they made it; which, indeed, were almost always nearly sufficient, as on the stone the effect of the drawing can be very well foreseen, though the artist is sometimes deceived by the colour of a half tint, natural to the stone, that gives a softness to the drawing, which he misses afterwards on the paper. But to obtain an impression in all lines and points perfectly similar to the original, a number of seemingly trifling circumstances must be attended to; and very few chalk drawings, since the invention of this art, have proved quite satisfactory and perfect. The most common defect is, that the finer and more delicate

spots grow too light, and the darker grow too dark, by which the keeping of the drawing is materially altered. The cause of the first defect is, that the finest points lose their quality of taking ink ; and of the second, that the dark shades where only a very small and almost imperceptible interval exists between the single points, form one blot, either from the biting in being too weak, by which the points are not sufficiently elevated, or from the subsequent spreading of the ink during the printing. Besides these, chalk drawings are liable to two other defects ; the first is, that frequent, and sometimes very large, white spots arise ; the second, that black spots or soiled places appear, which, in the beginning, were not visible on the stone. The white spots arise when the artist talks during the drawing, by which some drops of saliva fall on the stone ; this liquid covers part of the stone as if with a coat, which prevents the penetration of the chemical chalk, so that in the subsequent printing the spots so covered with saliva are wiped away. If the saliva contains some particles of grease, the same spots afterwards appear, but of a black colour. The same effect is produced when the stone is touched by greasy hands ; the form of the fingers, and of the skin, will then appear on the stone. Of the other precautions in printing, I have fully treated in the preceding section.

Let us now suppose that a drawing, which, before the biting in, looked very well on the stone, appears subsequently in the printing to have all the above-mentioned, defects, viz., that the

fine shades have disappeared, or at least become very weak, and that the darker shades look quite black or form one large blot, that there are white spots in some parts and black spots in others, besides marks of greasy fingers ; so that the drawing is imperfect in every respect, and has altogether the appearance of being quite spoiled. Two questions now arise : can all these defects be remedied or removed ? and how is this to be done ? To the first question I would answer, that it is my conviction, every one of these defects may be corrected ; but still it will be for the artist to decide whether it would not sometimes be more expedient and require less time to make a new drawing, as these defects can only be corrected by himself, and not by the printer, and as this process requires great skill, costs a great deal of time, and is very tiresome. In answer to the second question, I would give the following directions :—In the first place, let every thing be removed from the stone which ought not to be on it. Where the shade has become too dark, white points or lights must be introduced by the etching needle ; for this purpose let the stone be charged first with very strong, and afterwards with softer, etching-colour ; and then all stains which are not in the drawing, but merely disfigure the white margin of the paper, must be removed by scraping, or rubbing with pumice-stone. In the drawing itself neither erasures nor rubbing down can take place, as this would spoil the grain, and render it impossible to substitute afterwards the emendations in their place. Recourse, therefore, must be had to a needle of good steel, with which

the defective spots must be removed by dotting ; so that after their removal, the surface of the stone may not lose any part of its grain. If some points are too thick and coarse, by a single white point engraved between them, or by a line traced with the needle, they can be rendered as small as necessary, and pleasing to the eye. Here I must observe, that the blotting of dark spots may also happen when the chalk during the drawing slips occasionally over the plate, even though it leaves no visible traces, which arises from the unequal mixture of the lampblack in it ; or when in the re-touching the drawing, by unskilful management the parts already finished are wiped away, the grease of which has already penetrated into the stone. As the subsequent biting in is but very weak, this grease, which on the surface of the stone is not visible, takes ink, and thereby renders the spots more dark than necessary ; in this case a judicious use of the needle mends not only the defects, but renders the drawing more perfect than in the beginning, as parts thus mended take a more pleasing tint, and at the same time more expression, than those that never were mended. When the stone is thus cleaned of all stains and superfluities, let a weak solution of aqua-fortis be poured several times over it, and then let it be washed with gum-water. After a lapse of some minutes, let it be filled in with a good strong ink ; it will then appear that all the light parts of the drawing, by this second biting in, become a great deal lighter : in order to remedy this, let the plate be washed with gum-water, then wiped with a clean dry rag, so as to leave but

a very weak coat of gum upon it. In order to be able to see this well, it is advisable to mix a very small quantity of red chalk with the gum. The stone being now dry, take a flat steel and very elastic pallet-knife, or some similar instrument free from all unevennesses, and rub it on the surface with moderate pressure, and without injuring or erasing the elevated points of the drawing. Care must be taken that the knife be free from all humidity, nor must the exhalation of the person performing this operation touch the stone ; otherwise the exact contrary would be produced from that which was intended, and the parts that ought to take no colour would be prepared to take it. When all the defective parts have been well touched, let the whole surface be rubbed gently with tallow or linseed-oil, and afterwards washed with a weak gum-water. This being done with great exactness, let the stone be charged with a very soft ink, by which all the points that are lost and have disappeared will be made visible again. But if the pressure with the elastic knife has been too great, and the grain has been injured, new stains will arise ; it will, therefore, be necessary to proceed with caution, and rather to repeat the operation, if the first do not turn out quite satisfactory. It will now be better to print with soft ink ; but afterwards, when all the points are sufficiently saturated with grease, a stronger ink may be taken.

Should any one feel disinclined to restore the strength of the

places which are too light by this process, he may attain his purpose by retracing them; but for this he must choose a chalk containing in its composition a great deal of soap, and the stone must be well washed with a great deal of clean water. It will, however, be advisable to complete this sort of correction as soon as possible, and not to leave the stone for days without a coat of gum; because in that case it would be very liable to become stained or monotonous, even if washed with gum-water before the printing. Should, however, the corrections be of great extent, and require more time, the best way then would be to fill in the stone well with etching colour, to wash it with water and leave it to dry. It may then remain thus for several months, but before printing it again, the above process must be repeated, and a weak solution of aqua-fortis and gum-water applied subsequently. Very small defects, such as little white spots, &c., are best corrected by re-touching them, during the first proof impressions, with chemical chalk. A chalk drawing, already bitten in, may likewise be corrected with the pen or with the hair-brush. Spots of a too deep shade can be rendered lighter by passing them over several times with a hair-brush dipped in weak aqua-fortis, and by afterwards re-preparing them with gum-water. These, according to my experience, are the best rules for re-touching and correcting imperfect or defective chalk-drawings, and I am sure, that by exactly observing them in every respect, perfect impressions may be obtained; and a spoiled stone may be restored.—Some practice, however, is in-

dispensably necessary. I shall conclude this article with the following observations which will be found of utility.

1. I have had dogs' skins or very tender calves' skins prepared for covering the rollers, which have answered very well on account of their durability. An ink roller covered with this sort of leather, the outside of the skin where the hair originally was being outermost, (not the inside, though this is the practice of some,) has a particular affinity to the ink, which I suppose arises from its smoothness, and the elasticity of the surface, that contribute very much to spread the ink uniformly on the stone. This quality is still increased, when the roller, before it is saturated with ink, is wetted a little with water ; but if, during the printing, the stone is kept too wet, this will render the taking ink difficult, for, instead of attracting the ink, it will then repel it, leave it in too great quantity on the surface of the stone, and cause unclean and spoiled impressions. When the roller has been used very long, it loses likewise the elasticity and smoothness of its surface, and is thereby rendered unfit for good impressions, especially of chalk drawings. This is the case in a still greater degree, when the roller has become hard by the drying of the ink. In order to obtain tolerable impressions with such a roller, the ink must be of a very hard nature, and contain a great deal of lampblack, which, however, is only compatible with coarse pen-drawings, for in chalk-drawings this would occasion imperfect impressions, and most likely spoil the plate. By using again a very soft ink, con-

taining a considerable quantity of varnish, the impressions would spread. If, after having used for some time a roller of this nature, it is changed for a fresh-covered one, the drawing will not seem to be the same, so striking is the difference between the impressions. I am, therefore, inclined to believe, that the quality of the roller is of greater importance in obtaining perfect impressions of chalk, or fine pen-drawings than even the quality of the ink ; the best way is, to change the rollers from time to time, and after using them, to rub them well with linseed-oil or butter, in order to keep them the longer soft and smooth. In chalk-drawings of great value, I would recommend the incurring this trifling expense, and the giving new coverings to the rollers.

2. I have already observed, that the colour of the stone often deceives the artist in the just proportion of the tints, and that in general the drawing on the half-tinted stone has a better effect to the eye, than on the white shining paper. This induced some artists to take impressions on a yellowish paper, like the stone, which satisfied their utmost expectations. Some difficulties, however, arose, for this paper is very expensive when of the best quality, and the inferior kinds contained ingredients in the colour which soiled the impressions. Experiments were therefore tried, to print the paper first and afterwards colour it. But this likewise could not be effected without difficulty ; so that after many fruitless experiments the method of printing a yellowish tint by means of a second stone

on the drawing already printed, obtained the preference. This method was not only found the cheapest and most expeditious, but it possessed this advantage, that the margins of the paper could be left white, which contributes to heighten the effect of the drawing. It had scarcely been used several times with complete success, when Mr. Piloty, an eminent artist, suggested the idea of printing in lights with white colour, in order to render the impressions more like autograph drawings. The experiments which I tried for this purpose, were not crowned with success, as white oil-colour does not print lively enough ; and I, therefore, proposed to leave white spaces for the lights in the tint-plate, or to cut them into it, and thus produce the light by the mere effect of the white untinted paper. This was the origin of the manner of printing chalk-drawings with one or more tint-plates, which has since become so generally admired, that amateurs of the art think it the triumph of Lithography. It will not, therefore, be unwelcome to my readers to find here a detailed description of the manner of managing and printing these tint-plates. I have devised several methods for this purpose, but supposing that these different schemes will be familiar to every one, who attentively peruses this treatise, I intend to communicate here only the most perfect of all.

Take a middling good stone (it need not be of the first quality;) and prepare it in the same manner as for chalk drawing, *viz.*, uniformly rough, of a coarse grain. When clean and dry, let the following chemical ink be spread over it very strongly, so

as to resist fully the action of the aqua-fortis ; the ink must not be too thick, otherwise the subsequent introduction of the lights will become very difficult. Chemical ink for preparing the tint-plates : 4 parts of wax ; 1 part of soap ; 2 parts of vermilion. The two first ingredients must be melted together, over a moderate fire, in a clean vessel ; then let the vermilion be mixed with it. Of this ink take as much as the size of a hazel-nut ; rub it in a clean saucer ; dilute it with rain-water, till it gets so fluid that, with a hair-brush, it can be spread over the stone. The stone thus charged with ink should be left to dry ; let an impression with rather soft ink be taken from the drawing on the other stone, on well-sized, but sufficiently soaked, paper. As soon as taken, and before the paper has time to shrink by drying, let the tint-stone be put into the press, and the impression just obtained be placed upon it. Then, with a moderate force of the press, let a transfer impression be taken, so that the whole drawing may be copied on the wax. The paper, after this operation, will adhere strongly to the stone ; in order to remove it without injuring the tint, let it be soaked with a solution of aqua-fortis, till it dissolves, and is easily wiped off. Great care, however, must be taken not to injure the transferred drawing by too strong pressing and rubbing. This operation may be performed with still greater ease, if a peculiar paper for transferring is prepared ; this is best done by washing the side of the paper upon which the impression is to be taken, with diluted starch ; the paper must be well sized in this case ; a small quantity of gamboge may be

mixed with the starch. This paper must be soaked very slightly, otherwise it will refuse to take the impression. When transferred to the tint-stone, let the blank side of it be soaked with diluted aqua-fortis, after which it will easily go off the stone, as the starch when dissolved by the water does not retain the ink any longer. The drawing being thus transferred to the tint-plate, let the coat of wax which covers the stone be scraped off, in all those places where lights are to be introduced, by means of mezzotinto scrapers. The stone being prepared rough, as if for chalk-drawing, in the beginning of the scraping a few single points will appear, as only the most elevated points are touched. By continuing this operation, the scraper penetrates at last to the true surface, and produces a perfectly white light. Whoever has acquired the necessary skill in this operation, can imitate in these tint-plates the effect of India ink, and from the most delicate light rise to the most brilliant and striking, by which the drawing gains considerably in effect and perfection. The lights being thus introduced, the margins of the drawing must likewise be scraped off, so as to remain white in the impression ; let the whole plate then be washed several times with aqua-fortis and water (twenty parts of water to one of aqua-fortis,) and subsequently treated with gum-water. When this is done it will be fit for printing. As to the act of taking impressions, it is necessary to take very great care to put the paper for the second impression exactly in the old position, so that the lights may appear in their proper places. In order to effect this, the artist used formerly to mark two points

on the plate containing the drawing, very near the margin, with chemical ink, which were printed on every impression, transferred to the tint-plate, on which they were likewise marked by engraving. When the drawing was printed, the margin of the paper was cut away just over the two marked points, and with these points exactly coinciding it was put upon the stone ; in this manner the paper was placed always in the same position, and the impression of the two stones perfectly coincided. The only inconvenience of this manner was that every impression required to be cut carefully off, otherwise the impressions were deficient ; for proofs, however, it was suitable enough. But when a great number of impressions must be taken, it is more advisable to contrive a small moveable frame, in the printing frame (which must be very carefully made, so as to shut always in the same spot, and never to vary in the least,) in which two steel pins are fixed, which can be put at certain distances from each other. The printing frame being thus constructed, let the inside of the leather be rubbed with wax, and a sheet of white paper put upon it. When the tint-plate is fixed in the press, let an impression be taken on this sheet of paper, so that the two points, serving as guides, may be also printed. The two steel pins in the little frame are placed so as to be exactly over the two marked points. Now, if an impression of the drawing is put in the frame, so as to be just under the needles, with its two marked points, there is no doubt that it will be in the exact position for the tint-plate, and coincide in all parts. As soon as the

printing-frame fixes the paper on the leather, let the small frame with the steel needle be removed, in order not to impede the impression. The strings of the printing-frame must be well stretched, so as to prevent any alteration of the position of the paper. For printing the tint-plate take strong varnish, mixed with umber or satinober, or any other colour. The rollers for this purpose ought to be fresh covered, in order to get an equal unspotted tint.

3. In giving the rough polish to the stones, it is very difficult to avoid coarse lines, or furrows, occasioned by sharp sand grains. On a plate, thus disfigured, no drawing of very great value should be made, as these defects always appear in the impressions, and produce a very bad effect. If, however, such a stone has been chosen, the most striking of these furrows ought to be corrected, or concealed with chemical ink and a fine hair-brush; for with chalk, though pointed as sharp as possible, it will be very difficult to enter.

4. One of the greatest difficulties is to preserve in chalk drawings the proper keeping, as after the biting in, the light spots appear lighter, and the dark ones darker than before; I, therefore, tried to draw the lighter parts on another stone, somewhat heightened in strength, and to print them afterwards with lighter colours; the success surpassed my expectations, and I am induced to hope, that, by clever artists, true masterpieces of art may be thus produced.

5. When any one is well versed in the mode of printing with two stones on the same sheet of paper, with perfect coincidence, the transition to the art of printing with more than two plates, and parlicularly to that of printing in colours, will not seem difficult. Even shortly after the invention of the art I tried to fill in a chalk drawing with more than one colour, for which purpose I used to cut out patterns, in the manner of card-makers. I took on transparent paper as many impressions as the number of colours amounted to which I wished to print. Then I cut out in one all those spots which were to be coloured red, in another all those that were to be green, and so on. When the stone was wetted, the cut-out impression was put upon it, and the uncovered spots charged with the colour. As soon as all the colours were thus put on the stone, and during this process the stone was wetted several times, I took the impression, which in general had a good effect, though more like a sketch of a coloured drawing than a real picture, because in no colour, except black, vermilion, and dark blue, could I obtain the necessary degree of strength, at least in proportion to the rest of the colours. But by having recourse to more than one stone, each of which must be drawn in such a manner as to correspond with the greater or less degree of strength necessary for the colour, very perfect impressions, similar to the English coloured prints, may be obtained, especially when the pen, or hair-brush drawing, and the chalk drawing are united.

6. The rough preparation of the stone can be also produced

by acid, instead of sand, as above described ; this is done in the following manner : Polish the stone as smooth as possible with pumice-stone, wash it with a solution of aqua-fortis, and afterwards with gum-water. Let it then be well cleaned with water, and wiped with a clean cloth. After this, let a thin but uniform coat of tallow be put over it ; a small quantity of lamp-black may be mixed with it, in order to distinguish more easily whether the greasy coat be equal on all the parts of the stone. Take a roller covered with fine cloth, and pass it over the stone, till the coat becomes perfectly equal through-out. Let a few drops of diluted aqua-fortis be applied to a cor-ner of the margin, and observe carefully whether this acid has penetrated in an equal manner to the surface, and causes small equidistant bubbles to arise on the surface. Some practice is necessary, to determine the exact thickness of the coat ; it must be very thin, and just thick enough to resist, in some degree, the action of the aqua-fortis ; so that it may affect only those spots which, by the friction of the roller, have been de-prived of their coat. If the trial in the corner of the stone answers expectation, let an elevated margin of wax be put round the stone, such as copperplate-engravers make, and then let a proportionate quantity of diluted aqua-fortis be poured all over the stone, so as entirely to cover its surface. A very weak solution of aqua-fortis, for instance, forty parts of water to one of aqua-fortis, is better than too strong an acid, which is very apt to affect the stone too much. As soon as the bubbles attain the size of the heads of small pins,

let the aqua-fortis be removed, and pure water poured in its stead over the stone, in order to destroy the bubbles ; as soon as this is effected, the water must be let off, and a solution of aqua-fortis put in its place again ; this operation ought to be repeated three, four, or five times, according to the size of the grain to be produced, and then the stone ought to be cleaned with oil of turpentine, in order to remove all remaining particles of grease. It ought next to be washed, first with a weak solution of aqua-fortis, and then with a great quantity of water; and, lastly, it ought to be wiped clean with linen rags. When thus prepared it is fit for use ; and, if this operation has succeeded, the grain produced will be much more equal and finer than if it had been obtained by rubbing the stone with sand.

7. The operation just described explains the process of drawing with chalk upon a stone previously prepared with aqua-fortis and gum-water ; this process is not in the least injurious to the durability of the drawing, provided the connexion of the gum with the stone be perfectly destroyed by the subsequent application of diluted aqua-fortis ; and the effect of this acid be removed by frequent washing with pure water. If the chemical chalk in its composition contains a great quantity of soap, the success will be more certain ; because, after having been twice, and, including the intervals between the elevated points, three times exposed to the action of the aqua-fortis, the stone requires afterwards, in the finer and more delicate shades, but a very slight degree of biting in.

The biting in of the drawing, at least before it is washed with gum-water, and charged with etching-colour, is altogether unnecessary, and every one must decide from his own experience, whether in general it may or may not be advantageous, previously to bite in the stones with weak aqua-fortis, after having been prepared even with sand, and to clean them well again with water, before the chalk drawing is begun.

8. Some experiments, which I tried to bite in chalk-drawings stronger than usual, convinced me, that though the finest spots suffered some injury, yet by the application of a flat knife they could be perfectly well restored ; and I thus obtained the advantage of having the stone better prepared, than can be effected by the common way of biting in too little.

9. Should a chalk-drawing by negligence or ignorance be spoiled during the printing, the same observations which were made with respect to pen-drawings, apply here.—As to the corrections, the judgment of the artist must decide, which of the proposed means and expedients are best suited for the various cases.—In general it may be said, that the best manner of mending such places as have been injured by rubbing, is to re-touch them with chalk, and for such places as have become soiled, the application of stronger ink, and subsequent charging with etching colour, and then a weak application of diluted aqua-fortis are advisable, which operation must always be terminated by washing with gum-water.

§ 3. *Transfer and Tracing Manner*.

In Pen, or Chalk drawings, all the lines and points which are to take ink and be printed, are drawn with a greasy matter on the stone itself. But there is another manner in Lithography where the drawing or writing with the same unctuous composition is made on paper, and is transferred from thence by artificial dissolution to the stone, and printed from it. This manner is peculiar to the chemical printing, and I am strongly inclined to believe, that it is the principal and most important part of my discovery. In order to multiply copies of your ideas by printing, it is no longer necessary to learn to write in an inverted sense ; but every person who with common ink can write on paper, may do the same with chemical ink, and by the transfer of his writing to the stone, it can be multiplied *ad infinitum*. At Munich, at Paris, and St. Petersburgh, this manner is already used in the government offices. All resolutions, edicts, orders, *&c.*, agreed to in the cabinet meetings, are written down on paper by the secretary with chemical ink ; in the space of an hour fifty impressions may be had and distributed at pleasure. For circulars, and in general all such orders of government as must be rapidly distributed, an invention like this is of the utmost consequence ; and I am convinced, that before ten years shall elapse, all the European governments will be possessed of a lithographical establishment for trans-

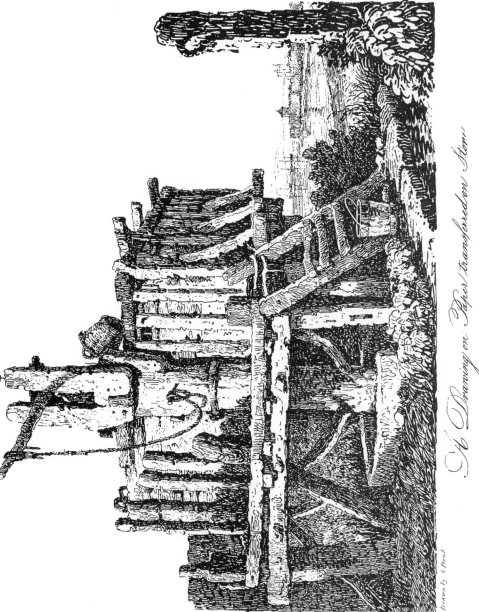

A Drawing on Paper transferred on Stone.

Drawn by S. Prout.

ferring writing to the stone. In time of war, this method is of the greatest use for the general staff of the army ; it supplies entirely the want of a field printing-office, and admits of greater despatch and secrecy. The commanding officer may write his orders with his own hand, and in his presence a number of impressions may be taken from them by a person who can neither write nor read ; or by placing the stone in such a manner that the reverse is turned towards the printer, he may be prevented from reading any thing. If plans of military positions or topographical sketches must be given, the engineer has only to draw them on paper,. and in a short space of time all the general officers may be supplied with them. In commerce and trade the transfer manner will, ere long, be generally introduced ; especially in great commercial houses, where it often happens that a quick and accurate multiplication of price lists, letters, and accounts is of the utmost importance. Men of letters and authors may by means of it multiply in a cheap and easy manner their manuscripts, which they are often obliged to transcribe with great pain and trouble to themselves. Music printing will, by the introduction of this manner, receive new life, as the expenses of engraving will be very greatly reduced. In all countries, where type-printing is not yet introduced and type foundries are unknown, the transfer-manner will obtain the preference ; and even in European printing-offices, where a number of books in the oriental languages are printed, in those of the Bible societies for instance, it will be found highly advantageous.—It will be of the utmost benefit to artists by enabling

them to obtain fac similes of their drawings. From the most sincere conviction of its utility, and not any motive of vanity, I have thus detailed in a brief manner the various advantages of transfer-printing ; it would indeed be an easy matter, by expatiating on these advantages, to fill a whole book. I wish from the bottom of my heart to gain friends to this manner, and to point out the various important purposes to which it may be applied, in order that clever artists may devote themselves to its improvement.

In the various methods which I have tried in the transfer manner, in order to transfer a writing executed with chemical ink to paper, I have used either hard or soft ink : and the paper may either be prepared on purpose or not. The operation of transferring may be effected either with warm or cold stones. The writing may either be entirely dissolved, or only in part. To describe all this, would lead to unnecessary digressions ; and I have, therefore, chosen in the following lines to communicate only that method, which after many experiments, I am of opinion is the best ; *viz.*, that where soft ink is used for the writing, and the stone is not warmed before the transfer, this is the best, quickest, and surest manner, and possesses besides the advantage of not spoiling the original. Take as much as the size of a hazel-nut of the chemical ink described page 112, dissolve it in a clean saucer, and dilute it with rain or soft river water. The degree of liquidity should differ according to the size of the characters ; if they are of a large size, the ink

To

Mr Alois Senefelder Inventor of the Art of Lithography and Chemical Printing.

Eer Art is to its full perfection brought,
What strength of mind, what energy of thought!
What bold Invention, what expansive power,
Blend in the Labours of the pregnant hour!
How much then from a grateful Age is due
To those who toil, Senefelder, like you!
How great your boast, who, by your matchless Skill,
Can quicken Labour's progress at your will;
Can, by your chymic, multiplying powers
Convey to Life so many added hours;—
And, since your potent Art began to live,
One Hour creates what days were wont to give.
Bavaria, happy to enroll your name,
Among her fav'rite Sons partakes your fame;
While her sage Sov'reign bids that fame encrease;
And gives thee Honour, Competence and Peace.

The above lines are a Transfer composed by, and in the Hand Writing of my Friend the Author of Dr. Syntax.

London February
25th 1819

R Ackermann

ought to be made very fluid, in order that after the drying the letters may not have too much body, which disposes them to spread. It is not quite so easy to write with the chemical ink, as with the common writing-ink prepared from gall-nuts and vitriol of iron. This is owing to the following disagreeable qualities which it possesses, *viz.*, its tendency to run on the paper and to affect very soon the writing pens, by rendering their point soft, which causes them to require frequent cutting. Perhaps, one day an ingenious chemist may obviate these inconveniencies by inventing ink of a more perfect composition. Practice, however, is of great advantage in this respect, and there are several copyists at Munich, who can write with chemical ink with almost as much ease as with common ink. The best plan is to have a store of new-cut pens in readiness, and to lay aside those which have been used for a time to dry. As to the running, there are some sorts of writing paper, which are not liable to this defect. But I have discovered a composition by which almost every species of paper may be rendered fit for the use of the chemical ink. If a steel pen could be invented, as flexible and elastic as a common goose-quill, this would be attended with great advantage, and then the art would be near its perfection.

The following is the composition for preparing the paper, for very fine writing or very delicate drawings;—Take half an ounce of gum-tragant in a clean cup, and fill the cup with water; let this stand at least forty-eight hours: a week or two,

however, is still better. During this time the gum will be dissolved and form a kind of paste with the water, not unlike common starch. Then work the mixture well together, and press it through a clean cloth, in order to remove all uncleanness. After this, let one ounce of common joiners glue, and half an ounce of gamboge, be dissolved together in water. Then take four ounces of fine French chalk, half an ounce of plaster of Paris, mixed with water and afterwards dried, and one ounce of common starch. Let all these ingredients be well pulverized and mixed with a proportionate quantity of the above liquid, so as to form a fine paste; let the rest of the liquid composition be then added to it, and let the whole be pressed through a fine cloth. Add a sufficient quantity of water to make it so liquid, that with a hair-brush it may be applied to the paper. The paper, by this operation, will take a light yellowish colour; when dry, let it be put with the prepared side on a smooth stone, and passed through the press with a considerable pressure, in order to effect a still finer preparation for drawing upon it in very delicate lines.* This composition must be used sparingly, or the ink will be apt to spread in the print.

While the drawing is drying on the paper, take a very

* The fine French paper, called *Papier de Satin,* is very good for the above use; and for this paper, another composition, composed of glue dissolved in water and Venetian sugar of lead, mixed with a small portion of hogs' lard, may be used. After it is dry, let it be pressed through the press upon a smooth stone, to render it as brilliant and smooth as before.

clean stone, carefully rubbed down before-hand, and, in order to be quite sure of the effect, let it be rubbed down a second time with water and pumice-stone, so that no stain or particle of grease may be left in any part of it. Let the dust arising from the rubbing down be carefully wiped off with soft waste paper; let the stone then be fixed in the press, and the scraper well examined, to ascertain whether it fits the stone exactly. Great care must be taken not to touch the surface of the stone thus prepared, even with the finger, and still more not to soil it with grease or dust. Then examine the paper, to see whether the whole of the lines composing the drawing are perfectly dry; if this is the case, let the reverse side of it be sponged with very weak aqua-fortis, till it is thoroughly wet and soaked. Then put it for some time between dry blotting paper, in order to free it from the superfluous liquid, and render it uniformly moist; for it must not be too wet, but only soft, otherwise the ink in transferring would be liable to spread. When the paper has thus obtained the proper degree of softness or dampness, let it be placed on the stone with the side containing the drawing next the stone, but without moving it much, or altering its position; let two sheets of dry blotting paper be put upon it, then a piece of silk cloth, then again a sheet of blotting paper; and let the stone, under a moderate pressure, be passed two or three times through the press. In very large plates, it is desirable to use a cylinder-press, instead of a lever-press. After this the stone ought to be taken out of the press, and left to dry for a minute or two. It must next be placed in the

preparing vessel or box, used for biting in, and let a weak so-
lution of aqua-fortis, one hundred parts of water to one of
aqua-fortis, be poured over it, as in chalk drawings, so as to wet
the whole of the surface. When this is done, let pure water
be poured in like manner over it until the paper is disengaged,
and the stone ought then to be put by for some minutes to dry.
If the work presses very much, the solution of gum, necessary
for the preparation of the stone, may be applied directly.
The drawing is supposed to be now on the stone, bitten in,
and prepared. But, in order to be sure of obtaining very clean
impressions, the ink must be well prepared, the stone charged
with etching-colour, and bitten in a second time, and more
strongly than before. Do this in the following manner :—Take
a small piece of linen or cotton, dip it in the colour which has
been spread on the stone, till the colour has every where ad-
hered to it ; rub the transfer on the stone all over with this,
till all the lines and points of it look jet-black. This must be
done while the gum is yet on the stone. I call this operation
the ink preparation ; and as in the course of this chapter I
shall have occasion to mention it repeatedly, I shall henceforth
suppose it known to my readers.

The transfer manner is not only applicable to pen drawings,
but likewise to chalk drawings. The chalk for this purpose
must be rendered very soft by adding a little tallow to it ; or
if hard chalk is preferred, the stone, before the transfer, must
be warmed a little. But the filling in of it, or the ink pre-

paration, cannot be effected till it is quite cold again. For chalk transfers a common well-sized drawing paper is necessary, which must be soaked afterwards with a stronger solution of aqua-fortis, in order to leave the chalk more uniform. The rest of the process corresponds with that above described.

Besides these two sorts of drawings, the transfer manner is applicable to all products of printing, either with types or wooden blocks ; and a newly-printed sheet can immediately be transferred to the stone, especially when the printer, instead of his common ink, has used the above-mentioned etching-colour, or ink. In order to obtain a perfect transfer, the printer ought not to apply too great a pressure, by which the types make impressions or small cavities in the paper ; if, however, these cavities have been produced, the printed sheet, before being transferred, must be passed through the press under a moderate pressure, in order to become perfectly level and smooth, and free from all impressions. But lest in effecting this, the ink should be too much weakened, and afterwards unable to pro-duce a perfect transfer, the best way is to soak the printed sheet, to put it upon a perfectly wet stone which has been previously well prepared, in order to diminish its tendency to take ink, and pass it through the press with a very moderate pressure.

The tracing-manner has a very great resemblance to the transfer-manner, as the quantity of grease left on the stone is

very trifling, and can only obtain the necessary strength by subsequent ink-preparation. It is managed in the following manner :—Take a piece of very thin bank post-paper, rub one side of it with tallow and lampblack, and wipe it carefully, so that only a fine coat may remain on the paper ; which, when placed on a clean stone, will not soil it, provided it be not violently pressed upon it. If on such a paper a drawing has been executed with a common lead-pencil, containing no hard particles or sand-grains in its composition ; or with a composition of lead, bismuth, and zinc ; the lines touched by this pencil must be violently pressed upon the stone, which, in the parts thus pressed, takes the grease, and can afterwards be printed. The operation of biting in of a drawing thus traced, must be done with a great deal of care, and the aqua-fortis must be very weak and diluted. The rest of the process is the same as in the transfer manner.

This manner holds a medium between the pen and chalk manners. For sketches, or such drawings as are to be coloured afterwards, it is of great use, very easy, and takes but very little time.

§ 4. *The Wood-cut Manner.*

Here the dark parts of the design are covered entirely with chemical ink. When perfectly dry, the lights are taken out

In imitation of Woodcut

R. Ackermann's Lithography

with apointed and flat etching needle. As to the parts which are more white than dark, and where very fine points and lines occur, they are produced by the pen. The wood-cut manner, therefore, differs principally in the management of the darker parts from the common pen-drawing. The execution of it on the stone is a great deal easier than on wood. Among the specimens will be found one which shows how the wood-cut and chalk manners may be imitated.

§ 5. *Two sorts of India-Ink Drawing.*

One of these manners is in practice very like the wood-cut manner, but the effect of it is more like that of scraped or mezzotinto engravings. The following are the details of the operation :—The stone is prepared of a coarse grain, cleaned with water, washed with soap water, wiped and dried ; and, lastly, a thin coloured-coat of grease is put over it. This last is done by covering the plate either with etching ground (as will be described elsewhere in the engraved manner,) or with hard chemical ink. The previous biting in and preparing is indispensable, in order that this coat of grease may not penetrate too deep into the stone, but remain only on the surface. The drawing is now executed with the same tools which mezzotinto engravers use ; the more you scrape away, the stronger the lights appear. This method is, therefore, perfectly similar to that described for preparing tint-plates ; but it requires a

greater degree of attention, as the plate in this case serves not only to heighten the effect, but represents a finished drawing. In this manner, contrary to the common way of engraving, all must be worked from shade to light. The drawing being completed, it is bitten in (this is best done with phosphoric acid,) and washed with gum-water. A few drops of oil of turpentine are then poured over it, and all the colour is wiped off with a woollen rag, without rubbing hard. The stone may now be filled in with a strong etching colour, and in printing it, care must be taken not to press it so much as to cause the spreading of the ink. Several experiments made by myself, have convinced me sufficiently that, in this manner, very fine india-ink drawings may be produced ; especially when the very dark spots are engraved, and when the stone is not charged with the roller, but filled in with linen rags, as will be more fully described in the engraved manner.

The second manner, if carried to the degree of perfection of which it is capable, would surpass even the chalk drawing. As I have tried a great number of experiments in it, I shall here communicate my method to my readers, in order to point out a way by which the improvement and perfection of this very interesting manner may be attempted. The stone, which must be very clean, and free from all grease, should be prepared of a coarse grain, washed with soap-water, cleaned with turpentine, and left to dry. Then let a hard chemical ink, which in its composition must contain a proportionally great

quantity of soap, be dissolved in rain-water; the drawing should then be executed on it in the same manner as you would observe in an Indian ink drawing on paper. When all is completed and perfectly dry, let the whole surface be rubbed with a brush or cloth, in order to produce small holes in the colour. But as on those places where the ink is thinner, the effect of the rubbing is greater than on those where the coat is of more consistency, the aqua-fortis which is subsequently applied will bite them in stronger, and will render them lighter in proportion to the gradation of the different tints ; but much will depend on the durability of the ink. It therefore requires some practice to determine the necessary strength of the aqua-fortis, and of the ink ; for this purpose it is advisable to prepare at once a greater quantity of ink, and to write down the exact proportion of the mixture of aqua-fortis with water, and make some experiments, in order to be sure of success in subsequent ap-plications. In no case, however, should the aqua-fortis, or other acid applied, be too strong ; and the biting in must be effected in the manner which is practised by engravers, by surrounding the stone with a border or rim of wax, and not by infusion or washing, for the effect of the aqua-fortis must be equal and uniform on the whole surface. As soon as the bubbles are of the size of a small pin-head, let this aqua-fortis be taken off, and fresh poured on, in order to destroy these bubbles. The number of times this is to be repeated, must depend on the strength of the ink. The smaller the quantity of lampblack it contains, the stronger it is, and the better it will

resist the aqua-fortis. It remains to be observed, that to produce very dark shades, the strong touches must be twice passed over with chemical ink, even after the plate has been wiped with cloth, because by this rubbing or wiping the darkest spots, if not very strongly expressed, are too much perforated, and in the printing would appear too light. The washing of the stone with gum-water after the biting in, is a matter of course. The putting on of the ink is done with the cylinder, or, as in the engraved manner, by rubbing in. The latter method produces softer, but not very dark, impressions. So much as to this manner, which I am sure deserves to be more known and practised by artists, than it has hitherto been. I conclude with the observation, that in this manner tint plates may be very well prepared for chalk drawings.

§ 6. *The sprinkled Manner.*

This easy manner will, I am sure, become one day very general. It is practised in the following way :—The outlines of the drawing are traced on a stone prepared for pen-drawing ; then they are retraced four times, on different sheets of paper. In each of these sheets, all those places which belong to one of the four principal tints are cut out with a pen-knife, so that these four sheets may serve as patterns, such as those which card-makers use. The principal outlines of the drawing being now traced on the stone with a pen or hair-brush, let one of

Part of an unrolled Papyrus.
from Herculaneum

R. Ackermann's Lithography

the patterns be placed exactly upon it, and kept down with some weight to prevent its moving ; the operation of sprinkling may then be performed. This is done by dipping a tooth-brush in chemical ink, and by passing it over the edge of a knife, so as to sprinkle the ink on the stone. After this ope-ration it is necessary to try the sprinkling a few times on paper, to remove the superfluous ink, and to see whether the points produced by it correspond to the degree of shade required. By practice in this operation fine and uniform points may be pro-duced, such as it would be impossible to make with the pen. As soon as, by repeated sprinkling of the chemical ink on the parts of the stone which have been cut out, the adequate tint is produced, the stone must be left to dry; then the second pattern should be placed upon it, and the above operation re-peated. The greater the number of patterns which are made, the more the drawing may be finished by sprinkling. But it is not necessary to make too many, as, in general, the drawing must always be finished by hand. This finishing is completed by reducing the points which are too large with the needle, and by uniting the different tints with the pen, and by thus introducing the just proportion of the tints and tone. The pro-cess in biting in and printing is the same as in pen-drawings.

§ 7. *India-Ink Drawing, with several Plates.*

———

This manner is a multiplication of tint plates; drawings may

be produced by it equal to those made in Sepia or Bister. Great attention, however, is required in fitting and printing the stones, each plate yielding a distinct tint or shade, which, when properly fitted, in printing produces an admirable effect. The outlines are drawn with chemical ink on the stone ; then transfers of the same are printed upon four, five, or six other stones prepared for pen-drawings, in which the two leading, or marking points, for the exact fitting of one impression on the other, as already described in the tint plates, must be likewise printed. Then the darkest shades, or tints, are put on the first stone, the middle tint on the second, the half tint on the third ; and so on, till the whole drawing is completed. The drawing must be executed with the camel hair-brush and flat tools. The sharp lights are either pared or scraped out from the lightest tint stone ; the dark touches, if any are required, must have a separate plate or stone. One or more of these stones may be done in chalk, in order to produce more gradations of the tint ; but to imitate the effect of India ink correctly, the number of plates must be increased, in order to conceal as much as possible of the chalk-drawing*. The biting in is the same as in pen-drawings. In the printing, appropriate ink must be chosen for every plate, answering to the tint

* This sort of India ink-drawings may be printed with transparent or opaque-coloured ink, according to the choice of the artist. The first is prepared with strong varnish, mixed with French chalk, and, according to the strength of the tint, with more or less lamp-black. For the second, the same varnish, with white lead, mixed with a proportionate quantity of ink. The latter has more resemblance to those

requisite for that part of the drawing. It is hardly necessary to mention that great care must be taken to make the drawings on the different stones coincide perfectly with one another ; and I would only observe, in recommendation of this manner, that any seeming difficulty ought not to deter a person from continuing it, as a small degree of practice will convince him that no other is so fit for producing very finished drawings.

§ 8. *Manner of Printing in Colours with several Plates.*

This manner, in which the different colours are drawn with the pen, with the brush, or with chalk, on several plates, has in practice the greatest resemblance to that which has just been described. The manner in which the artist executes the drawing will determine whether it is to resemble a painting, or an engraving printed in colours ; or, when the different colour-plates are printed upon a black impression, which already contains the whole of the drawing, whether it is to resemble an engraving coloured by the hand. In other respects, the whole process is like that just mentioned ; and I have only therefore to treat of the composition of the colours which I found best to answer the purpose. For a red colour, take vermilion, red-lake of cochineal, or carmine, mixed previously with

drawings which are commonly called gray neutral tint. If one wishes to obtain brown impressions, a little vermilion, burnt umber, or red-lake, and a sufficient quantity of lamp-black, may be added.

Venetian turpentine, and then with varnish. The varnish must be added after the turpentine, otherwise it will not unite with the rest, and, when mixed with water, it will produce a red tint all over the paper. For a blue colour, take Prussian blue, or mineral blue; of these colours, however, only a small quantity can be mixed at a time, as they last but a few hours, dry very quickly, and render the varnish too hard, so that it must be diluted with linseed-oil. Fine indigo may likewise be used. For green and yellow I have not yet been able to discover good compositions. Verdigris is very difficult to manage, and will mix with very few colours, and is apt to soil the stones. Schweinfurt green, a newly-discovered colour, is much better, but not deep enough. Prussian blue, or indigo, with crome yellow, or king's yellow, as also Prussian blue and yellow ochre, make tolerably good dark greens; but with the latter colour a small portion of Venetian turpentine should be mixed. For a fine dark yellow I have not yet discovered a good composition; in the meantime, however, till a perfect colour for this purpose be found, recourse must be had to ochre, terra di Sienna, Naples yellow, mineral yellow, crome yellow, and Indian yellow. From quercitron, or some substance yielding a similar yellow colour, a durable yellow lake may be prepared. One which I tried to prepare from French berries has a very good effect, but is very perishable, and does not stand the effect of the sun.

The manner of printing in different colours is peculiar to the

stone, and capable of such a degree of perfection, that I have no doubt perfect paintings will one day be produced by it. The experience which I have gained in this respect corroborates my conviction ; and if my time were not so much taken up by various occupations, I would justify it by some specimens. I do not, however, give the matter up, but postpone the consideration of it to a supplement, which I shall publish perhaps very soon.

§ 9. *Manner of Printing in Gold and Silver.*

This manner is very useful for ornaments, and is thus managed:—Those lines, or points, which, on the impression, are to appear in gold or silver, are drawn with chemical ink upon a stone prepared for pen-drawing ; which, after the drawing is perfectly dry, is bitten in and prepared in the common manner. It is then printed with a grey colour, composed of hard varnish, fine chalk, and very little lampblack. The paper used for this purpose must be quite dry, and very smooth. The best is the French *papier de satin*, or the glazed English plate-paper. Soon after the impression is taken, the printed places are covered with gold or silver leaves, such as are used in gilding. They are pressed down gently with cotton, to prevent their flying off, then a piece of paper is put upon them. The same process is observed on the second impression, and so on with

every succeeding one. More impressions ought never to be made than what can be covered with gold or silver in two hours ; for when the ink is too long on the paper before it is gilded, or silvered, the colour will sink into or dry on the paper, and not allow the adhesion of the metal. The impressions must be left for some hours, or rather till the next day ; in order that the ink may adhere better, and that in the subsequent pressing the colour, it may not shine through the metal and spoil its effect. The pressing of these impressions covered by metal, is effected by laying six or eight of them upon a clean, dry, and very smooth stone, fixed in the press, and by passing them through the press with the usual power of printing. The degree of pressure must be regulated by the consistency of the varnish which is used for the ink. It is, therefore, advisable to make first an experiment with one single impression, and if it should be observed that the metal does not adhere sufficiently, the degree of pressure must be increased. Let the superfluous gold or silver be then gently wiped off with clean cotton, which may be done without difficulty, as it adheres only to the printed spots, and not to the rest of the paper. If gold or silver is to be introduced into drawings, where other colours, or at least the black colour, is used, the metal must be put on, and fixed first of all. When the operation of covering and cleaning has been performed, the other colours may be printed in. The precautions with respect to the fitting the different plates in printing, must be diligently observed.

I conclude this chapter with the sincere wish and hope, that in my explanations and descriptions I may have been sufficiently clear and intelligible, and have detailed every particular operation in such a manner that the exertions of artists can hardly fail to be attended with success, if they have only patience and perseverance, and will observe with judgment and accuracy the rules laid down for them.

CHAPTER II.

The ENGRAVED MANNER *of* LITHOGRAPHY.

———

THE difference between the engraved manner and the elevated manner consists in this—that in the former, the greasy substance, which, on the stone, is to attract the printing ink, lies beneath its surface, as the lines of the writing, or drawing, are previously engraved into the stone by the needle, or etched into it with an acid, and subsequently filled with grease ; so that it remains fixed in the cavities, and though partly pressed out in the printing, can always take fresh ink. Like the elevated manner, it has several subdivisions, which, as they differ in management, have a different character. The principal of these are the following :—

§ 1. *The incised or engraved Manner.*

———

This manner is one of the most useful in Lithography, and is nearly equal to the best copper-plate-printing, (provided the artist has acquired sufficient practice, and the printer the necessary experience,) while the stone can be wrought rather

more expeditiously and easily than copper; for fine writing and maps, it is peculiarly well adapted, as the number of lithographic maps published sufficiently prove. It is equally fit for vignettes and other small drawings, as may be seen from the specimens after Callot, here given. The manner of line engraving may also be imitated by it.

The following is the mode of managing this manner :—

Let a hard and faultless stone, of the best quality, be selected, rubbed down as smooth as possible, bitten in with aqua-fortis, and prepared with gum-water. This at least was my first manner of proceeding, which is still to this day in use in all lithographic establishments. I have since discovered, that it is rather better to prepare the stone only with gum-water, without biting it in previously, as it may thus be more easily wrought on. Immediately after the stone has been prepared with gum (and not after a lapse of some hours, as is usual with some under the idea that they will obtain a better preparation,) let the gum be washed off with clean water, lest it penetrate too deep and afterwards prevent the finest lines from taking any ink. The stone ought then to be covered with a thin colour, prepared from a solution of gum and lampblack or red chalk; this may be done with a flat varnish brush. This preparation is intended for the double purpose, first of giving a fine colour to the stone, by which the lines subsequently engraved with the needle may appear more distinctly; and second-

ly, in order to cover its prepared surface with a preserving coat, which may admit the greasy colour only on those spots where it has been removed by the needle. It is evident, that it must possess this latter quality in a proper degree. This covering colour should contain but a very small quantity of gum, which ought to be just sufficient to secure the covering colour from being rubbed off during the etching or engraving. As this depends on the quality of the lampblack, no specific quantity can be prescribed. The proportion will be best ascertained by a few trials, in which it will be seen that a greater quantity of gum though it preserves the stone better, causes greater difficulties to the artist, as it is not very easy to work through it, and the needle is apt every moment to slip. For the red colour a very small solution of gum is requisite; as for instance, for a stone of the size of a folio-sheet of writing paper, a single drop of gum-solution, of the consistency of common honey, is sufficient. Before this covering colour is used, let it be diluted as much as is necessary for laying it easily on the whole surface of the plate. Both colours, the black as well as the red, can be preserved and kept dry in this state for years; and thus one may be always sure of having stones equally prepared. Before any thing can be done with the stone thus prepared, red or black, it must be perfectly dry, otherwise even the best prepared covering colour is liable to be rubbed off. The drawing ought then to be either traced by means of transparent paper on the stone, or sketched with black lead, or copied upon it with a pentagraph, which on the prepared stone produces

shining lines, that may be easily distinguished : but the pin or point of the pentagraph must not be too pointed or sharp, because it would then penetrate into the stone. The drawing being thus traced on the stone, the principal operation of engraving or cutting in the lines may be begun.

For this operation no other rule can be given, than to choose good and well-pointed etching needles of the hardest steel, hard enough to cut glass, and that all outlines of the drawing must be done as clean as possible ; to a strong pressure and in broad lines to deep engraving is therefore not always advisable. For very delicate lines the stone must be but gently touched ; and when they appear perfectly white, and produce a very fine dust, we may be sure that in the subsequent printing they will make their appearance. Broad lines may often be produced by a single stroke of a broad needle, but such lines are usually traced by repeated and successive passing over with the needle. If the stone in the subsequent printing is to be kept clear and light, the lines must have no more depth, than necessary to re-move the ground, as they are otherwise liable to spread ; but in valuable works of art, where you wish to obtain their full beauty and colour, the printing must be performed with a strong ink and receive a stronger rubbing ; the depth of the lines must be proportionate, as the impression will be darker or lighter, according to their depth or shallowness.—Some practice and experiments will soon enable an artist to judge how he must proceed, in order to produce a drawing as clean as possible,

without making unequal or foul lines. It now remains for me
to mention the defects which may be committed during the
drawing. Above all things, carefully avoid touching the stone
with unclean or greasy hands, because it is not only very diffi-
cult to engrave a plate thus soiled, but the grease may pene-
trate through the very thin coat of gum, and in the printing
will be very difficult to remove, and it may thus give rise to
many inconveniencies. It is still more injurious, to allow wet
in any manner to touch the stone, because this would dissolve
the gum, penetrate into the lines already engraved, and affect
them in such a manner that in the printing they would take
little or no ink ; it is, therefore, necessary, especially in winter,
to warm the stone a little before you begin to work upon it,
because the humidity in the room and your breath immediately
settle upon the cold stone and injure it. Even the perspira-
tion of the hands and the exhalations from the mouth may in-
jure the stone, and it is, therefore, very advisable in every case
to expose the stone first to a moderate warmth ; if for instance,
a plate has become humid by exhalation from the mouth, it
must be left to dry before the working is renewed, and during
that time all touching it or rubbing on it must be avoided. The
fine white dust, arising from the needle, must be removed by
gently blowing it away, or by means of a hairbrush. As to
the correction or mending of defective places observed already
during the engraving, they must be erased as superficially as
possible, in order not to make deep furrows, or be rubbed
down with a very fine grained piece of stone ; then again be

prepared, and covered with the necessary coat of gum, upon which the requisite corrections may be made without difficulty. If some small lines only are wrong, they may be merely covered with a mixture of diluted phosphoric acid, gum, and lamp-black or red chalk, by which they may be so prepared as to take no ink when subsequently printed. On the drawing being completed, the stone, in order to receive the ink in the engraved lines, must be kept very dry, but in no case ought it to be warmed, as this would render it liable to soil. A soft ink, composed of thin varnish, tallow, and lampblack must be rubbed all over the surface of the stone, into all its lines, and immediately afterwards it must be wiped off, together with the red or black covering-coat, with a woollen rag dipped in gum-water. Thus the stone, previously coloured black or red, will be rendered perfectly white ; and the first observation, which will then force itself on the observer, will be, that all the lines and points of the drawing look considerably finer than they seemed before, for the white lines in the dark ground look broader than they do in a light ground, which pheno-menon arises from optical deception. It is therefore necessary in the engraving, to make all the lines a little broader, than the eye would seem to require, if a good effect is to be produced.

In the printing of an engraved drawing, besides those things which it is necessary to attend to in the printing of all the different manners ; as for instance, the proportionate pressure

of the press, the sufficient soaking of the paper, &c., printing ink of a good composition, is a matter of the greatest importance. The engraved stones may be charged with ink in different ways; 1. by rubbing the ink lightly in ; or, 2. by rubbing it more strongly in ; or, 3. by rolling it in. The first manner is managed in the following way :—Prepare an ink from thin varnish and well burnt lampblack ; the latter may be taken in great quantity, but it must be very well pulverized and without grains ; mix this ink with a solution of gum equal to one half of the quantity of the ink ; the solution must not be too liquid, otherwise it will not easily mix with the ink. In order to promote the drying, a little fine pulverised minium may be added, but no more than what is wanted for one day ought to be prepared at a time, as the minium would gradually dissolve in the ink and change it into a soiling preparing-ink. Prior to the minium and gum being added, the printing-ink may be preserved for a very long time in well closed vessels, without spoiling. Sometimes a skin is formed over it ; this is always taken off, when part of it is taken out for use. For charging the plate with ink, three clean rags of cotton or linen are necessary. The first serves to wet the stone, and at the same time to wipe it perfectly clean, when the ink is put on. The second is charged with printing ink, and serves to communicate it to the stone by gently rubbing in all directions in all the engraved lines. The third rag serves to wipe off the superfluous ink which may have adhered to the prepared spots. The operation is finished by rubbing the stone perfectly clean

with the first rag. All three rags must be wetted with diluted gum-water, and the first and third must be washed several times during the day in clean water, and freed from any printing-ink adhering to it.

It is not so easy to rub in the ink at first, as when fifty impressions or more have been taken ; and though the ink does not adhere to any but the engraved places, provided the stone has not taken a kind of tint by the first rubbing in of the grease-colour, yet very often particles of ink almost imperceptible adhere to the prepared spots, which though easily wiped off, sometimes appear in other places. To remedy this, it is necessary to use at first either more clean rags, or more gum, than afterwards. If the stone, however, is perfectly polished, this defect will not be perceptible at all, and will disappear entirely in the progress of the work ; so that the same rag with which the ink is rubbed in, might serve to wipe the plate nearly as clean as is necessary.

The second manner of charging the stone with ink, in which a stronger rubbing in is used, is for the purpose of wiping the ink from the less deeply engraved lines, in order that they may appear lighter, and thus heightening the effect of the darker and deeper engraved places, in which a greater quantity of ink remains. To imitate perfectly the full beauty of a well engraved copper-plate print, it is necessary, as already observed, to attend to the proportionate depth of the lines ; and

in the printing, the manner of rubbing the stone must correspond to the nature of its different parts. This manner is, in other respects, perfectly similar to the preceding ; and I have only to add, that with an ink prepared from stronger varnish, very fine and brilliant impressions may be obtained, provided the stone can bear the strong pressure of the press which then becomes necessary.

The third method of inking the stone with a roller, is similar to that used in the elevated manner ; and the only circumstance necessary to be mentioned here is, that the ink must be softer, and the roller charged with more ink, and that it requires some practice to be able to introduce the ink into all the engraved lines during the rolling. With these deductions this manner is the most advantageous of all, on account of the expedition of which it admits, and because it does not affect the stone so much, by which means a greater number of impressions may be taken. The impressions, however, are very often not so delicate as those produced by the rubbing method.

The stone being now charged with ink in the etched manner, the impression must be taken without delay, because the ink would otherwise penetrate too much into the stone to produce a clean and strong impression, and a repeated charging with ink would become necessary.

The paper used for the impressions of an engraved drawing,

must be soaked a little more than is necessary for a drawing in the elevated manner, but not too much ; as this, if the ink is soft, disposes it to spread, and if strong, prevents the impression from taking it at all. The force of the press must be in proportion to the size of the stones, but in general it must be twice or thrice as strong as for an elevated drawing of the same dimensions. In very delicate engraving, a still greater degree of pressure is sometimes necessary, because it is much more difficult to print fine lines than strong ones. The paper may be put immediately on the stone, as the danger of soiling it in this manner is not so very great ; but the operation is a good deal quickened when the paper is placed in a frame, instead of being placed on the stone. As soon as a clean proof is taken off, it must be closely examined, to see whether in the writing or drawing any errors or improper lines have crept in, in order to correct them before the printing commences. Should there be any such errors, the stone must be washed with a weak solution of gum, and taken out of the press, and then the artist may proceed in the following manner with his correction :—First of all, the defective or erroneous spots which are to be removed, should be erased with a sharp knife, or rubbed down with a fine stone ; in both manners great care must be taken not to go deeper than necessary, and not to produce cavities or furrows, but to make the unevenness which must necessarily arise on the surface so soft and imperceptible, as to have no margins at all to which, during the printing, the ink can adhere, and produce stains. It is advisable to make these corrections

shortly after the first proof has been taken, and before the ink has had time to penetrate considerably into the interior of the stone. The places thus amended, must then be prepared by the application of a composition of six parts of water, two parts of gum and one part of aqua-fortis. If, besides the removal of defective or erroneous spots, additions are to be made to the drawing, the stone should be entirely washed with clean water, then again covered with a coat of gum and lampblack, or red chalk, as before described, but very thinly, so that the whole drawing may be seen distinctly through the coat ; if the additions are only limited to a particular spot, it is sufficient to wash only a part of the stone. As soon as the coat gets dry, all the requisite additions may be inserted with the engraving needle ; the stone must then be treated as before, charged with the ink described in the first process, cleaned with gum-water, put into the press and printed.

I shall conclude this subject with some useful and necessary observations :—

1. It often happens that a stone, after the first rubbing in of grease-colour, and the subsequent cleaning with water, takes a sort of tint all over its surface ; or, in other words, takes ink in some degree, and seems to have lost its original preparation. The cause of this may be, that the coat used for covering the plate did not contain a sufficient quantity of gum; or that the rubbing in the colour was performed with too much violence,

whereby the coat was injured ; or that the greasy ink remained too long on it, before it was wiped off with gum ; or, finally, that the proportions in the composition of the greasy ink were not well calculated. A similar effect may be produced from the same causes in the second rubbing in of the ink, after the correction of the defects. Negligently prepared ink, in which small grains of sand are concealed ; or ink mixed with minium which has become too old ; or pressing too violently with rags impregnated with grease ; or rags which were not perfectly cleaned from the soap used in washing them ; or many other apparently trifling circumstances, by which the stone loses entirely, or in part, its preparation, produce the same effect of spreading a gray shade, or tint, over the whole surface of the stone. To remedy and remove this defect, more gum must be added to the ink, and even to the water in which the rags are dipped ; sometimes the application of a stronger ink removes it, which must, when wiped off, be rubbed more violently ; by which operation, this stronger ink takes with it at the same time all the soil remaining on the stone. If this should not produce the desired effect, there is no other remedy than to rub down gently the whole surface of the stone, with a very fine-grained pumice-stone and gum-water ; or, as this is not applicable to very delicate drawings, where the fine lines have scarcely any depth at all, the stone must be washed with diluted aqua-fortis, or very weak phosphoric acid, applied by means of a rag very sparingly dipped into it, till this unwished-for tint disappears. It is good to add a little gum, and rub in the stone previously

with etching ink, in order to prevent the acid from affecting the drawing too much.

When by this operation, and repeated biting in, the tint is removed, it sometimes happens that another defect arises, *viz.*, that the ink, after the rubbing in, cannot be entirely wiped off, and that a quantity of small black points remain in different parts of the surface ; this arises from the roughness produced by the repeated biting in. It is, therefore, necessary to use at first several clean rags and gum-water for wiping the stone, or to pass the roller gently over the stone, after it is charged with ink, by which operation all the little black spots are removed ; in general, this defect very seldom occurs when the ink is put on by the roller. As soon as several impressions are taken, this roughness of the surface disappears, and the plate may be wiped off, without leaving any black spots or points behind. As I have observed, however, this roughness may be immediately removed, by rubbing the surface gently with pumice-stone ; but this is a dangerous operation, as the delicate lines of the drawing may be easily injured by it.

2. A very fine line, of so inconsiderable a depth as to be nearly on a level with the surface of the stone, may, by repeated printing and rubbing with the ink-rag, become gradually as black as a deep engraved one ; and with a hard ink the broader lines are liable to be so much overcharged with black, as to spread considerably in the printing. If the roller is passed over the stone a few times, it will take off the superfluous ink,

but this is an unnecessary prolongation of the operation, as by some practice in rubbing in the ink, and by using ink of a good composition, the same purpose may be attained, without any fear of the roller taking off too much ink from the cavities of the engraved lines, as the ink in these is generally of a much softer nature than that on the roller. If the roller has been charged with too liquid an ink, this will not happen, but then such an ink does not take off so well the stains and impurities on the stone, for it is very apt to leave small particles behind.

3. The best manner of putting the ink on an engraved drawing, is to rub it first with a strong ink, in which a sufficient quantity of gum must be mixed ; to wipe this away, and then to rub the surface gently with a rag impregnated with softer ink, without employing any pressure. A strong and dry ink does not adhere well to the finest lines, and is very difficult to manage in the printing. But in the manner just described, the strong ink first employed will produce clean and distinct impressions of the broad and deep lines ; and by the subsequent addition of a softer ink, the fine and delicate lines will get the necessary strength and blackness. The rag containing this soft ink must not, however, be overcharged with it, but contain just sufficient to make it black, otherwise the soft ink would penetrate into the deep-engraved lines, and mix with the harder ink already rubbed in there. When all is done, the

stone must be wiped again with a perfectly clean rag, to take away all the remaining spots or particles of ink.

§ 2. *The manner of Etching on Stone.*

In this manner the lines of a writing, or drawing, are not produced by the graver, but bitten in with aqua-fortis, or any other acid ; and in tracing the drawing, no other pressure is employed than what is just necessary to cut through the coat of varnish with which the plate is covered. This manner, there-fore, admits of greater liberty in the management of the needle, and is particularly adapted for landscapes and drawings in Rembrandt's style. The process to be observed in this manner is very like the etching of copper-plates, and the effect produced in both is nearly the same. There is this advantage, however, in the etching on stone, that, by a greater pressure of the needle, the lines can be made stronger, by cutting them in somewhat deeper ; so that, in the subsequent etching, they grow considerably broader and stronger ; an advantage which, in copper, it is impossible, or very difficult, to obtain. This circumstance, and the increased expedition in printing, recom-mend it particularly to the artist ; in other respects, little is gained in labour, as nearly the same management is required as in etching on copper. It is necessary, however, at all events that a good lithographic artist should be familiar with it, as it

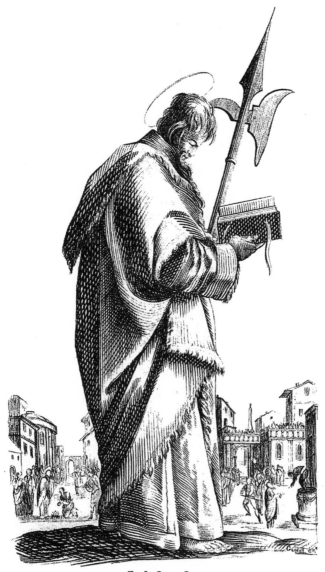

Etched on Stone,
R. Ackermann's Lythography.

is not only very useful in itself, but may, in conjunction with other manners, be applied to the best and most excellent productions, and may be regarded as the foundation of all the other branches of the deeply-etched and engraved manner. The following is the mode of treatment :—Let the stone be rubbed down as smooth as possible, then washed with aqua-fortis and gum, so that its surface may be perfectly prepared. The aqua-fortis may be as strong as that used in the biting in of the pen-drawing. The stone requires only to be washed well with a sponge, dipped in stronger aqua-fortis ; but care must be taken to do this uniformly, otherwise inequalities may arise on its surface. When this operation has been performed, the stone, after the lapse of some minutes, must be cleaned with pure water and left to dry. Let it then be covered with the etching-ground. This may be done in different ways ; the following deserve the preference :—

1. Let the stone be heated to a degree such as engravers require for laying an etching-ground on copper-plates ; so that the etching-ground which has become liquid, may, with a leather or silk ball, be spread all over the surface uniformly, but very thinly. In heating the stone, care must be taken to heat it equally in all its parts, in order not to expose it to the danger of breaking. If there is any opportunity for heating it in a baker's oven, this would be very desirable. After its first heat is over, no particular preparation or contrivance will be necessary. The stone being thus covered with etching-ground, let

it be turned upside down, when yet warm, and then smoked, or blackened, with a common tallow or wax candle, in the manner in which engravers blacken their copper-plates. In order to do this on the heavy stone with ease, and without danger, a particular contrivance is necessary. Take two perpendicular boards, which, according to the size of the stone, can be placed at a greater or smaller distance from one another, and let the stone be placed so as to rest upon them at its two extremities. A candle may then be easily introduced under it, and thus it may be blackened without difficulty. The stone should now be left to cool, and care must be taken that no dust gets upon it. When cooled, the dust will no longer injure it; and it may be preserved for any length of time, provided the coat is not injured, but remains whole and undamaged.

2. The manner just described is certainly the most perfect; yet, as the heating of the stone is attended with some difficulty, another manner, in which no heat is required, will, in some cases, be preferable. In this second manner the common etching-ground is dissolved in oil of turpentine; and then, as in the preceding, it is spread upon the stone with a clean printers' ball. The stone must then be preserved for a day at least, in a place well secured against dust, in order to allow time for the oil of turpentine to evaporate. The etching-ground thus dissolved and rendered liquid, may also be spread on the stone with a hair-brush, but it requires some practice to spread it equally, and to avoid laying it in some places too

thick, and in others too thin on. The surface of the stone must be every where covered with it, thick enough to resist sufficiently the action of the aqua-fortis, so long as it is not removed by the needle, or tracing-instrument. In order to colour the etching-ground, it may, as in the first manner, be smoked, or a red or black colour, vermilion, or lampblack, may be mixed with the etching-ground, previously to its being spread on the stone. In order to be very sure that the aqua-fortis do not penetrate the etching-ground, it ought, last of all, to have a solution of hard chemical ink rolled over it. When the stone has been covered with etching-ground in either manner, the outlines of the drawing are traced upon it from transparent paper, or transferred to it; in the latter case, as soon as the transfer to the stone is finished, a solution of chemical ink, in which, however, there must be no lampblack or other colour, so that it may be perfectly transparent, ought to be spread over it, though very thinly. This is the more necessary, as the inequalities in the paper, and the force of the press, may produce small holes in the coat, with which the stone must be covered, in order to render it perfectly secure against the effect of the aqua-fortis.

For executing the drawing itself, common gravers or etching needles may be used, which must be more or less pointed, according to the nature of the lines. In those lines or points which are to be very fine, the hand must not press too much, but just enough to remove entirely the etching-ground from them,

otherwise the aqua-fortis will not bite them in equally. Experience is here the best guide. I have often observed, however, that very fine lines, drawn with a less pointed or worn-out needle, after the etching was over, appeared much finer than more delicately-drawn lines, effected with a sharp needle, by which the surface of the stone was cut in some measure ; for in these the aqua-fortis had greater effect, and rendered them in the same space of time broader than those in which the stone was not cut at all. It is in general necessary to know, that the acid acts not only upon the depth, but likewise upon the width, of the lines, and that a deeply-engraved line becomes broad in proportion to its depth *.

As the excellence of an engraving chiefly depends on the proportion observed in the size of the different lines, this point requires the most unremitted attention in this manner, which comes so very near the copper-plate engraving. When, by repeated practice, one has acquired the knowledge of every species of lines, produced either by merely removing the covering etching-ground, or by cutting into the surface of the stone with a

* Other experiments have convinced me that, in some cases, lines drawn equally strong upon the stone, may be etched considerably deeper, without growing broader in the same degree as on copper. Besides, as in this manner, the white colour of the stone makes the lines of the drawing appear broader to the eye than they really are, the artist will be less easily deceived, and able to judge with more accuracy of the effect of the impression before-hand, by accustoming himself to suppose the drawing placed in a contrary light from that in which it then is; as in the impression all the lines appear black, which in the drawing on the stone appeared white.

sharp needle, it will be seen that this manner of etching in stone has a great advantage over that of etching in copper. In copper it is impossible to engrave, or cut in very deep, as the needle sticks every moment, and the inequalities produced by this have an unfavourable effect on the etching. In the stone all the lines, by merely removing the etching-ground with the needle, may receive any degree of sharpness or depth, and at the same time the artist has the advantage, by pressing more strongly with the needle, or by cutting in with it, of producing all those lines which are to have greater expression, and a more decided character, and which in copper can only be done by the graver.

The drawing being now properly finished, the plate must be etched with aqua-fortis, by which every line will acquire the necessary depth. For this purpose, let the stone be placed in the etching-box, or draught, and let diluted aqua-fortis be poured over it repeatedly. This must be done as uniformly as possible ; and it will be proper, after every application of the acid, to wipe the stone gently with a piece of linen, in order to remove all bubbles which may arise, and which may prevent an equal action ; as in every place where a bubble arises, the effect of the aqua-fortis is partially impeded and consequently its action in the neighbouring places will be increased. The number of times the acid must be poured over the stone, or its strength, must depend on the depth intended to be given to the lines. To judge whether a stone has been sufficiently etch-

ed is altogether a matter of practice, which must be learned by repeated experiments. If the etching is weak, the finest lines may be produced ; and for this it is only necessary to apply once or twice, with a degree of quickness, a solution of one part of aqua-fortis, in 40 parts of water. If, however, these fine lines are to be etched very deep, and consequently broad, the infusion of aqua-fortis must be repeated more frequently, in some instances 50, or more times. For stronger lines, if expedition is a matter of consequence, a stronger solution of aqua-fortis may be used. But, in general, the effect of an etched drawing is much finer and more delicate, if etched only gradually or slowly. The stones may also be etched in the manner of engravers, by enclosing the square stone with a margin of wax, and by leaving the aqua-fortis for some time standing upon it ; but in this case the bubbles which arise must be carefully removed with a soft hair-brush, or the aqua-fortis must be changed from time to time. The etching thus produced is very equal and perfect. If, for the sake of a better and more striking effect, soft and strong tints are to be produced by the etching, the stone, after a repetition of the infusion a few times (as often as is necessary for the finest lines*,) must be cleaned well with water from all the particles of acid which adhere to

* In order to judge of the effect of every infusion of aqua-fortis on the stone, a sort of scale, consisting of lines of different dimensions, may be contrived in one of its corners on the margin. By scraping off, from time to time, the covering coat over these lines, and by rubbing them in with soft ink, it may be ascertained very distinctly what degree of depth and etching the stone has already got.

it. Then, with a small hair-brush, dipped in chemical ink, let all those parts be covered which in the subsequent etching are to be no more affected ; the chemical ink used for this purpose must contain a little more soap than the common, in order to give it a greater disposition to fill the cavities, and to leave no intervals open. Great precaution must in general be taken in forming the covering coat ; and too much, rather than too little ink ought to be used, as it would entirely spoil the drawing, should the aqua-fortis penetrate in some parts through it. When all the proper spots are covered, and the ink is become perfectly dry, the etching must be repeated, till the second class of lines are bitten in sufficiently ; then let the cleaning of the stone, and the application of the covering coat produced by chemical ink over them, be repeated.

These operations ought to be continued in succession, till all the lines are done. It is unnecessary to observe, that these various and nice distinctions are not so necessary in those drawings which have been very carefully executed by the needle ; but those that are drawn with less care, and rather monotonously, can only by these frequently-repeated etchings get a fine and appropriate character. By repeating the covering of parts, and the etching of the rest three times, a very good effect may be produced ; but the oftener they are repeated, the more delicate will be the effect of the single parts. The determination in all these particulars must be left to the judgment of the artist. This successive etching may also be effected

in another manner, *viz.*, by drawing the deepest shades first, and then etching the stone ; then by adding the lighter shades and etching again, and so on, till the whole drawing is finished. In this method it is not necessary to employ any covering ink, as the darker shades, by being exposed more frequently to the action of the aqua-fortis, are etched in the same proportion as the finest, which are only once exposed to it. In this method the artist has the advantage of introducing the fine and light lines or shades between the darker and broader which is not the case in the other manner of etching ; the latter, however, is a little more difficult, and it requires more practice to draw over and between the lines already etched and consequently deeper. After every etching, the stone must be left to dry sufficiently.

The stone being now well bitten in or etched, its surface ought to be washed all over with clean water, and all that remains yet uncovered, ought to be carefully covered with chemical ink. The covering-coat, applied before, served only to secure the parts so covered against the action of the aqua-fortis ; but the chemical ink, subsequently used for the same purpose, by penetrating into the cavities of the lines, prepares them also for the taking of the ink ; it is, therefore, necessary to impregnate the remaining parts with the same ink before the printing of the stone is begun*. The stone should then

* As the etching-ground covering the stone is very hard, there is no reason to fear

be laid aside to dry, and oil of turpentine ought afterwards to be poured upon it, in sufficient quantity to dissolve the coat of covering-colour, which may then be wiped off clean with a woollen cloth and gum-water. This is done in the same way as in the elevated manner, which I have described in its place. I have now only to describe the manner of correcting faults or defective lines in drawings done in this manner:—When an error is discovered before the etching or biting in, the question is, whether the wrong line is cut into the surface of the stone, or only drawn in the covering-coat, without leaving any trace in the stone. In the last case, the wrong line requires only to be covered with chemical ink, and when dry it may be altered and set right. But when cut into the stone, though it may also be covered in the mean time, no alteration can be substituted in its place, and it must remain till the stone is bitten in and rubbed in with ink. The defective or wrong lines must now be scraped or rubbed away, with a small piece of pumice-stone, then the spot must again be prepared with aqua-fortis and gum, and the correction made with the etching needle. If some lines or parts, which have been omitted, are only to be added, this may be done subsequently, and without using aqua-

its being easily dissolved by the ink, provided the chemical ink is put on very gently ; for, without great care in this respect, it might penetrate the covering-ground, and injure, (or neutralize,) in part, the preparation of the stone, which would cause the above-mentioned kind of tint, or veil, to spread all over the stone, or at least over the injured places. Should the covering-coat have been injured by too strong rubbing with chemical ink, the stone, after being charged with the ink, must be cleaned by the process just described.

fortis. In some cases, certain lines or parts are omitted on purpose, and afterwards put in with the etching needle, as some parts may be more easily and better produced in this manner. The contrary, however, is not unfrequently the case, and a drawing executed by cutting in or engraving, is sometimes covered with etching-ground and certain parts are executed, in the manner just described. When the engraved lines have once been rubbed in with ink, it is not very easy to draw over them, and it will be much better to cover the stone with etching ground, to add the omitted lines, and to etch it subsequently. This method is employed in Bavaria, in the new survey of that country, for the purpose of more correctly assessing the land-tax; in the correction of the maps and topographical plans, mountains are invariably introduced after the rest is completed, and after proofs are taken, by a second etching over a covered ground : for the purpose of introducing the mountains and other delicate parts, the stone is covered with etching ground dissolved in oil of turpentine, but to which no lampblack is added. It is then of a brownish colour and transparent, so that the rest of the drawing may be seen through it, and the mountains which have been omitted may be inserted in their appropriate places.

I shall conclude this part of the subject with the following necessary observations.

1. A copper-plate may be covered white over the usual

etching ground, by a composition of white-lead, ox-gall and gum ; the copper being of a reddish colour, the etching executed on this white ground looks like a drawing made with red ink on white paper. This manner has the advantage of enabling the artist to judge better of what he does, than if the ground were dark, as the light and shade appear nearer to their true effect and keeping ; for great practice, or I might almost say a natural talent, is requisite, to judge well beforehand of the effect of a drawing, when the proportion of light and shade in the impression is exactly reversed, and when all that before was light appears black, and what was black before white. It is, therefore, natural that artists should greatly prefer working upon a stone with white covering colour. Now, as the application of this white colour would not do for the stone, as the lines drawn in it would appear likewise white, I have tried to attain the same object by giving to the stone a darker colour. This may be done very easily, as the stone, when smoothly rubbed down and prepared, takes very easily all vegetable colours or dyes in which no acid is mixed. The stone may therefore be coloured dark blue, for instance, with a decoction of blue wood, or red with Pernambuco wood. These colours penetrate deep enough into the stone, so that even the lines cut into its surface do not appear white, but coloured. By subsequent washing with vitriol of iron the dark-blue coloured stone might be easily coloured quite black, but then it would be difficult to see in the printing, whether the stone was sufficiently filled in with ink ; it is therefore adviseable not to employ too dark a colour.

In the drawing it is only necessary to remove the coat which covers the stone, and no lines require to be cut into it, the colouring is superfluous, but this operation may be effected in the following manner :—

Cover the stone with black etching ground, then spread the white colour over it. I have found that well-ground white lead mixed with gum, in quantity merely sufficient to bind the colour, answers the purpose best, especially if a very little potash is added, which renders the gum more viscous, so as to adhere better to the colour. Ox, or fish-gall I have found equally suitable. By the first application of aquafortis this white ground is dissolved, and can be easily wiped off with a small hair-brush.

2. An etching may, in some cases, be greatly improved by printing it with a tint-plate, such as is used in the chalk manner. This process requires, in the method already described, a second plate ; but here in the etched manner, the tint may be produced even on the same plate. For this purpose the stone ought to be well cleaned with pure water, and then the whole surface, or only those parts of it upon which a light tint is to be produced, should be covered rather thickly with chemical ink containing a good deal of soap. When lights are to be introduced into this tint, they may be etched in after the application of the ink, by means of a small hair-brush dipped in weak aquafortis. In the printing of a plate, thus aquatinted, the

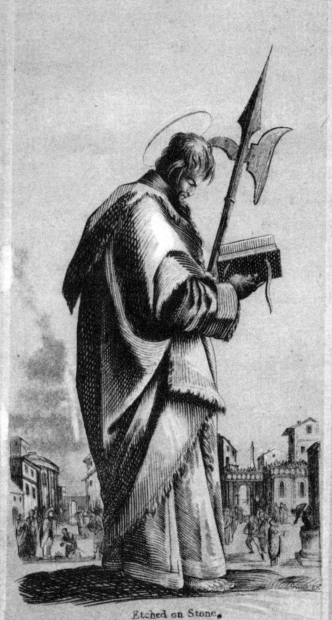

Etched on Stone.
R. Ackermann's Lythography.

black ink must first be rubbed in, after which the plate ought to be wiped as clean as possible ; the tint spread over the surface will then be too dark in general ; but this point depends on the greater or less degree of consistency of the ink. A second rag must therefore be at hand, charged with a much softer ink, diluted with oil or butter. This colour may contain white-lead, yellow-ochre, yellow-lake, vermilion, satinober, &c. according to the tint required. Let the rag be passed several times over the plate in all directions, without pressing too much, till the over dark colour of the tint lightens up and changes into a milder colour. The only thing which requires particular attention is, that stones for this manner must be etched much stronger and deeper than usual, because the finest lines would be lost in the tint, and in the impressions would appear too weak and pale. Even deep and strong lines, in a certain degree, lose their darkness, particularly when, instead of white, they are printed on stained paper, and it is therefore necessary to bite them in deeper, as by this they will produce a very excellent effect.

3. In all the different subdivisions of the engraved manner, the artist has the advantage of being able to render those places which appear too dark, lighter, by fine and delicate scraping, or rubbing down. The stone must be previously charged with etching colour, in order that the drawing may not be injured or spoiled by the subsequent preparation with aqua-fortis, neces-sary for the preparation of the spots thus rubbed down. Who-

ever has acquired a little practice in this operation of rubbing, or grinding down with a piece of blue slate, or pumice-stone, can, in etched stones, produce the finest gradations of shades, and in less time, and with less difficulty, than is practicable on copper. If the plate has shortly before been rubbed in for the first time with ink, it is not necessary to etch again the rubbed down places, but it is sufficient to wipe them well with a rag dipped in gum-water, because the colour has not penetrated so deep as to re-appear in the subsequent printing. If this operation takes place long after the stone's being first rubbed in with ink, the repeated etching is advisable, on account of the better preparation.

4. Even single lines or points, may be taken out, or rendered smaller, in stones recently saturated with colour ; but when the colour is of longer standing, this becomes a more difficult matter, as very small spots cannot so easily be prepared again, without retaining a slight disposition to take ink. Now, as it is very difficult to wipe the ink from those faulty spots, it is almost impossible, in the printing of a plate where many corrections have taken place, to prevent these spots from appearing. It is, in this case, better to rub down at once the parts alluded to, which can be done by care, and by avoiding a halo, and to introduce afterwards the necessary corrections, or improvements.

§ 3. *Manner of Drawing with Preparing, or Gum-Ink, and the sprinkled Aquatinta manner.*

If a few drops of a solution of gum are spread upon a very clean stone, and the whole surface of the stone is rubbed with printing-ink, all those parts of the stone which are covered with gum will not take ink, or, in other words, the stone is prepared in those places. If the gum has become dry, and the ink is rubbed in, these prepared spots will become as black as the rest ; but, by washing the stone with water, and passing it over with the ink roller, all the places prepared by the gum will immediately re-appear white. This quality of the gum induced me to make an ink prepared with gum, with which a writing or drawing might be executed on the stone, and by the preparing quality of which, in the subsequent printing, all the lines drawn with it might appear white. The following is the manner in which I proceeded :—With the gum-arabic, dissolved in water, mix an equal part of lampblack, and rub the whole well together. If the gum is thick, the lampblack will unite the better with it. This mixture will produce a sort of ink, not unlike the Indian ink, which, when well dryed, can be easily preserved. When it is wanted, it must be rubbed in a clean saucer, with a little water, and then it will be fit for use. With this ink write or draw upon a perfectly clean stone, or, as it would be liable to run upon such a stone, wash

it previously with a solution of weak aqua-fortis, mixed with a small quantity of pulverised gall-nuts. The lines of the drawing may be made still finer, if the stone, some days before hand, is washed with oil of turpentine, which afterwards must be carefully wiped off. But, in this case, it is advisable to mix a drop of phosphoric acid with the water used for rubbing on the ink, in order to be sure that the lines drawn with it are perfectly prepared.

The drawing being dry, the whole surface of the stone must be covered with printing-ink, and great care must be taken to see that during this operation no water falls upon it. But after being well covered, pour a little water upon it, and continue to pass the ink-roller over it, till all the parts of the drawing executed upon the stone with this preparing ink have become perfectly white, and look clean. Now, impressions might be taken from this stone, by treating it in the same manner as a pen and ink drawing. But, in order to render the drawing more durable, and to prevent some of the finer lines from running in the printing, so as to form one blot, the stone may be well rubbed in with etching-colour, and, after the lapse of a few hours, to allow it to settle well, and resist aqua-fortis, the drawing may be etched in. The stone ought then to be washed with gum, when a very great number of impressions may be taken from it. In this manner we have bitten-in lines prepared, which are printed white, directly the reverse of the two preceding manners, in which

the engraved, or bitten-in lines take the ink, and produce black impressions.

The process, however, may also be inverted, that is to say, the black surface of the stone may be made white, and the drawing black ; for a stone covered with preparing ink, and afterwards with etching-ground, is almost in the same predicament, as if the drawing were etched in the etching-ground, as described in Sect. 2. It is only requisite to fill the deep etching lines with chemical ink, as in the foregoing manner, instead of covering them with gum ; they will then take ink, and the only circumstance which remains to be considered is, that the stone is not, as in the other manner, in a prepared state as to its surface, and, therefore, would be inclined to take ink every where. But it is not now very difficult to clean the surface, and to give it a full preparation, especially as it has been polished very smooth. To effect this, let it be well rubbed in with ink, which ought afterwards to be carefully and cleanly wiped off ; without, however, taking out the ink remaining in the deep lines. In order to make the ink more liquid, some tallow and Frankfort-black, may be added to it. The same colour-rag with which the ink has been rubbed into the stone, should now be dipped into a solution of twenty parts of water to two parts of gum, and one of aqua-fortis, (or phosphoric acid) and with this let the surface of the stone be well rubbed. The rag used for this purpose ought not, however, to be charged with too great a quantity of ink, lest the finest lines of the drawing should be too much deprived, during this

operation, of their ink, and then exposed too much to the action of the aqua-fortis. An attempt should now be made to ascertain whether the ink cannot be rubbed off the surface with the finger; if this is not yet the case, the rubbing or washing with the above described composition must be repeated, till the surface is so far prepared by it that the covering coat and the dark ground can, without difficulty, be removed with the wet hand, or with a wet piece of leather. The stone must then be charged in the usual way with strong ink, or with etching-colour, which ought afterwards to be well wiped from the surface, and the stone should be washed several times with weak aqua-fortis, or diluted phosphoric acid, by which it becomes well prepared, and in the subsequent printing is not liable to soil, or to take ink in wrong places. If, however, this repeated etching should appear too troublesome, as it requires some experience and practice, the stone may previously be prepared in the same way as in the foregoing manner. It must then be well cleaned with water, to remove all the remaining particles of gum; then it should be left to dry, and, for greater safety, rubbed over once more with oil of turpentine. The drawing being now quite completed, and the whole surface covered with etching-colour, it ought to be left standing for some hours before water is applied to it, and the subsequent cleaning of the drawing by the roller, should be performed as delicately as possible. If the etching-colour still adhere to the stone, the remaining particles of it can then be easily removed by repeated rubbing with gum-water and oil of turpentine,

and by the application of a strong and hard ink. After this treatment, the stone, on its being properly cleaned, may be looked on as in the same situation with one executed in the deep etched manner; and in the biting in, covering, rubbing in with ink, and printing, must be in every respect treated in the way already described. In general, this manner of drawing with preparing ink, and afterwards etching in, in the way just detailed, is very applicable to many subjects; and the conclusion that it is superfluous because the same purpose may be attained in a shorter way by having the whole plate covered with etching-ground, and the drawing put on with an etching needle, would be very erroneous. This will be explained in the following manner :—

The very finest lines and points may be very easily traced in the etching ground by the etching needle, but the broader lines are more difficult to manage, take much time, and require great attention and practice; the reverse of this is the case in the second manner, where the strong and broad lines are very easily executed with the pen. By applying now the process just described, both advantages may be united; and those parts only may be drawn with the pen, which are most easily executed by it. The whole drawing, therefore, with the exception of the finest lines, may be executed with the above described composition ink on the white stone; the whole being thus covered with etching-colour, and rendered white, as already mentioned, the finer and more delicate lines and parts

must be traced in it with the needle, or they may be left out entirely, and be afterwards introduced with what is called the dry point, that is to say, in the manner of engraving. In order to obtain a stronger covering coat, which, in the subsequent introduction of the finer lines may not be so liable to be injured, instead of the etching-colour here mentioned, the usual composition of etching-ground, consisting of wax, mastic, and asphaltum, dissolved in oil of turpentine, and mixed with fine lampblack, may be used ; it will be found that this composition may be spread over the plate very uniformly, by means of the roller.

Here I conclude my directions respecting this manner, the advantages of which cannot fail to be seen in the application of it.

I shall now advert to another manner, called *sprinkled aquatinta*.

It is well known that in the aquatinta manner the engraver covers his plate with a ground that resists the action of the aqua-fortis, but as it covers the plate in the shape of innumerable little points or grains, the acid penetrates between them, and acts upon the plate. The different gradations of light and shade are produced by repeated covering of the places previously etched, as in the deeply-etched manner. The etching-ground used for this purpose should consist prin-

cipally of rosin, which, in the form of a fine powder, is strewed
on the plate, and afterwards runs into small round points, when
moderately heated. The process of the engraving, however,
is not easily applicable to the stone, which does not bear well
the heat requisite to melt the rosin. But the same purpose
may be attained in another way, and the stone be covered with
an etching-ground, appearing in the form of little points, and
allowing the aqua-fortis to act between the intermediate spaces
on the stone, and produce the desired effect. This is done with
tallow and lampblack rubbed upon the stone by means of a
ball of cloth; and I have described the process elsewhere,
in speaking of the manner of producing a grain in stones
for chalk drawing. It is my intention to explain here how a
similar aquatinta ground may be produced by sprinkling, much
better than the other, for the very dark and strong shades,
which cannot bear a very strong etching.

Let the outlines of the drawing be first etched into the stone,
with clean but very fine lines; black printing ink should then
be rubbed into it, and afterwards well wiped off: it ought
next to be washed with clean water, in order to remove all the
remainder of the gum. When dry, dip a tooth brush in pre-
paring ink, and sprinkle the surface with small and almost
imperceptible spots; this must be done with the same pre-
cautions as in the sprinkled manner, with chemical ink; as
soon as these little points become dry, those that are too large
may be separated with the needle; and in the parts where they

are not in sufficient quantity, others may be added by the pen. A dissolved etching ground should then be communicated by the roller, which ground ought only to contain ink enough to render the outlines of the drawing transparent, and the sprinkled points will become visible by rolling it over with water. Let the lightest parts of the drawing be then covered and etched, then again covered and etched as described in the etched manner, till all the different gradations of shade are produced. The etching or biting in being thus completed, the rubbing in of the ink, and the printing, may take place in the manner already described.

§ 4. *Aquatinta after the manner of Engravers, and with Etching-ground.*

It has been mentioned in the foregoing Section that the application of the aquatinta ground, in the manner of engravers, is not very advantageous on the stone, on account of the great heat which it requires. Should, however, an artist possess the apparatus necessary for covering the plate with powdered rosin, and also possess the necessary knowledge for this operation, the stone when covered with this fine powder, may be heated by a flame of burning spirit of wine, and the ground may be melted upon it. The aquatinta engravers obtain a more convenient aquatinta-ground by dissolving rosin in spirit of wine, which they pour in a state of solution on the plate ; small

resinous particles form themselves as the spirit of wine eva-porates, which constitute the required aquatinta ground. Both these manners, however, are more fit for large and bold draw-ings, than for high-finished ones ; for which it is much better to use etching-ground dissolved in oil of turpentine, or the common aquatinta-ground, composed of etching-colour or merely of tallow, very nicely and uniformly daubed upon the plate with a ball of woollen cloth. By this operation a finer effect, more like that of the highly-finished India ink drawing, is produced. As it is, however, more applicable to the lighter, than the darker, parts, it is requisite to sprinkle with chemical ink those parts which are to form a darker tint ; this process takes place after the first and lightest tints have been etched in, and charged with colour. The sprinkled places are so prepared by this process, as to stand the strongest etching without any danger of injury.

§ 5. *Aquatinta manner, with Chalk-ground.*

This manner may be described as occupying a place be-tween the aquatinta, and the scraped manners. It has this advantage, that, in a very short space of time, very perfect drawings may be produced by it. Take a stone prepared for chalk-drawing, and cover it with red or black gum ground, described in the engraved manner, without etching it previ-ously. The outlines of the drawing must be slightly traced

in with the needle, as they serve only to guide the artist in the subsequent operation. Those lines which, in the impression, are on the shadow side, and are to appear distinctly, must be deeper than the others, in order to produce a proper effect. The stone is rubbed in with ink, and cleaned with water, as in the engraved manner. When it has been cleaned and dried, all the lines traced on the stone will look black, while the rest of the surface looks white. The drawing should now be closely examined, and the different gradations of light and shade divided into eight classes, four for the lighter, and four for the darker tints. The four dark gradations must be entirely covered with chemical chalk, so that the effect produced may appear like a half tint. The object of this operation is to produce a tint of innumerable small and equidistant points on these places, in order to resist the subsequent etching, or aqua-fortis, by which a still coarser grain than the one already obtained by its original preparation, will be produced. This being done, let the light tints be covered with the chemical ink ; the lights, and all those parts which are to remain quite white, ought to be left untouched with either chalk or ink. The stone being thus far prepared, must be bitten in for the first time, and afterwards cleaned with water, and left to dry. The least dark of the four darkest tints should now be covered with chemical ink. As soon as the ink is dry, let the plate be immersed in aqua-fortis, then in water, and left to dry ; the next gradation should then be covered and treated as before, and in this manner it is necessary to continue to cover, or stop out,

and to etch, till the darkest tints are covered. A flat hair-brush should be dipped in gum-water, with which all that is to remain white must be passed over.

A few drops of oil of turpentine should now be applied to the plate, by which the chalk, as well as the chemical ink, will be dissolved, and ought to be wiped off ; let the stone be then carefully cleaned with a woollen rag, and charged with a soft printing ink. The drawing will then look as if a black crape was thrown over it. Take a rag, dipped in a weak solution of gum and phosphoric acid with water, and, during the time that the lights are scraped in, or ground out with a slate pencil, let this wet rag be passed repeatedly over the drawing, by which it will be easy to judge how far the work gradually approaches to perfection. In this manner the very finest gradations of tints may be produced, as also great depth of tints, equal to any India ink drawing. All this may be done in a very short space of time. If the rag contains a small portion of printing-ink, this will be of service. If the effect of the etching in the darker spots has become too strong, they may easily be rendered lighter by scraping or grinding. For printing this, as well as all other aquatinta manners, soft and liquid ink is required, and the paper must be soaked a little more than what is usual in other manners. The press requires more pressure, and the stones ought not to be too thin.

§ 6. *Engraved or reversed Chalk, and Soft-ground manner.*

The difficulty of producing impressions of a chalk-drawing, which should not differ from the original, induced me to try whether it was not possible to reverse the elevated chalk manner, by sinking the grain in the stone, instead of causing it to project. I was the more induced to make this attempt when I reflected that a chalk-drawing, in the engraved manner, is capable of greater expression in the darkest spots, and of greater delicacy in the lighter, and that therefore it admits of easier correction, and is less liable to be spoiled. I plainly perceived that, if I succeeded in these experiments, I should likewise gain a great advantage for the manner of printing in colours. In the course of my experiments, I discovered that the two manners were nearly related to each other, a discovery which I hope will one day be worthy of the serious attention of all artists. Take a stone prepared for chalk-drawing, and prepare it with aquafortis and gum ; clean it well with water, and when dry, cover it very thin and even with etching-ground, in the deep etched manner. When the outlines of the drawings are traced upon it, take a scraper of the best steel, and scrape all the gradations of light and dark shades into it. At first the scraping instrument touches none but the most elevated points of the surface, and only by strong and repeated application produces larger points, in the manner in which French chalk acts upon paper, only

with the difference that the points produced on the black stone are white. The whole plate being thus finished, let it be bitten in gradually in the deep etched manner, and then cleaned and printed in the same way.

If one chooses to etch the plate in all gradations, very strongly, it may subsequently, when rubbed in with ink, be gently ground with fine-grained pumice-stone, and with a piece of black slate and gum-water, in order to render it perfectly smooth, and remove the coarse grain arising from the first preparation. Parts which appear too dark, may be rendered lighter by gentle rubbing down, and light can also be corrected by the dry point. The drawings executed in this manner are fine and full of expression. The only thing to be wished for is, that this manner might possess the great advantage of allowing the drawing to be executed black upon white, as the inverted proportion certainly impedes the freedom of the artist.

Among the experiments tried in this manner there were two, which principally answered my expectations. In the first of these the stone was prepared with a rough grain, then prepared with a solution of aqua-fortis and gall-nuts, cleaned with water, and left to dry. Then I used to draw upon it with a black chalk, prepared of oil of vitriol, cream of tartar, and lampblack. In other respects, the whole was treated as described in the article respecting the preparing ink. *

* I have not yet had sufficient time to compose a preparing-chalk, strong enough to

In the second I prepared a certain colourless chemical ink, of one part of wax, two parts of tallow, and one part of soap. These ingredients I dissolved in water, and with them I covered the rough-grained stone, previously prepared with phosphoric acid, gum, and gall-nuts, and cleaned with water ; the composition must be put on strong enough to withstand the subsequent etching. As soon as the stone got perfectly dry, I drew upon it with a black chalk, composed of cream of tartar, gum, a little sugar, and sufficient lampblack ; or I used the Italian chalk, or a fine English black-lead pencil. The drawing was now etched or bitten in, washed with alum-water ; when dry, I covered it with a fat ink, and cleaned the stone with oil of turpentine and gum-water. If the surface was to be smooth, I used to rub the stone gently down ; but in this case the drawing required to be etched very deep, otherwise it would soon have been injured by the rubbing down. In general, in the etching of these manners , it ought to be constantly kept in mind, that the aqua-fortis must first remove the elevated points before it can act on the surface of the stone.

The success of these experiments, induced me to try the application of the soft ground manner upon stone. By adhering exactly to the rules which I am about to give, chalks, as

lose nothing of its preparing quality. The composition of vitriol, cream of tartar, and lampblack, gives, however, a chalk which, after some days standing, answers very well to work with. It has, moreover, the advantage that one can work it with a stump composed of rolled paper, by which the finest gradations of shade may be produced.

well as India ink drawings, may be perfectly imitated; the operation of the drawing is perfectly easy, and the printing very elegant, so that I am inclined to class this manner as one of the most interesting in Lithography. The following particulars must be attended to :—Let the outlines of the drawing be traced on the very thinnest and most uniform bank-post paper which can be procured ; the thinner and more equal the paper is the better. A very smooth polished stone should now be prepared with aqua-fortis and gum, or with phosphoric acid, gall-nuts, and gum, which answer still better ; then cleaned with water, and left to dry. Let it be afterwards very thinly covered with tallow, by means of a roller, or spread very even and equal with the palm of the hand.

It is of great importance that the grease on the surface should form a very thin, but equal and uniform coat. Let the stone be then smoaked with six or eight wax tapers twisted together. The durability of the ground depends upon this operation ; for, without a coat of tallow, or weak linseed oil, the action of the aqua-fortis could not be resisted. The stone is now perfectly prepared, and must not be touched any more with a finger. Let the fine bank-post paper, on which the drawing has been traced, be fixed by its extremities upon the stone, without moving it, as the smallest friction on the ground would be apt to injure it. Two slips of wood, a little higher than the stone, should be placed on both sides of it, and a broad and strong rule across them, in order to rest your hands upon

while drawing, and without touching the surface. The drawing itself ought to be executed with Italian chalk, or with a good English lead-pencil. When all the lines and shades are on the paper, and your drawing complete, on removing the paper a *fac simile* will appear on the stone, and in the subsequent etching, the aqua-fortis acts upon the design only ; it is bitten in and covered, as described in the deep-etched manner, and the printing is managed in a similar way. By practice, the artist may be certain of always producing a perfect preparation, and it is astonishing to what high perfection, and miniature-like delicacy, as well as strength and expression, drawings in this manner may be brought. This last described process may be very advantageously used in conjunction with the preceding deep-etched manner.

§ 7. *India Ink Drawing with Etching-Colour.*

This manner serves very well to shade drawings already deeply etched or cut-in ; and, on the other hand, to amend, correct, and finish, the different aquatinta manners. Mix juice of lemons with a little lampblack, and with this composition let the drawing be executed on the smooth polished and prepared stone. This acid produces a beautiful grain on the stone, and takes ink, provided the lemon-juice be well cleaned off as soon as it has had the desired effect ; and the stone, when dry,

be well rubbed in with unctuous ink. In order to produce dark shades, the same process must be repeated ; and for the lighter shades, the acid must be diluted with water. By means of this process, drawings may be executed with the camel-hair brush on stone, in the same way as with Indian ink on paper. The advantages derived from this manner are incalculable.

CHAPTER III.

MIXED MANNER.

————

LITHOGRAPHY possesses a peculiarity of which no other species of engraving or printing can boast, namely, that the elevated, as well as engraved lines, may at once be printed from the same stone; and by mixing these two manners, the finest effect may be produced. To give a description of all the means of effect which this branch of the art possesses, and the various subjects to which it may with advantage be applied, would alone fill a thick volume. Supposing, however, as I do, every amateur of the art, after an attentive perusal of the preceding pages, to be tolerably well acquainted with the nature and power of the new art, I leave it to his own reflection to determine the occasions when the different manners ought to be applied, and the mode of doing so with success. I shall, therefore, now content myself with merely pointing out the course necessary to be followed in the principal mixed manners, by attending to which, little difficulty will be felt as to the others.

§ 1. *Pen-Drawing mixed with the Engraved Manner.*

This may be done in two different ways, *viz.*, by first completing the pen-drawing, and by covering it after its being etched with red gum-ground (as described in the engraved manner) and then executing the finest lines with the graver, or needle.* In printing, the very same process as in pen-drawing is observed. The second way is, first to execute the engraved or etched-in parts of the drawing ; and when the stone is rubbed in with etching colour, cleaned and dried, to add the rest with the pen, and with chemical ink. As soon as the drawing is perfectly dry, it should be etched-in, and prepared ; in other respects it ought to be treated like the common pen-drawing. In both these manners the artist has the advantage of drawing only those parts with the pen which are best adapted for it, and reserving for the needle those for which the needle is better calculated. The latter has a peculiarly excellent effect in very fine and elegant writing ; and above all in title-pages, where the finest hair-strokes are drawn in first with the needle, and the thicker, or shade-lines, added with the pen.

* A pen-drawing of this description, may likewise be covered with etching-ground, and the omitted lines may be cut in, and afterwards etched in with aqua-fortis ; but in the subsequent cleaning of the stone, it requires some skill not to injure the pen-drawing by rubbing.

§ 2. *Engraved Drawing, with elevated Tint.*

———

This manner, which consists likewise of a mixture of the engraved and elevated manners, has already been fully described in the deeply-etched manner, page 290.

§ 3. *Engraved and elevated Manners with several Stones.*

———

As it may be seen, from the foregoing description, that the elevated and engraved manners may both be printed from the same stone, it may naturally be concluded that this must be much easier than when the separate manners are assigned to separate stones, and united only by the printing upon one and the same sheet. Upon an etched-in drawing, for instance, one or several elevated tint plates may be printed ; and to an elevated pen or chalk drawing, tint plates in aquatinta manner may be applied. How this must be done, has been already described, and recourse must be had partly to the elevated, and partly to the engraved, manner.

§ 4. *Manner of changing an elevated Drawing into an engraved one, and vice versâ.*

———

This operation, in some cases, may be applied with very

great advantage, but the most essential requisite for suc-
cess, is the skill and experience of the artist; and as it is the
most difficult in the whole compass of Lithography, demands
the most perfect knowledge of all the different manners and
rules, I think it will be best explained by some Examples.

FIRST EXAMPLE.—*Manner of sinking a Transfer.*

Let a well-polished stone be prepared with phosphoric acid
and gum, thoroughly cleaned with water and left to dry.
A drawing made with very soft ink, or chalk, or the recent im-
pression of the stone, or of a copper-plate, may then be trans-
ferred to it in the usual manner. Let the stone be then laid by
for some hours, in order to give time to the greasy ink to get
fixed and settled, to prevent its being easily rubbed off. Let
the stone be now washed with clean gum-water, and with a rag
dipped into etching-colour; let so much ink only be rubbed
upon it as is necessary to preserve the drawing from the action of
the aqua-fortis. The biting in may now be effected with pure
aquafortis, with which a small quantity of pulverised alum
may be mixed; let this composition be left upon the stone, till
the uppermost surface, prepared with phosphoric acid, is bitten
away, except on the places covered with ink. Let pure water
be then poured on the stone, which should afterwards be washed
with soap-water, and which must be left to dry on it. Let the

stone be cleaned from the soap with oil of turpentine, rubbed in with etching colour, and it will take ink all over its surface and become entirely black. But as soon as it is gently rubbed with a rag dipped in soap-water and weak phosphoric acid, the whole drawing will re-appear white, as if this had been effected with preparing ink. Let the stone be now charged again with etching-colour, and treated as has been described in what was said respecting preparing-ink; by which treatment the drawing that in the beginning appeared elevated will become etched into the stone. This manner is susceptible of great perfection, and when employed with sufficient experience and skill in the transfer of drawings executed on paper, with chemical ink or chalk, it will produce perfect masterpieces, especially when the plate, thus deeply etched, is subsequently finished with the graver. Even before the operation of changing the elevated drawing into a sunk one, the lines and points which are too thick may be rendered finer, and those which are too fine stronger; but this must be left to every artist's own judgment, as in general this manner requires a perfect master of the art, to whom only a few hints are sufficient to guide him in his operations.

SECOND EXAMPLE.—*Manner of etching deeply a Drawing executed with unctuous Chemical Ink or Chalk.*

———

Let a fine-grained stone be bitten in and prepared with phosphoric acid and gum; let the drawing be executed on it

with ink or chalk, and in the subsequent etching and all other operations, let the process described in the first example be observed.

THIRD EXAMPLE.—*Manner of sinking an elevated Drawing.*

———

In the two preceding examples the stone is etched with phosphoric acid, before the transfer or drawing is made upon it. Now, as those places which are covered with grease are not acted upon by the slight etching with aqua-fortis and alum, they retain their preparation of the phosphoric acid, which by the subsequent preparation of soap, is not easily removed ; on the contrary, the etched places, when washed with soap-water, are perfectly disposed to take ink. But in stones, prepared and drawn in the common way, where the fat lines do not rest only upon the prepared surface, but have penetrated to some depth into the stone, the changing of one manner into another is a little more difficult ; with some experience and practice, however, the following treatment will ensure success : Let the stone be washed with water, then covered with strong soap-water, or chemical ink, and left to dry. Let the stone be now well cleaned from the soap with oil of turpentine, and charged with etching colour. A linen rag should then be dipped in a solution of gum-water and phosphoric acid, and with this let the ink be wiped off the elevated lines. Having

passed the rag a few times over the whole surface of the stone, endeavour with the finger to ascertain whether the drawing is not disposed to separate from the ink ; and, if this is not the case, let the rubbing with the acid be continued. Great care must be taken that the ground be not injured by too violent friction in rubbing. If the lines of the drawing are at last sufficiently white, let the stone be charged with a strong etching colour, and in other respects treated altogether as in the preceding examples. In this manner drawings, which in the elevated manner, had failed in their keeping, by being changed into deep etched ones, may be entirely corrected, and the most delicate gradation of tints may thus be produced ; but, as I mentioned before, this requires great skill and practice, otherwise the stone may be entirely spoiled.

FOURTH EXAMPLE.—*Manner of changing a deeply-etched Drawing, into an elevated one, for the sake of greater facility in Printing.*

———

Writings and drawings may, by some artists, be more easily executed with the graver than with the pen, in the elevated manner. The pen requires more skill and diligence than the art of using the graver. If, however, you require to have the drawing or writing in the elevated manner, for the sake of increased facility and expedition in printing, the method here described may be of great use, especially as the process is much

more easily learned than the preceding methods, being in its character exactly the reverse of them ; for, in this case, all that was before engraved must become elevated. To effect this, let the stone be charged with good etching colour ; and, after the lapse of some hours, let it be bitten in with aqua-fortis, in the manner of a pen-drawing, till you see that the points and lines become elevated. After this operation lay it aside for some hours, till perfectly dry, then let it be covered with gum, and printed as a common pen-drawing.

Here I conclude this Course of Lithography, with the sincere conviction that I have faithfully described and explained with all the clearness in my power, all the operations in the different manners of Lithographic Printing, the knowledge of which I have obtained by unremitted study and innumerable experiments. In the annexed Supplement will be found some useful observations, which do not exclusively belong to Lithography ; but which, notwithstanding, are nearly related to it, and therefore will not, I hope, be unwelcome to the amateurs of this important and interesting art.

SUPPLEMENT.

SECTION I.

Printing with Water and Oil Colours at the same time.

A STONE which has been wrought either in the elevated or en_
graved manner, when it has received an oil colour, may be afterwards
coated over with one water-colour only, or illuminated by parts with
various colours, and then printed off. For this purpose, take two parts
of gum-arabic and one part of sugar, and mix them with the water-
colour which you may wish to use; and in colouring the stone, it is
only necessary to see that the colours are properly dried before the
impression is taken, for without this precaution the impressions would
be stained and dirty.

If however it is wished that in this process each colour should retain
its own peculiar shade, and that the drawings should bear a resemblance
to the French or English coloured engravings, the following particulars
must be attended to :—

All the various shades of each colour must be pretty deeply etched into the stone in the engraved dotted manner; for example, in one of the aquatinta manners already described. After the etching, the stone must be washed with gum-water, that its hollow parts may take no colour. The ground, or chemical ink, should then be removed by means of oil of turpentine, and the whole stone must be prepared, if a preparation has not already been given to its surface. Let it then be covered with a red gum ground, and let all those strokes, which are to appear black be immediately cut or scratched in. The colour ought then to be rubbed in, and the stone cleaned, so that it may every where appear white, except in the strokes which have been cut into it. If the stone is then inked, it will take colour every where but in the lines or strokes which have been cut, and the remaining places which have been deepened, namely, the various shadowings of the colours, will remain white, because they are prepared. If each part is now coated over with its proper water-colour, this colour will be denser and consequently darker, where the deepenings are greatest and most numerous.

SECTION II.

Printing in the Chemical and Mechanical Manner at the same time.

IF a pen drawing is of such a nature that the single lines or strokes are quite close to each other, and that it contains no spot entirely white of a greater diameter than half an inch at most; this drawing may be inked and printed in a manner altogether mechanical, and without receiving any preparation, if the etching has only been executed in as

elevated a mode as is compatible with security, from the danger of exposing the finer touches to corrosion. If the strokes or touches therefore are not too fine, the operation is attended with little difficulty, and in order to lay the colour on the elevated strokes, in a perfectly pure manner, notwithstanding the slight degree of their elevation, it is only necessary to have a colour-board, which must be prepared in the following manner :—Plane a small board of tender wood, of about eight inches in length by six inches in breadth, so thin that it shall not exceed a twelfth part of an inch in thickness. To this board glue a piece of fine cloth or felt, of the same length and breadth. Above this glue another board of very dry wood of the same magnitude, but only one quarter of an inch in thickness, after it has been previously planed extremely even, or polished by a smooth stone with sand, which is still better. The thickest of the two boards must be furnished with a handle, and when the whole is dry, let this colouring board be polished on a very level stone, with fine sand and oil till it becomes as smooth and even as possible. To colour a stone drawn and etched in the elevated manner, the colouring board must be previously made black or red, &c., in a delicate and uniform manner, by a leathern ball, which has been worn smooth by printers' ink. Let the whole surface of the stone, which ought to be cleaned before-hand with oil of turpentine, be now cautiously touched by this instrument, holding it all the while as horizontally as possible, till the colour is every where well distributed.

This manner of printing is in itself of no great advantage, when compared with the chemical; but then, by the union of the two manners, three colours may be printed on one stone. The mode in which this may be done is shown in the following

EXAMPLE :—

If a drawing consist of black, blue, and red, colours, and these colours are all to be communicated at the same time to the same stone, then a stone, fit for a pen drawing must be taken, and prepared in the first place with phosphoric acid, an infusion of gall-nuts and gum-water, and afterwards purified with water and left to dry. Whatever is to be red, must be drawn on it with chemical ink, which ought to contain no more soap than is absolutely necessary for its solution. When this drawing is dry, it must be highly etched, and the higher this can be done the better. After the etching, the stone ought to be prepared with gum purified again with water, and again left to dry. Let it then receive a coat of etching-ground, dissolved in oil of turpentine, and let all that is to be black be drawn between and over the highly-etched strokes. Let what has been drawn be afterwards pretty strongly etched down, then purified with water ; let alum-water be next poured over it, after which it may be dried. When the stone is thoroughly dry, the printers' ink must be rubbed into it, and then it should be cleaned with a woollen rag, gum-water, and oil of turpentine. After this it will again be every where white, except in the deepened lines where it has taken the printers' ink. On being again purified with water, and subsequently dried, all those strokes, which are to be blue, may be drawn on the stone with a chemical ink containing abundance of soap. This again must be well dried and the stone purified with gum and oil of turpentine, and then it will be ready for receiving the colour.

The process of laying on the colours properly, is as follows :—

The black colour must first be rubbed in, agreeably to the directions for the engraved manner. In the parts which are very deep, the stone

will become very black, but in the level parts last drawn, it will merely be grey, if the colour is only well rubbed in, which may be very much promoted by gum, and more particularly by wiping with a woollen rag; for the tone of the colour which remains on the even places, which have been drawn with chemical ink is so faint, that it can do no injury to the blue colour; dip a rag in blue colour, and rub the stone softly with it backward and forward, till it has sufficiently taken all that is to be blue. Take the colouring-board, which has been prepared with a red colour, and apply it to the stone, which in the mean time will have become dry, and the uppermost lines will receive the red colour, after which a tri-coloured impression may be taken. Further colouring must always take place in the same manner.

SECTION III.

Application of the Stone to Cotton Printing.

ENGRAVED copper-plates have long been applied to cotton printing, but as the ordinary oil colour could not be used, and the proper etching colour could not be managed in the same way, as from its fluidity it was rubbed by the rag out of the sunk part of the copper-plate, another method was devised of filling in the plates with water-colours. The whole plate received a coat of colour, and then a sort of rule was drawn over it, which removed all the colour from the surface, and allowed it to remain only in the hollows.

The same method is applicable to engraved stone drawings, and it is only necessary that the stone should be very level and very polished.

The colour, however, which is used, must be one which will come easily away, and the rule must be very equal and sharp that it may take off the colour well *.

Starch paste, or gum, mixed with etching materials, for instance, with acetate of iron, comes easily off, and in printing is not apt to spread, if it is of due thickness †.

SECTION IV.

Printing of Colours by the Application of the Rule.

THIS manner of covering the stone with colour, and removing it with the rule, is very applicable to paper for hangings, tapestry, &c. Almost all the engraved stone manners may be very beautifully printed in this manner, if the colour is good.

* A broad and very thin piece of steel plate, ground extremely straight, and highly polished on the side which lies on the stone, will be still more serviceable than a wooden rule.

† For the purpose of drawing on a stone-plate, or cylinder, I have invented a peculiar machine, by means of which, the most difficult design may be completed in two days. I will communicate this machine, along with a press adapted to the printing of cotton, to amateurs, in a separate treatise; as I am convinced that the stone is peculiarly fit for this branch, and deserves preference to a considerable degree over copper, both on account of the rapidity with which the drawing may be executed, and its cheapness, especially, if my artificial stone covering is to supply the place of the natural stone.

Starch-paste, or gum mixed with coarse starch, or fine flour, and with the necessary colour, suits extremely well for all sorts of printing in the tapestry manner, especially if the paper used is unsized and slightly wetted.

New cheese or fresh curds, mixed with soap, potash, linseed oil varnish, and a suitable colour, form an excellent composition, with which all the engraved manners (even aquatinta), if the stone is even, may be very beautifully printed, and is of the most essential service in the printing of colours either with one or more stones.

When a drawing, in the engraved manner, is properly executed for this purpose, the colours may be laid on with the pencil in a very coarse manner, without regarding whether they are thick or thin on the stone ; provided only, they do not extend beyond the limits of the places to which they belong, in case several colours are to be printed with one stone. When the stone is dry, all the colours may be at once removed, without fear of stains, though they should be drawn over one another.

A drawing coloured on the stone in this manner, is more beautiful than when coloured on paper, and the operation requires much less time.

SECTION V.

Printing of Oil Paintings by Transfer.

IMPRESSIONS resembling oil paintings may be produced by the printing of colours with several stones, if the paper has received a ground, that

is, if it has been run over with an oil colour ; but perfect oil pictures can only be multiplied in the following manner :—

Take unsized paper and run it over with a thin coat of starch-paste or common paste—Prepare a tolerable quantity of paper in this manner—On this take the separate impressions of each colour stone. If the picture itself is to be composed of these separately printed coloured parts, then take a piece of canvass grounded for painting in oil, and lay on it a wet impression, on which there is a particular colour ; for example, the red colour. Let this be put through the press, under a slight pressure, and when the paper is taken off, the colour will have been communicated from it to the canvass. Lay then another wet impression of another colour on it, observing accurately the place where it ought to be put, and press it in the same manner, and so on till all the colours have been gone through. The pressing the paper on the canvass, may even be effected without a press, by the mere hand, or in a variety of ways ; for it requires no great force, as the colour comes with great ease from the paper, and attaches itself to the canvass.

As to the colours which require to be laid fresh on one another, and those which must be previously dried, and the mode in which the separate colour-stones must be drawn, all this must be left to the judgment of the artist, who wishes to avail himself of this highly important manner.

SECTION VI.

Stone Paper.

THIS name is generally given to a substitute for the natural Solenhofer stone, of my invention.

For a long time I had been making experiments with the view of dis-
covering a composition bearing a resemblance to stone, and equally
fit for impressions.—The parchment, used for tablets, would have an-
swered this purpose, were not its coat soluble in water; to prevent this
I mixed it with lime and fresh curds, allowing the mixture to be suffi-
ciently saturated with carbonic acid from the air before using it; and I
had recourse to a mixture with chalk, gyps, and glue, which I afterwards
dipped in a solution of alum and gall; and I succeeded so far that
I could use it for coarser works, of which too many impressions were
not wanted.

My expectations, however, were not completely realized till I made the
observation, that spots of grease, produced by oil on a stone plate, and
also that drawings which were printed with oil alone, after a few weeks
would no longer take colour, if even the slightest degree of preparation
was given to them.—I concluded from this that the oil experienced a
change in the air, and that while it was probably uniting with acid, it
lost its fat and received a more earthy quality. Whether this con-
clusion was correct or not, it induced me to try to use oil as a connect-
ing medium of various earths; as I supposed, with reason, that such a
composition would be indissoluble in water. The great point was to
ascertain whether, notwithstanding the oil which entered into the mix-
ture, it could receive a preparation; that is, whether there could be com-
municated to it a disinclination towards other fats.

The result corresponded so much to my hopes, that I am convinced,
such a stone-like substance can be formed by means of various compo-
sitions of clay, chalk, linseed oil, and metallic oxides, that when paper,
canvass, wood, &c. are coated over with it, plates may be obtained

capable of supplying the place of stone as a printing material, and in many cases possessing considerable advantages over it.

I shall in like manner soon communicate to the world, in a separate work, the experiments which I made with so much success in this respect; and, thereby, perhaps supply our skilful chemists with the means of perfecting my discovery still more.

SECTION VII.

Application of Chemical Printing to metal Plates.

ALL metals have a great affinity to fat; however, when they are quite pure, for instance, when ground with pumice-stone or rubbed with chalk, they may be prepared like stone; that is, they receive by various modes of treatment, a disinclination to take oil colour, by which means they are rendered fit for the purposes of chemical printing.

Iron and zinc may, like stone, be prepared with aqua-fortis and gum.

Tin and lead may be prepared with aqua-fortis, gall, and gum. It may be still better prepared by the addition to this mixture of a small quantity of blue vitriol ; and the more coppery it is rendered by the application of this liquid, the preparation will be the more complete. The most durable preparation for tin and lead, is a mixture of aqua-fortis, sulphuret of potash or soda, gum, and nitrate of copper.

Brass and copper are best prepared with aqua-fortis, gum, and nitrate of lime, mixed in due proportions.

Lime and gum, as also potash with salt and gum, form a good means of preparation for all metals.

The alcoline preparation is, however, only applicable for the engraved manner; for the raised, the acid manner is much better.

I have lately applied the chemical printing of metal plates, to a new species of copper machines, in which all that is drawn with chemical ink or chalk on paper, is taken off by the press in a few moments, and may be multiplied many hundred-fold. His Majesty, the King of Bavaria, had the goodness to give me a patent for this invention for six years.

Hitherto I have been prevented by the publication of this work, from giving any extension to this subject; but now that I am again at liberty, I shall endeavour, with the utmost assiduity, to have a store of them executed; and it will be worth while to open a subscription, to enable me to deliver them at a very low price, which would afford me the more gratification, as the general utility of my inventions constitutes my highest reward, and the object that I have most at heart, to promote which, I have in this work laboured with all the pains and assiduity in my power.

I have been somewhat less circumstantial in the concluding sheets, from an idea that those who thoroughly understood the preceding directions, would not require so many words to understand the remainder, the essential points of which are always correctly laid down.

Had not the demand for this book, which perhaps was too early

announced, been so very urgent of late, that it was impossible to delay any longer the publication of it, I should have endeavoured to render the specimens of the various manners more worthy of the elegance of the printing. But I leave this to a supplementary volume which will soon follow the present, in which my principal object shall be to describe with greater minuteness the manners that remain still unknown, and to furnish each of them with a specimen of real merit, as a work of art.

I now close my instructions, and wish from the bottom of my heart that my work may find many friends, and produce many excellent Lithographists.—May God grant my wish.

THE END.

Directions to the Binder for placing the Plates.

LIST OF MATERIALS

AND

UTENSILS FOR LITHOGRAPHY,

FURNISHED BY

R. ACKERMANN.

———

English and German Stones, ready prepared for Chalk or Pen and Ink-Drawing, for Etching and Engraving.

Pumice Stone.

Spunges.

Gravers, Scrapers, and Etching-Needles.

Flat Varnish Brushes, Sables, and Camel Hair-brushes.

Steel Pens.

Rollers for filling in the stones with ink.

French Tracing-paper.

Prepared Paper for Transfers.

Chemical Ink to draw or write with, in boxes or bottles.

Autographic Ink for Transfers.

Chemical Chalk, soft, middle, or hard quality.

Printing Ink.

Burnt Oil, strong.

Ditto weak.

Gum Arabic.

Rectified Aqua-fortis, proper for Lithography.

Printing and Blotting-Paper, proper for Lithography.

*** R. ACKERMANN *offers his services as Printer to amateurs and artists.*